Wildlife Photographer of the Year

Portfolio 10

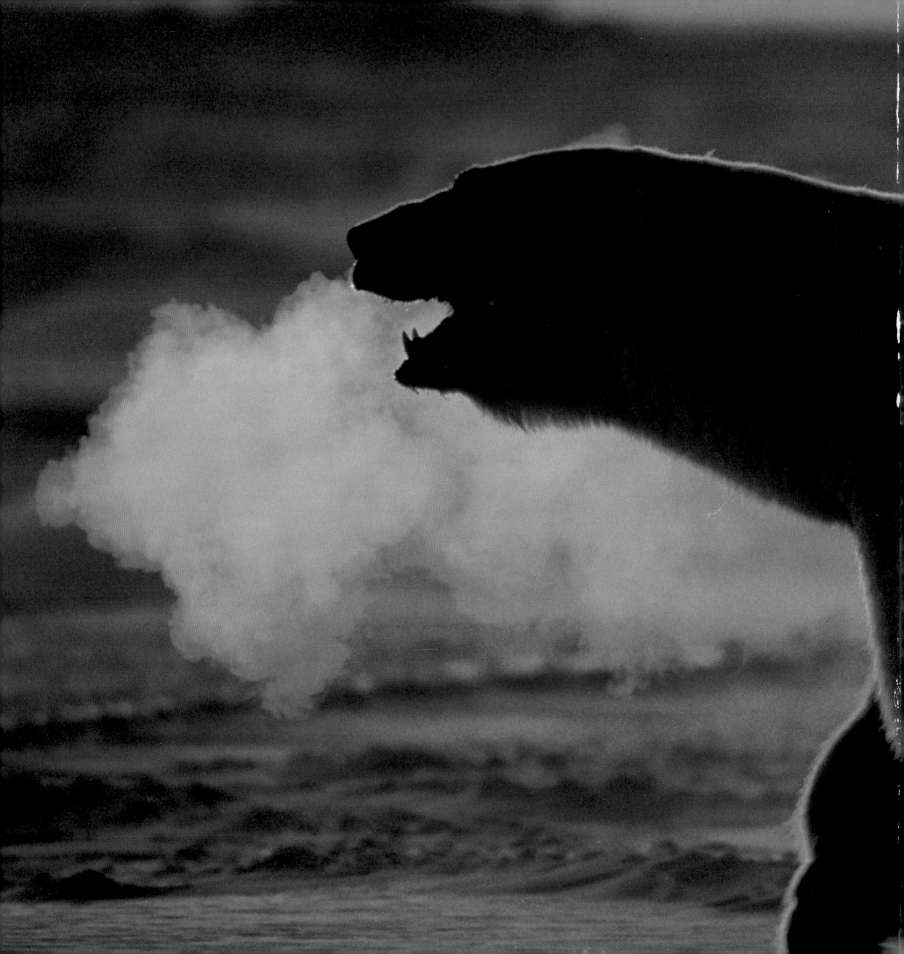

Wildlife
Photographer
of the year

Portfolio 10

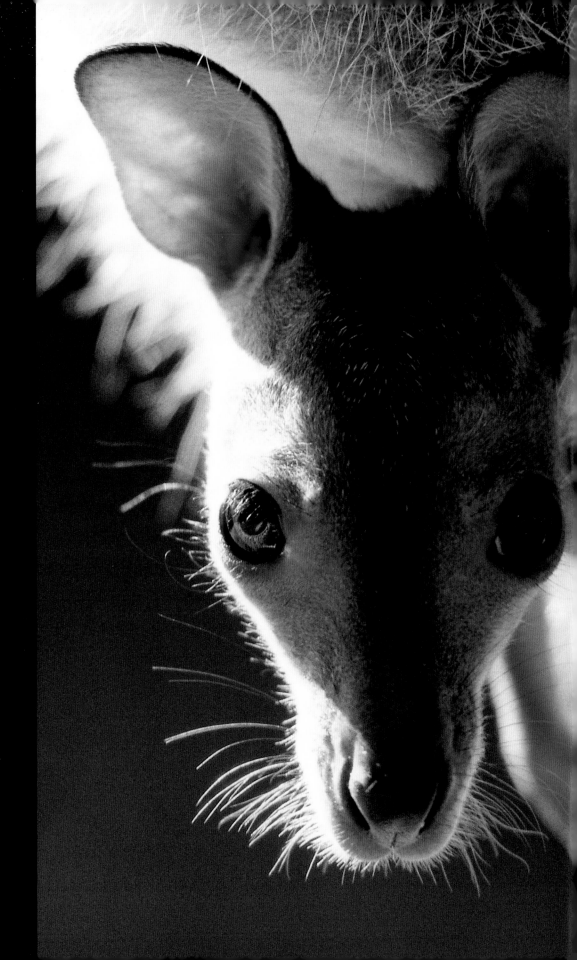

Competition Manager Louise Grove-White
Design and layout Alex Evans
Jacket Designer Pene Parker
Caption writers Rachel Ashton, Tamsin Constable

ISBN 0 563 53706 X

First published in Great Britain in 2000
Reprinted 2000, 2001, twice
Published by BBC Worldwide,
an imprint of BBC Worldwide Limited,
80 Wood Lane, London W12 0TT

Jacket printed by Lawrence-Allen Ltd, Western-super-Mare, UK

Colour separations by Pace Colour, Saxon House, Saxon Wharf,
Northam, Southampton SO14 5QF, UK

Printed and bound by Butler & Tanner Limited,
Frome and London, UK

Contents

Introduction 2000

A great deal has been written about wildlife photographs, most of it complimentary. Thousands of words have accompanied the sort of images you will see in this book, pouring eulogy and praise on the photographers and their patience, their eye and their artistry, and all of it well earned. But let's be honest here. Taking photographs isn't rocket science.

There was a time, of course, when simply capturing an image of any sort on film was a major technical achievement, and flash photography a life-threatening exercise. With the advent of hi-tech camera and lighting equipment, many of the practical problems of this work have been reduced or eliminated. But far from making the photographer's life easier, it makes it a whole lot tougher. Gone are the days when simply recording a well focused image of a fox was worthy of high praise. Now the fox has to be doing something interesting. Not only that, but it has to be doing it in gorgeous light. And there is always that little something extra, the composition, the light in the eye, the intangible ingredient that lifts an image out of the mass of good photographs into the elite of great ones. This book is stuffed full of great photographs.

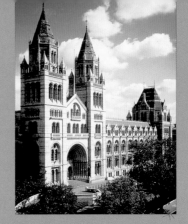

But there is more to this collection than a batch of pretty pictures. This is a feast of still (and sometimes very animated) life which has taken on an ambassadorial role. The BG Wildlife Photographer of the Year Competition has become an international showcase for the beauty and fragility of the natural world. It has been running since the mid-1960s, when its original objective was to stimulate photographers to take better photographs. Back then, apart from a few notable exceptions, there was a terrible dearth of good nature photography, and *Animals* Magazine (the predecessor of *BBC Wildlife* Magazine) was struggling to find enough material to fill its pages. In an attempt to motivate photographers to get out there and get busy, the competition was born. It would have been hard to imagine then that it would develop into the most significant and prestigious event of its kind in the world – a unique portfolio from artists whose vision carries us all across the globe and exposes us to some of the planet's most spectacular natural treasures.

The images on these pages are also showcased in an exhibition that tours the world, starting at The Natural History Museum in London, which has hosted the event since 1984. From there it travels,

The Natural History Museum

Home of the nation's unparalleled collections of natural history specimens and one of London's most beautiful landmarks, The Natural History Museum is highly regarded the world over for its pioneering approach to exhibitions, welcoming, each year, nearly two million visitors of all ages and levels of interest. It has also gained unequalled respect over its 300-year history for the excellence of its vital scientific research into pressing global issues such as conservation, pollution and biodiversity.

The museum is, of course, a leading 'expert voice' on the natural world, and considers provision of public access to information about the natural world a central aim. The museum's changing programme of innovative exhibitions and events entertains and informs, and its website provides scientific data, educational programming and resource material to millions of internet users across the globe.

For further information on The Natural History Museum call +44 (0)20 7942 5000, visit the Museum's website at **www.nhm.ac.uk**, e-mail **marketing@nhm.ac.uk** or write to the Marketing Department, The Natural History Museum, Cromwell Road, London SW7 5BD.

THE
NATURAL
HISTORY
MUSEUM

BBC Wildlife Magazine

BBC Wildlife is Britain's leading monthly magazine on natural history and the environment. It contains the best and most informative writing of any consumer magazine in its field, along with world-class wildlife photography. The latest discoveries, insights, views and news on wildlife, conservation and environmental issues in the UK and worldwide accompany regular photographic profiles and portfolios. The magazine's aim is to inspire readers with the sheer wonder and beauty of nature and to present them with a view of the natural world that has relevance to their lives.

Further information
BBC Wildlife Magazine, Broadcasting House, Whiteladies Road, Bristol BS8 2LR

wildlife.magazine@bbc.co.uk.

Subscriptions
+44 (0)1795 414748; fax: +44 (0)1795 414725
wildlife@galleon.co.uk
(quote WLPF00 for the latest subscription offer)

visiting more than 10 countries and seen by millions of people. Such ambitious objectives are expensive, and it is thanks to BG, the competition's sponsor for the past 11 years, that such erudite visual messages can be widely seen and appreciated. The fact that so many people have access to the collection has helped make it what it is today.

Perhaps people look at these images in pursuit of beauty, as a means of escape or simply to wonder at the colour, form and richness of the world about us. Anybody looking at these photographs cannot help but be influenced by them in some way. Perhaps that influence comes in the form of a better appreciation of what lies in a person's own back yard – or maybe a sense of wonder at the complex web of life all about us. Some of the images carry clear conservation messages, eloquent visual statements about the fragility of the natural infrastructure and how we affect it. Whatever the impact, every person who is lost for a moment in the golden glow of a sunset sky reflected on the mane of a lion or smells for an instant the salty tang of the southern oceans by way of an image of an albatross, comes away that little bit more caring, that bit more understanding

that we have got something pretty special going for us here on Earth.

And what of the people behind the cameras? Bonkers mostly. Who in their right mind drags thousands of pounds worth of equipment into deeply hostile environments to sit and wait for a moment which may never come? Bonkers perhaps, but passionate, dedicated and caring certainly. The ingredient common to all of the visual jewels in this book is passion. Without it the image has no soul. It is merely two dimensional, but everything you are about to see (or more likely have already seen – after all, who reads an introduction to a book like this before looking at the pictures?) has that extra level, that elusive element which tells a story, evokes a mood and stimulates the senses. The people who take these pictures, wittingly or otherwise, are responsible for carrying a message across the world. As we share in their time slices, their moments of marvel and beauty, we are reminded to care. As for all those words of praise which so often accompany these pictures, they cannot say enough – because, to use a thumping great cliché, the pictures say it all.

SIMON KING

BG Group

Our sponsorship of this prestigious international photographic competition is now in its eleventh year. During this time we have seen it grow in scale and stature. Indeed, this year's entries totalled some 19,000 separate images from more than 60 countries.

As an organisation whose business is so closely involved with the Earth's natural resources, we see our continued involvement with wildlife photography as an important manifestation of our corporate commitment to the environment.

I personally continue to be amazed at the quality and diversity of the winning photographs in the competition and hope that this book will give you the pleasure of revisiting these wonderful images many times over.

Frank Chapman
Chief Executive, BG International

The BG Wildlife Photographer of the Year

Manoj Shah

The BG Wildlife Photographer of the Year title is awarded for the single image judged to be the most striking and memorable of all the competition's entries. The 2000 winner, Manoj Shah, is no stranger to success in the competition, having been among the winning photographers for the past few years. He has built on his success and, this year, achieves the highest accolade of overall winner.

Manoj Shah

When Manoj was a small child growing up in Kenya, one of his favourite activities was visiting nearby Nairobi National Park. That experience became the foundation for taking photographs of wildlife. After finishing his degree in land surveying at Nairobi University, he went on to do a master's in photogrammetry at University College, London, before returning to Kenya. His interests in wildlife photography developed gradually, and it was only natural that he would focus on the large mammals that captivated him as a youngster. He has had no formal training in wildlife photography but learns by practice and making embarassing mistakes.

BG WILDLIFE PHOTOGRAPHER OF THE YEAR 2000

Manoj Shah
United Kingdom
ORANG-UTAN AND BABY

Canon EOS 1N with 300mm lens;
1/30 sec at f4; Fujichrome Velvia;
monopod

Populations of wild orang-utans have plummeted by 50 per cent in the past 10 years, to about 15,000 in Borneo and Sumatra. Habitat loss, particularly from illegal logging, is the biggest problem. The Bohorok Rehabilitation Centre, in Sumatra's Gunung Leuser National Park, rescues and cares for orphans. This female was three when she was brought here. Released four years later, she has been free-ranging ever since, and this is her third wild-born infant. I watched them for a long time. The female eventually turned her face into the light that filtered through the forest canopy, just as the baby looked up from its suckling.

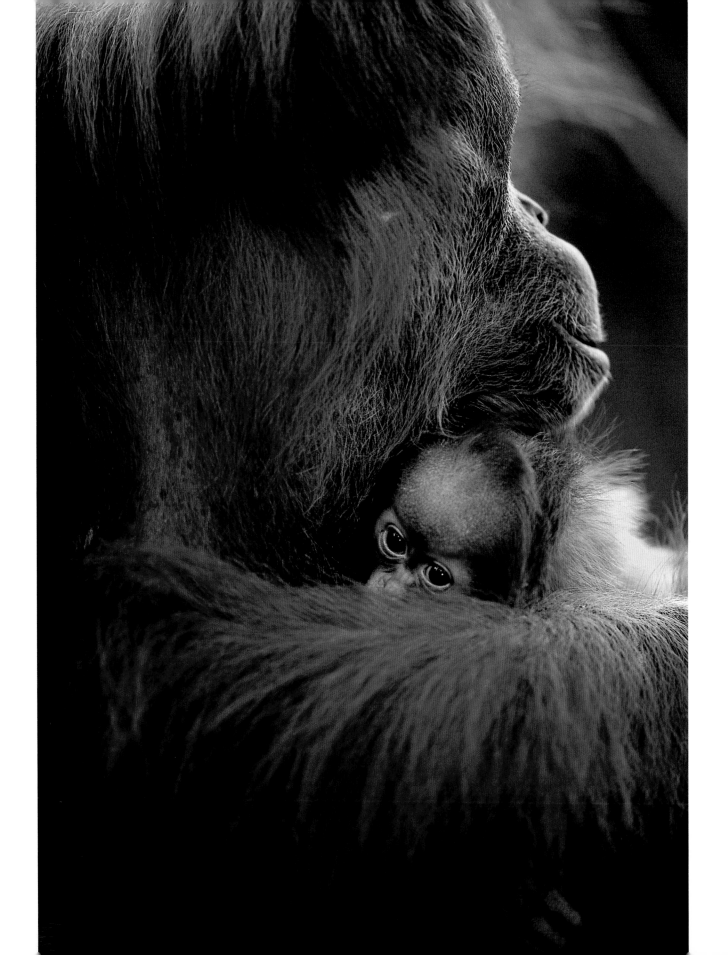

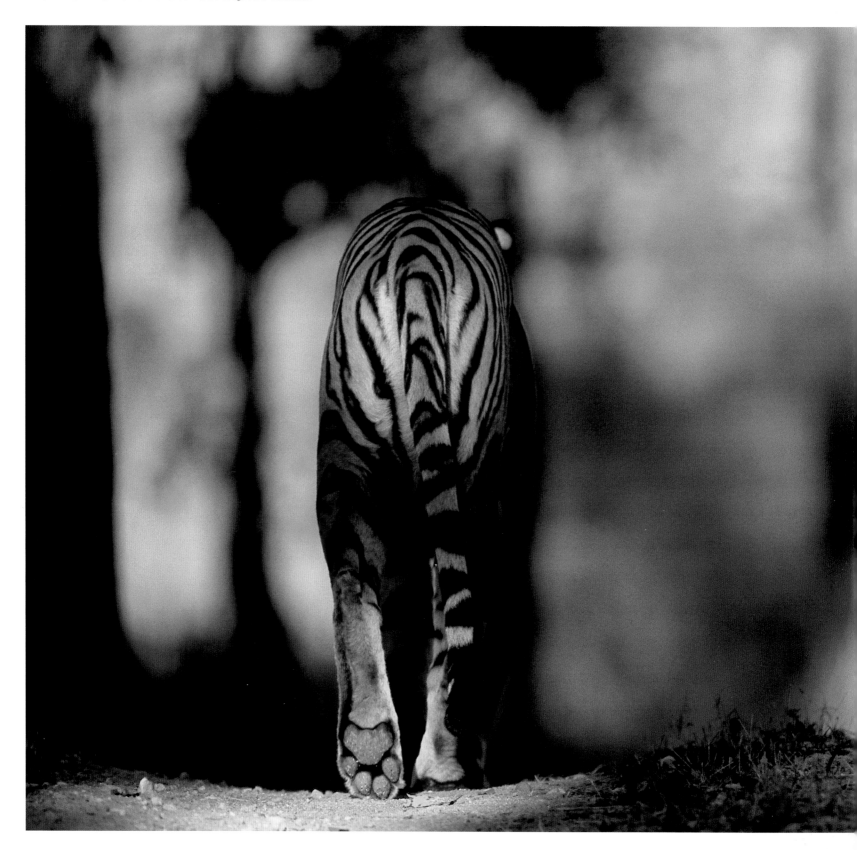

Nick Garbutt
UK

**BENGAL TIGER ON
A FOREST TRACK**

Nikon F5 with 500mm lens; f4;
Fujichrome Velvia 50 rated at 80;
beanbag

Tracking tigers can be frustrating. Usually it's a matter of following the alarm calls of other animals - langurs, chital deer, peacocks - and occasionally getting lucky. This magnificent young male was just strolling along the road one late afternoon in Kanha National Park, Madhya Pradesh, India. He didn't look back once. Then, right after this picture was taken, he lay down in the middle of the road. Five minutes later, he got up, walked straight past the jeep and, without a sideways glance, melted into the forest.

The Gerald Durrell Award for Endangered Wildlife
Nick Garbutt

This award highlights species officially listed in the 1996 IUCN Red List of Threatened Species as critically endangered, endangered, vulnerable or at risk internationally or nationally. The award commemorates the late Gerald Durrell's work with endangered species and his long-standing involvement with the BG Wildlife Photographer of the Year Competition.

Nick Garbutt

Nick is a wildlife photographer, author and tour leader to tropical places such as India, Tanzania, Borneo and Madagascar (his favourite destination). He first tried his hand at photography on a student expedition to Sarawak, where, he says, he took "abysmal pictures of proboscis monkeys." Twelve years later, his photographs appear in leading wildlife and environmental magazines, and he has published two guidebooks on the wildlife of Madagascar. His lifetime ambition to see a tiger in the wild was fulfilled in India in 1993. Since then, he has made several trips to both India and Nepal, specifically to watch and photograph the increasingly threatened Bengal tiger.

RUNNER-UP

Tom Schandy
Norway

CAPTIVE GIANT PANDA EXPLORING THE WILD

Nikon F5 with Nikkor 80-200mm lens; Fujichrome Velvia; tripod

Climbing trees gives five-year-old Xi Meng – Chinese for Hope of Dreams – a chance to spend time in natural conditions. She's one of 23 giant pandas in the captive-breeding centre in the Wolong Nature Reserve in Sichuan Province, China. The centre's ultimate aim is to return pandas to the wild. For now, it concentrates on captive-breeding, and since 1991, eight cubs have been born from natural matings. Scientists from all over the world visit the centre to learn how to breed the animals.

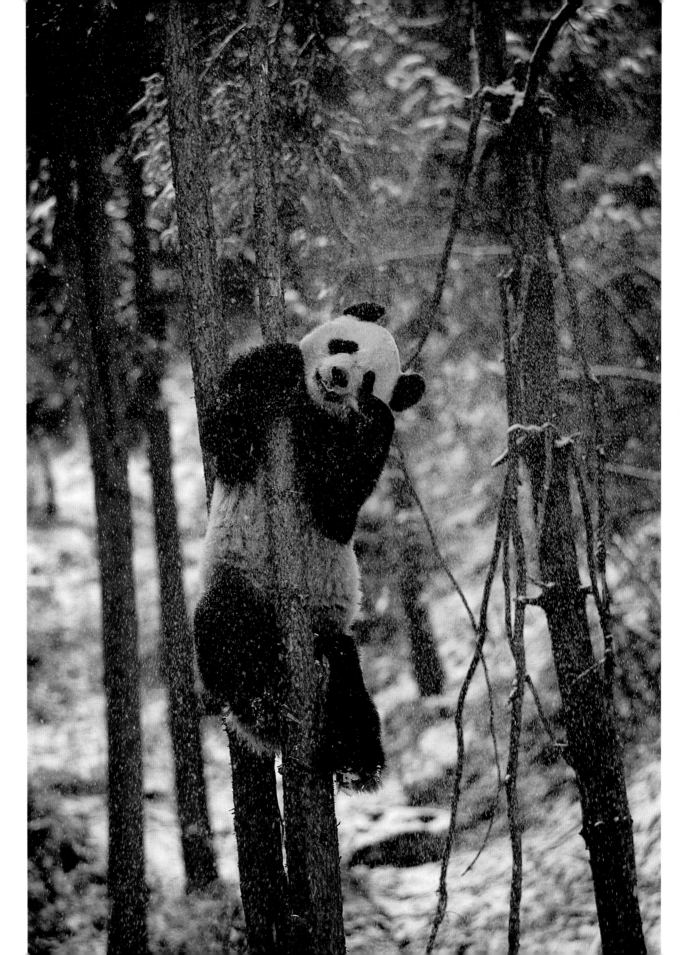

Arthur Morris
USA
HIGHLY COMMENDED

HEERMAN'S GULL DISPLAYING

Canon EOS 1N with 600mm lens; 1/1000 sec at f5.6; Fujichrome Velvia 50 rated at 100

After bowing, this male gull, which was in full breeding plumage, would throw his head back and scream, often four or five times, before going through it all again. He was one of about 20 endangered Heerman's gulls – the most beautiful gulls on North America's Pacific coast – roosting on the 15-metre cliffs in La Jolla, California.

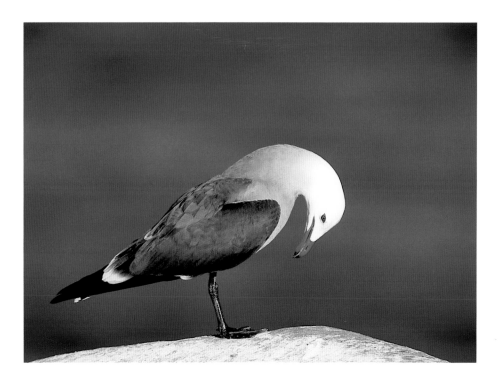

Cornelia and Ramon Doerr
Germany
HIGHLY COMMENDED

VICUÑAS WARMING THEMSELVES BY GEYSERS

Nikon F100 with 500mm lens; 1/100 sec at f4; Fujichrome Velvia; tripod

The southern end of the salt-covered lake Salar de Surire, 4,300 metres high in the Andes in northern Chile, is bordered by hot springs. From our campsite by the lake, we saw vicuñas heading through the steamy fog towards the springs. They stayed there all night, and this picture was taken the next morning, before they left to feed.

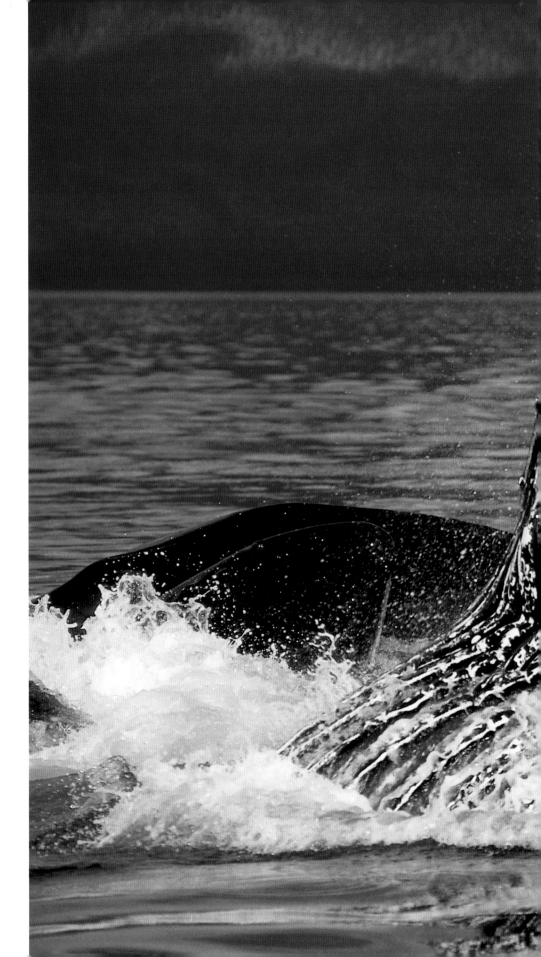

Jo Overholt
USA
HIGHLY COMMENDED

**HUMPBACK WHALES
LUNGE FEEDING**

Nikon F4S with 300mm lens;
1/500 sec at f5.6; Fujichrome
Provia 100

These humpbacks off
south-eastern Alaska were
hunting co-operatively,
probably for shoals of
capelin or herring. They were
performing their 'bubble-net'
feeding technique, used
exclusively by humpbacks.
This involves around five to
eight whales diving below
the prey. Then, by spiralling
and blowing bubbles
through their blowholes,
they form a circular 'net' of
bubbles that the fish can't
pass through. From the
surface, all you can see is a
huge ring of rising bubbles,
up to 45 metres across, and
then hundreds of tonnes of
humpbacks surging
upwards, open-mouthed.

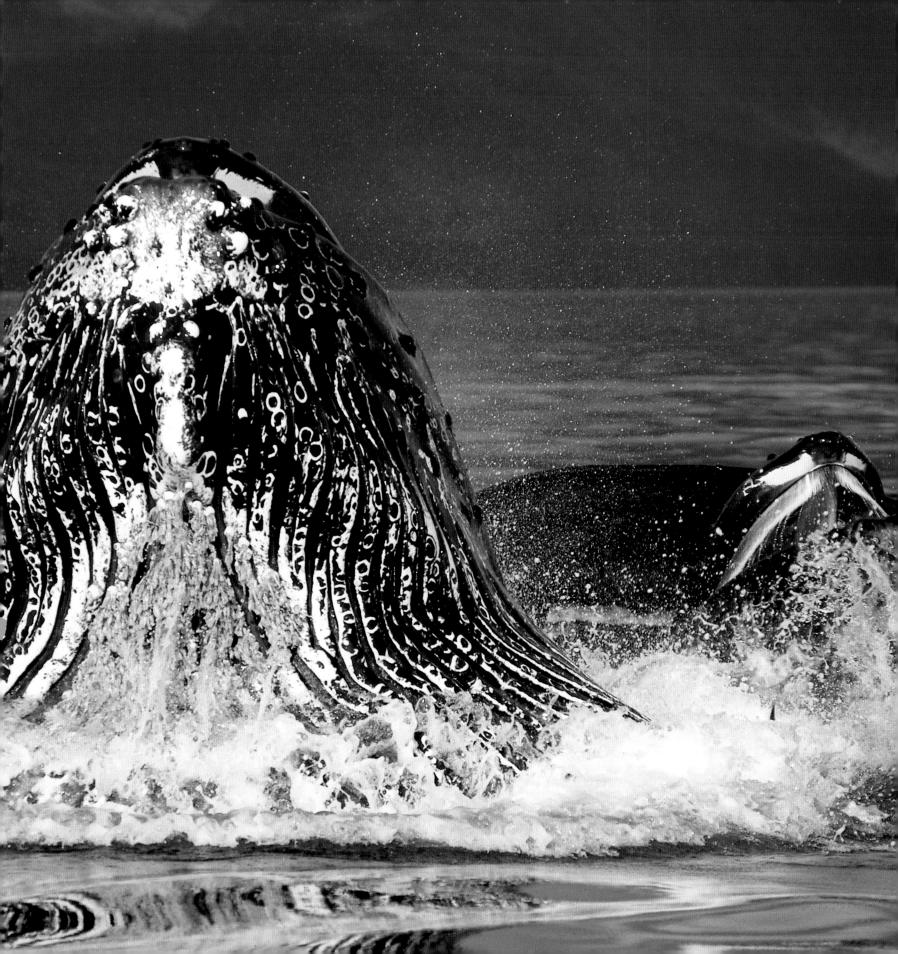

Animal behaviour: Mammals

Mammals photographed actively doing something. These images capture moments that have interest value as well as aesthetic appeal.

WINNER

Tony Heald
UK

CAPE FOX CUB PLAY-CHASING

Nikon F5 with 600mm lens; 1/200 sec at f4; Fujichrome MS 100/1000 rated at 400

Cape foxes are usually nocturnal, and so finding a family out in daylight on the South African side of the Kgalagadi Transfrontier Park – the other side is in Botswana – was quite unusual. The next day, one of the three cubs was missing, and later we saw the female threatening two black-backed jackals that were hanging around. To photograph the remaining two cubs playing at dawn, I had only 10 minutes of good light. After that, the sun would have been too bright.

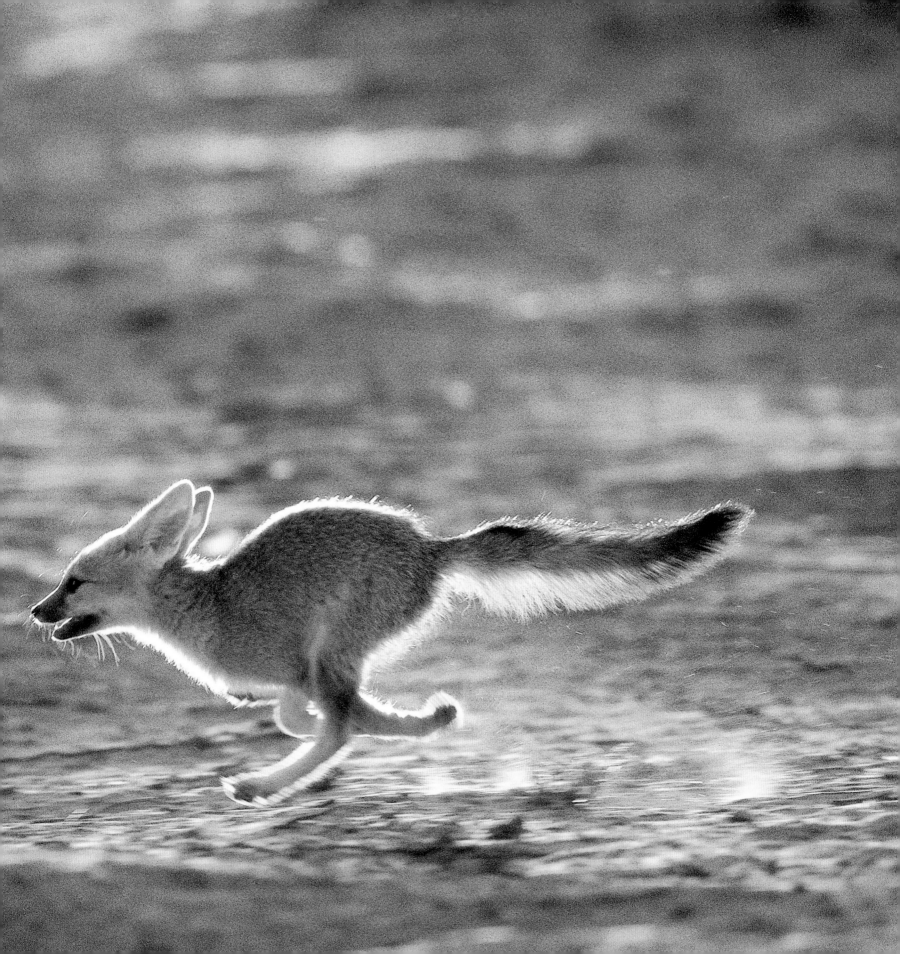

RUNNER-UP

Kari Reponen
Finland

PINE MARTENS PLAYING

Nikon F5 with 80-200mm lens; 1/250 sec at f4; Fujichrome 100

Last summer, pine martens made their den in an old black-woodpecker nest. I visited the den for several days, and the youngsters soon became totally fearless in my presence. Their play was often quite rough. Sometimes, all I could hear was constant whining as they bit each other's ears and pulled each other's tails.

Manfred Danegger
Germany
HIGHLY COMMENDED

MALE AND FEMALE HARES BOXING

Canon EOS 3 with 600mm lens; 1/1000 sec at f4; Ektachrome 200

When a male hare is interested in a female, he pursues her from a distance, and when he decides it's time to get more of her attention, he runs past, squirting jets of urine at her. If she's not ready to mate, she boxes the male. I took this photograph of a boxing match in June by Lake Constance in southern Germany.

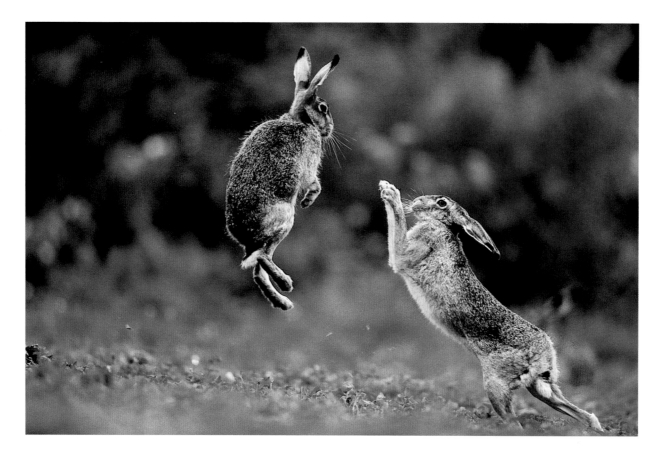

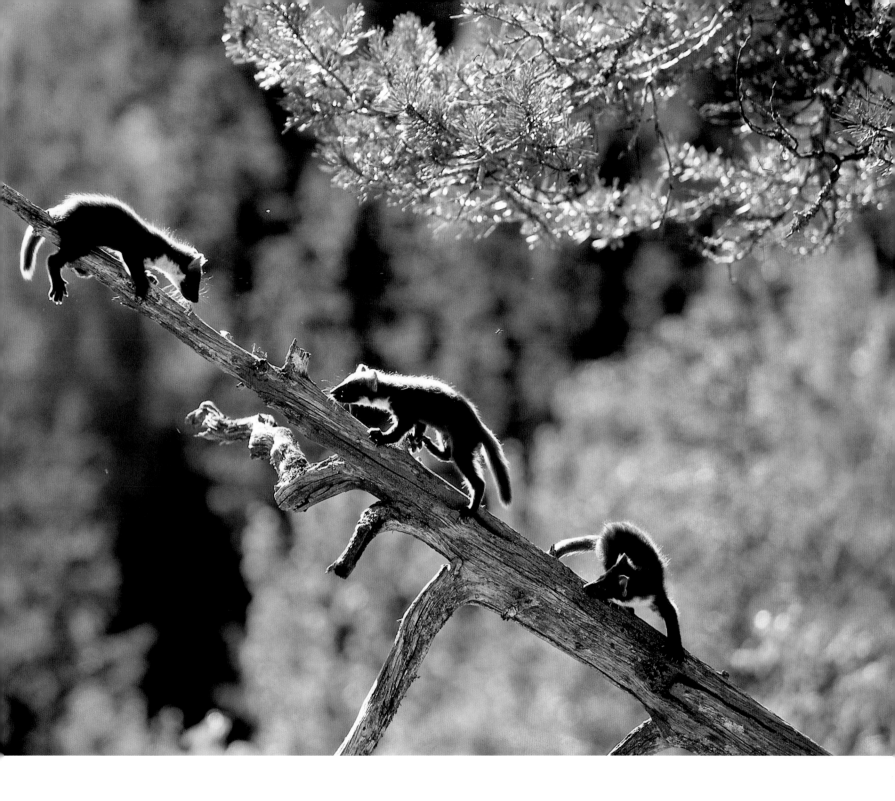

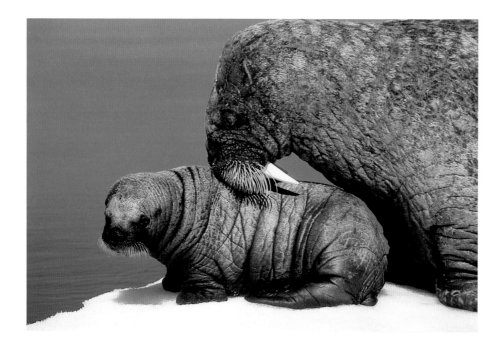

Paul Nicklen
Canada
HIGHLY COMMENDED

ATLANTIC WALRUS COW AND PUP

Canon EOS 1N with 70-200mm lens; 1/500 sec at f9.5; Kodak 100VS

I photographed this mother and newborn pup sitting alone on drifting pack-ice as our boat passed by in Foxe Basin, Nunavut, near northern Baffin Island in Canada. Here, walruses' predators are polar bears and occasionally killer whales. They are also hunted by the native Inuit.
I marvelled at how the Inuit manage to survive in such an unforgiving place.

George Gornacz
Australia
HIGHLY COMMENDED

ELEPHANT SEAL PUP DOZING

Nikon F90X with 80-200mm lens; Fujichrome 100; tripod

Elephant seals come ashore to give birth, suckle, moult and mate. Of the 800,000 left in the wild, more than half breed here on South Georgia Island in the Antarctic. There were hundreds on this beach. None of them seemed bothered by me, and so I managed to get pretty close. This pup, fast asleep between two females, looked in imminent danger of being crushed.

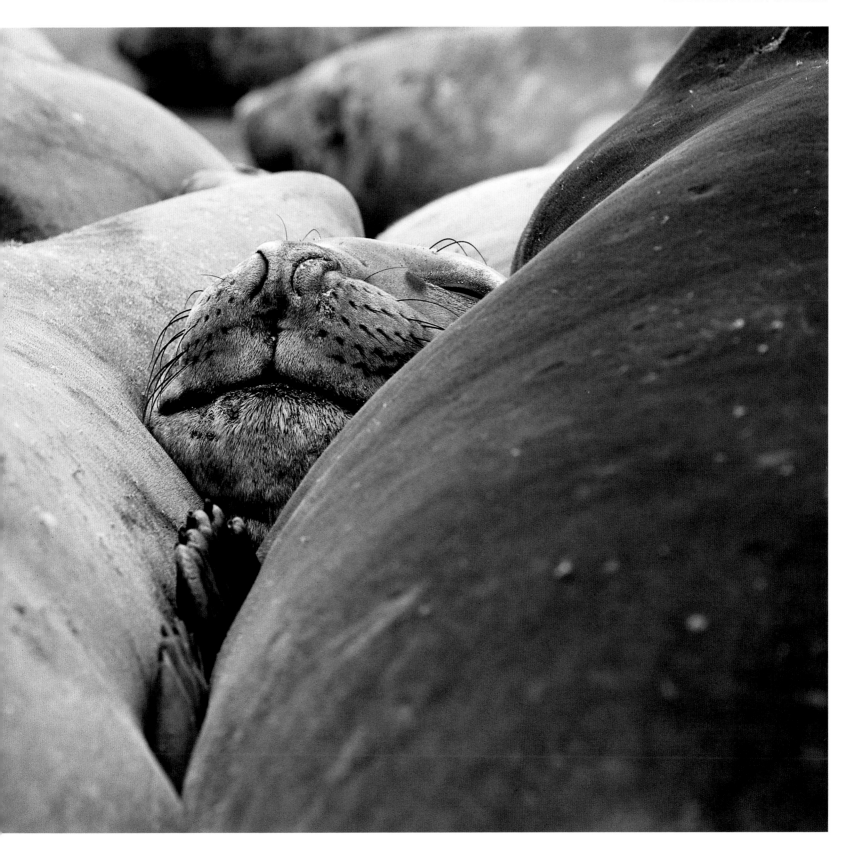

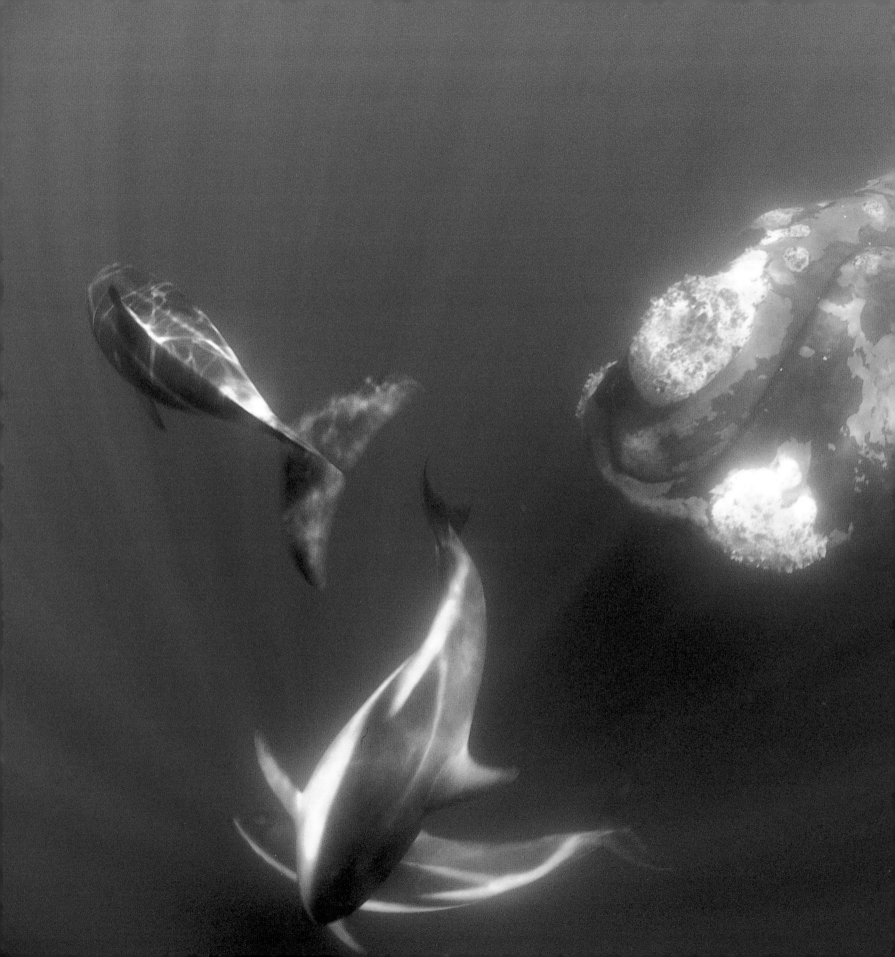

Willem Kolvoort
Netherlands
HIGHLY COMMENDED

RIGHT WHALE WITH DUSKY DOLPHINS

Minolta XGM with Minolta MC
Fisheye Rokkor; 1/60 sec at f5.6;
Fujichrome Sensia II 100

While photographing dusky dolphins in the Bay of Valdes in Argentina, this huge right whale suddenly appeared from the deep. I was astonished to see three dusky dolphins swimming in front of her as if bowriding a ship. But then I realised they have probably been doing this with whales for millions of years and have only added ships to their repertoire in the last few seconds on their evolutionary clock.

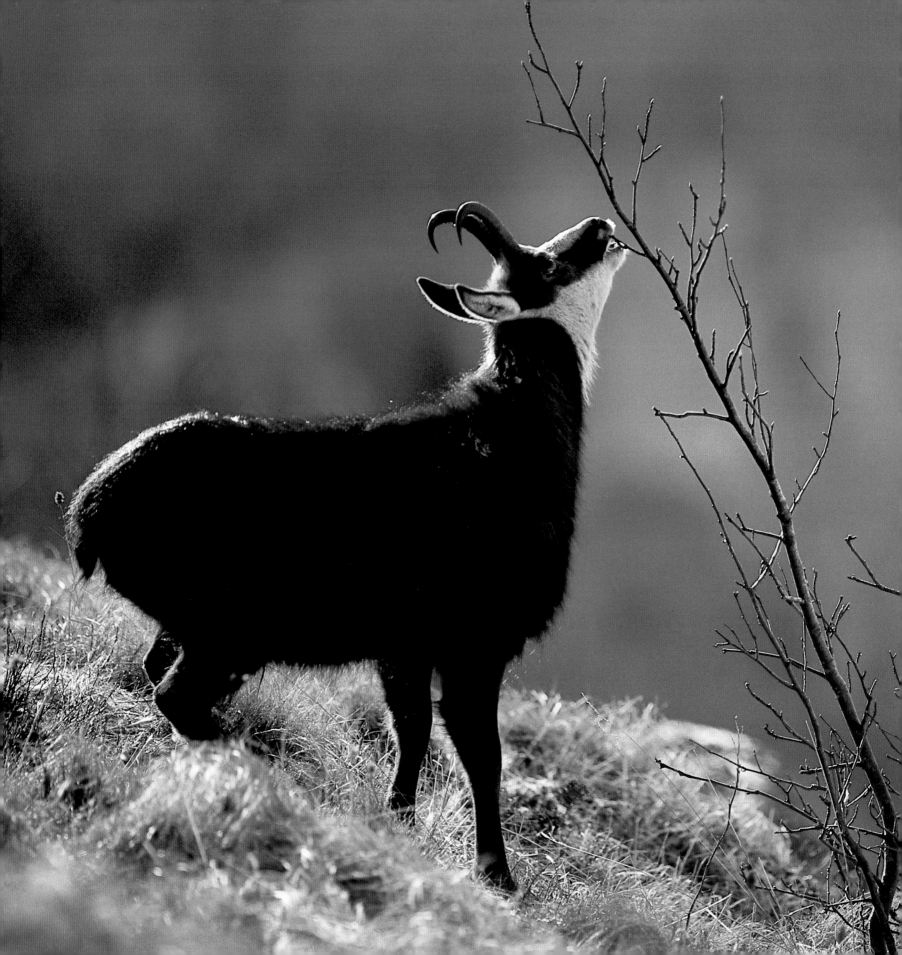

Vincent Munier
France
HIGHLY COMMENDED

CHAMOIS FEEDING

Nikon F801s with 300mm lens;
1/60 sec at f2.8; Fujichrome
Sensia 100; tripod

During the rutting season in
November, I like to study and
photograph the chamois
that live in the Vosges
mountain range of eastern
France. I watched this male
for several days. After a
fight with another male, he
casually wandered close to
my hide to nibble at a
nearby bush.

Manfred Danegger
Germany
HIGHLY COMMENDED

MALE HARES BOXING TO IMPRESS A FEMALE

Pentax 645 N with 800mm lens and 1.4x teleconverter; 1/500 sec at f8.5; Fujichrome RDP3

This was taken in February, early in the mating season, beside Lake Constance in southern Germany. The males are beginning to vie for dominance so they can impress more females, and the loser is the one who runs away first. They rarely use their powerful hind legs, which have sharp claws that can cause severe injury. The one judging the match from the ringside is a female.

Willem Kolvoort
Netherlands
HIGHLY COMMENDED

DUSKY DOLPHINS MATING

Minolta XGM with Minolta MC Fisheye Rokkor; 1/60 sec at f5.6; Fujichrome Sensia II 100

The highly acrobatic dusky dolphins live in large schools in the southern hemisphere. In the mating season in October, several males pursue the same female, as shown here in the Bay of Valdes, Argentina. A male swims under the female, and both swim at speed while synchronising their mating. Two other males wait their turn. I used a fisheye lens to help me get better contrast.

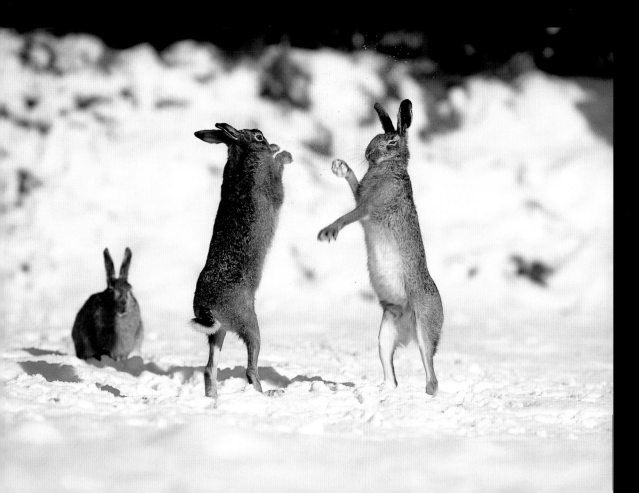

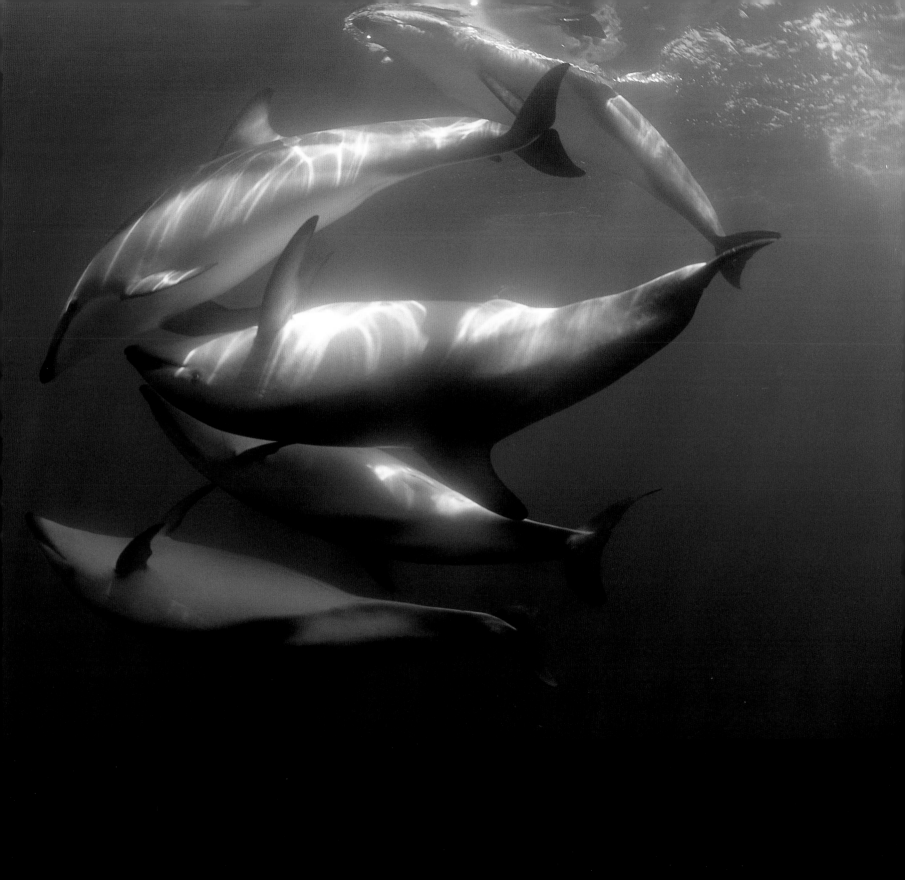

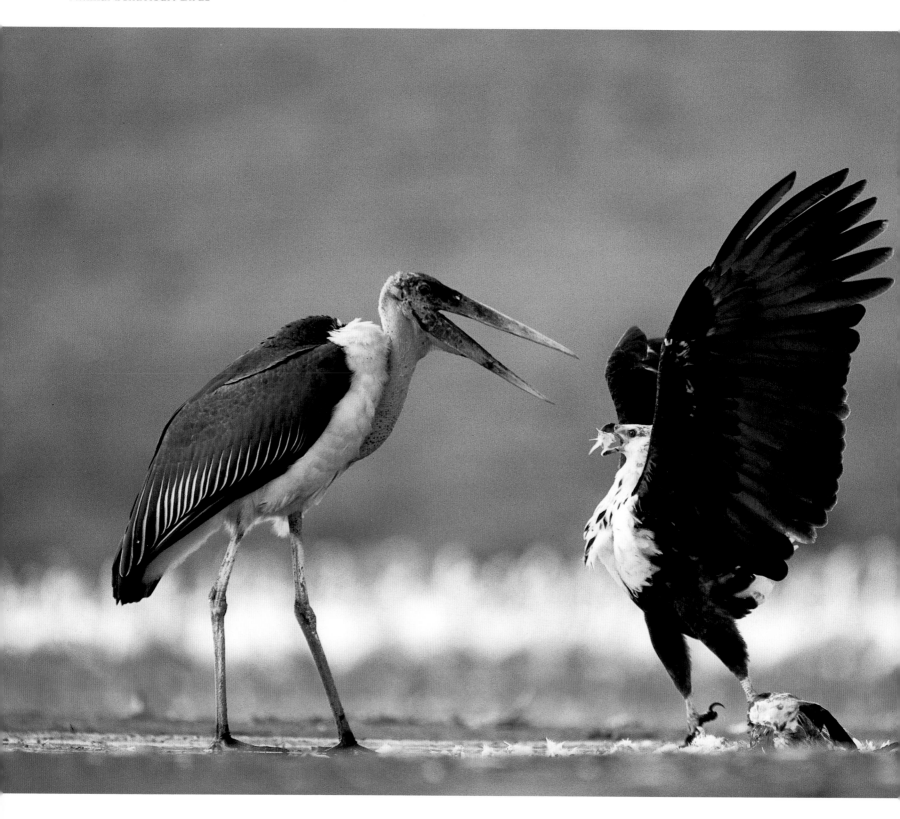

Tim Fitzharris
USA

AFRICAN FISH-EAGLE THREATENING A MARABOU STORK

Canon EOS A2 with 400mm lens and 1.4x extender; 1/250 sec at f5.6; Fujichrome Velvia

The stork was trying to get a scrap of the lesser flamingo that the eagle had killed on Lake Bogoria in Kenya. But it didn't stand a chance against the eagle's sharp beak and talons, and the eagle managed to eat its fill and keep the stork away. I was on a floating hide, and neither of the birds paid any attention to me. So I got to within 10 metres of them.

RUNNER-UP

Richard Kuzminski
USA

PEREGRINE FALCON STRIPPING ITS PREY

Canon EOS 1N with 400mm lens and 2x extender; 1/500 sec at f5.6; Fujichrome Astia

This laughing gull was too large for the peregrine to carry away, and so the falcon was forced to eat it on the sand, tearing at the gull's flesh with a sense of urgency. In the past, peregrines were poisoned by DDT in their prey, accumulated through the food chain, which made their eggshells too thin and brittle. In 1975, there were only 324 known peregrine pairs in all of North America. Now that DDT has been banned, there are about 1,600 pairs.

Animal behaviour: Birds

Birds photographed actively doing something.
These images capture moments that have interest value as well as aesthetic appeal.

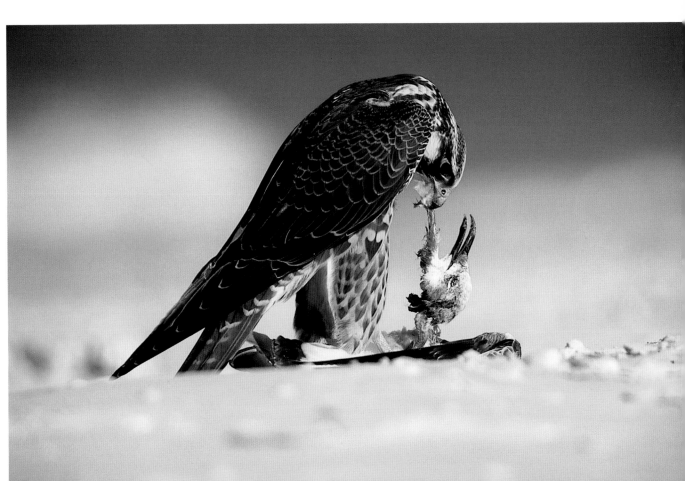

Anita M Weiner
USA
HIGHLY COMMENDED

GREAT NORTHERN LOON CHICK NAPPING

Canon EOS 1N with 400mm lens and 1.4x teleconverter; 1/125 sec at f11; Fujichrome Provia 100

The same pair of loons returns every summer to this lake in northern Michigan to nest. The lake is well used by people, but the loons don't seem to be bothered by the boats and the jet-skis. Once, when our pontoon was close to their nest, both adults took off to chase another pair away, and we were left to babysit the chicks for 10 minutes. Loon chicks will sit on their parents' backs for the first few days after they hatch, but by the time they're two weeks old, they don't climb up much any more.

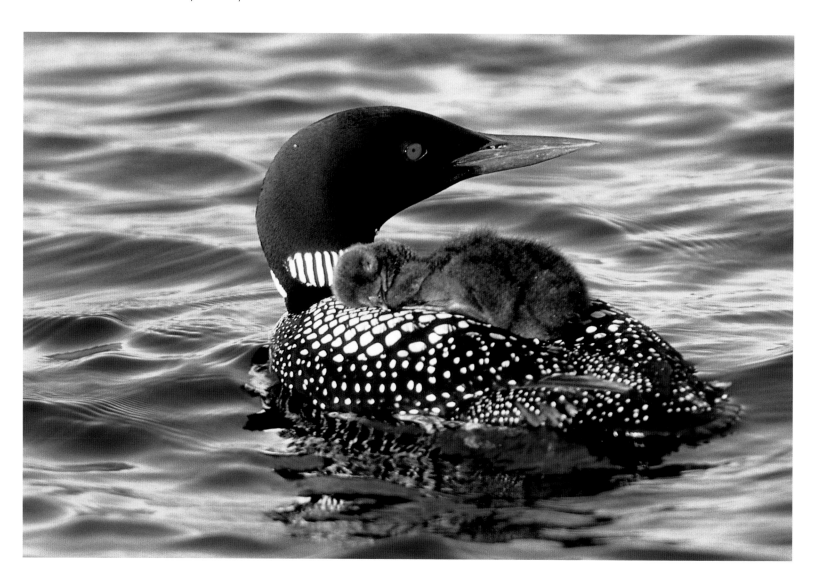

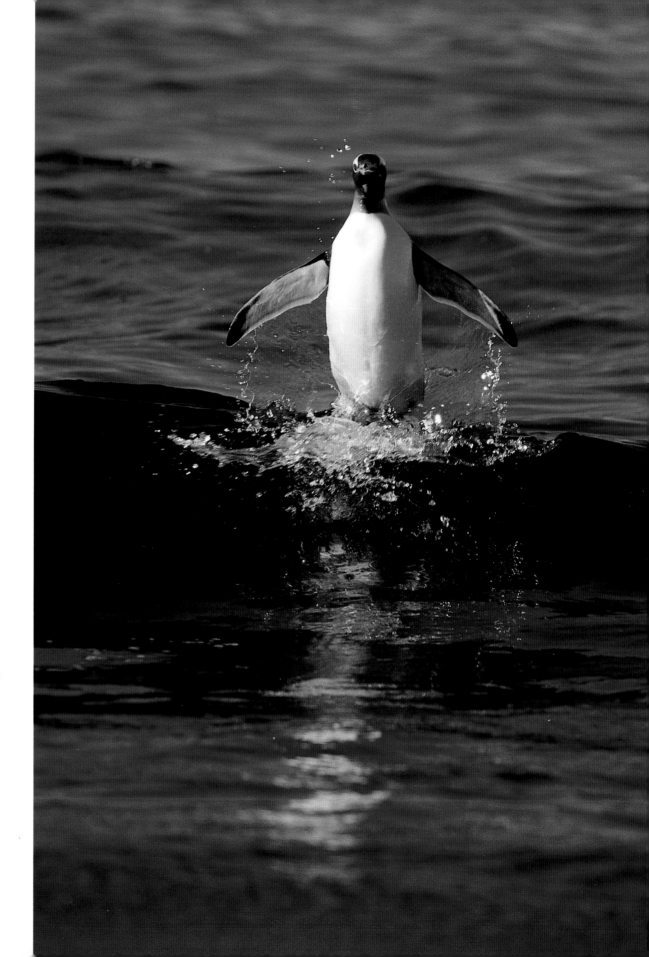

Mary Ann McDonald
USA

HIGHLY COMMENDED

GENTOO PENGUIN
SURF-RUNNING

Canon EOS 3 with 100-400mm
lens; 1/500 sec at f5.6;
Ektachrome 100

Adult gentoos in the
Falkland Islands spend much
of the day at sea catching
fish for their chicks. When
they're ready to come in,
they porpoise on the
breaking waves, catapulting
out of the crests and then
tucking their heads down to
dive again. Close to shore,
they sometimes ride the
very last crest all the way,
paddling hard with their feet
to keep up and running
straight onto the beach.
These ones at Sealion Island
were a thrill to watch.

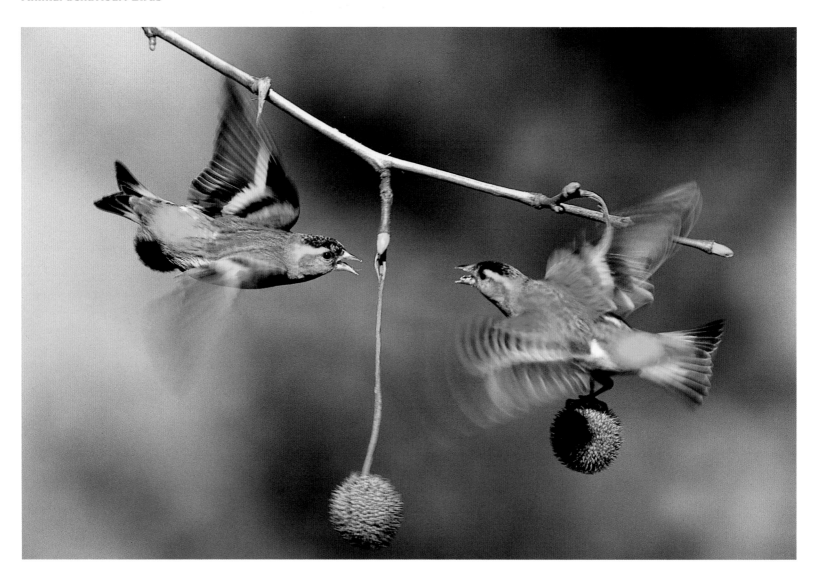

Luca Fantoni
Italy
HIGHLY COMMENDED

**EURASIAN SISKINS
SQUABBLING**

Nikon F90 with 500mm lens;
1/250 sec at f4; Fujichrome Velvia

Siskins are usually pretty tolerant of each other, but sometimes they can get quite aggressive. These two males, part of a flock that migrated to northern Italy in February, started fighting over the seeds in plane tree fruits.

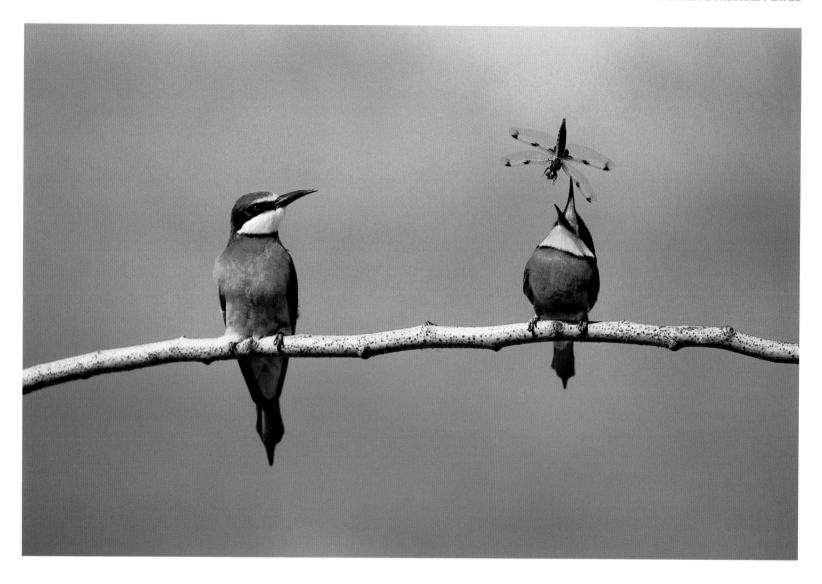

Rainer Müller
Germany

**EUROPEAN BEE-EATER
WITH A DRAGONFLY
GIFT FOR HIS MATE**

Canon EOS 1N with 600mm lens;
1/1000 sec; Fujichrome Sensia 100

Before mating, the male bee-eater offers the female food. This one had a dragonfly, which he juggled in the air to get in the right position before passing it on. He will go on to help to incubate the eggs and feed the nestlings. I shot this scene in Hungary at six frames per second, of which only one had the dragonfly in the right position.

Eberhard Brunner
USA
HIGHLY COMMENDED

WHITE STORK FEEDING ALONG A FIRELINE

Nikon 90s with 300mm lens; 1/125 sec at f5.6; Fujichrome Velvia

During the short rainy season, pastoralists living outside the Maasai Mara National Reserve in Kenya set fire to large tracts of the long-grass plains. This stimulates the growth of new, green grass – nutritious food for livestock. Hundreds of migrating white storks scorched their feathers as they stalked the fireline and plunged into the smoke to catch grasshoppers and other insects.

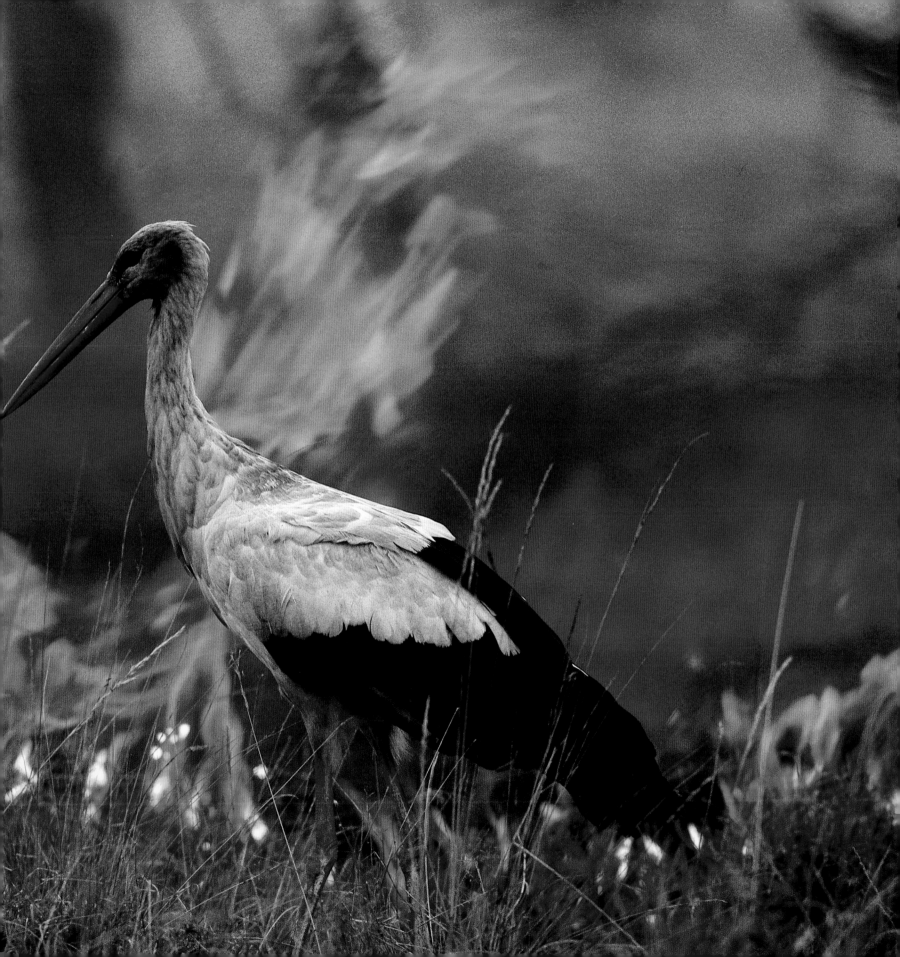

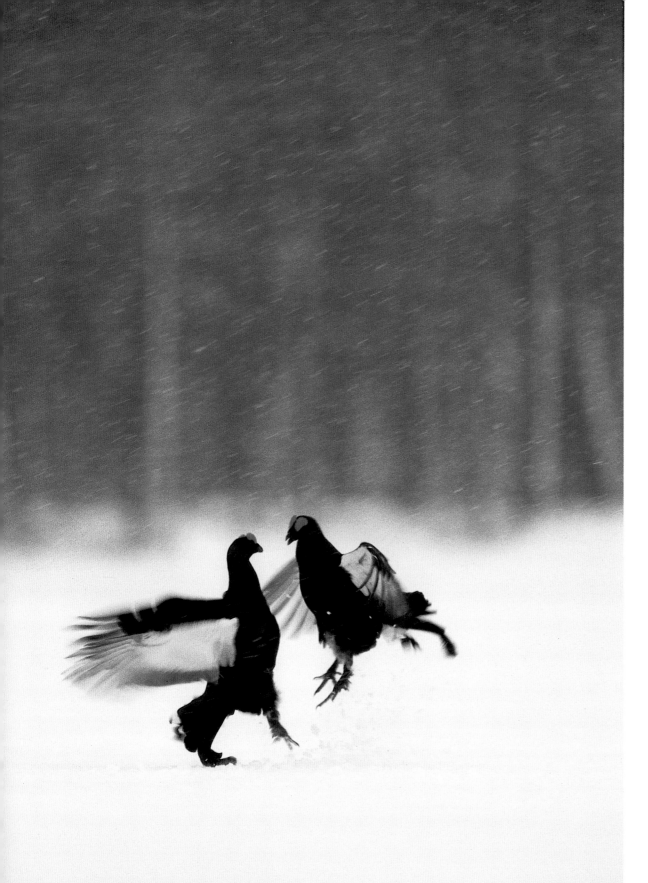

Konrad Wothe
Germany

BLACK GROUSE FIGHTING

Canon EOS 1N with 300mm lens and 1.4x teleconverter; 1/160 sec at f4; Kodak E200 rated at 400; tripod

Heavy snowfall in April had done little to deter the male black grouse from putting on this show on a frozen lake near Hamra in Sweden. Each male had claimed his own territory, and any disregard of the strict borderlines resulted in a ritualised bobbing – which in this case, escalated to fighting. Females usually watch from a distance, maybe dropping by if they are ready to mate. On this occasion, there were no females around.

Daniel J Cox
USA

SNOW GEESE FIGHTING

Nikon F5 with 300mm lens; Fujichrome Sensia

Snow geese overwinter in New Mexico, beginning their long trip north to breed in the Arctic in spring. I photographed this pair fighting in Bosque del Apache Wildlife Refuge in New Mexico. Given the sheer numbers that make up snow geese flocks – up to hundreds and thousands of individuals – it's hardly surprising that squabbles break out.

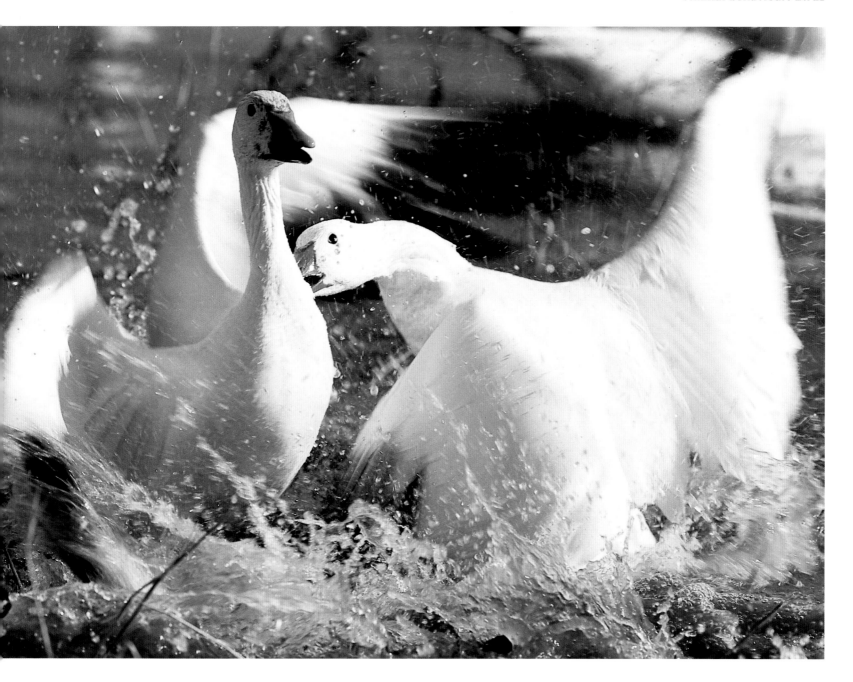

Yossi Eshbol
Israel
HIGHLY COMMENDED

**COMMON TERN
FEEDING AN
ADOPTED CHICK**

Nikon F5 with 600mm lens;
1/500 sec at f4; Fujichrome
Velvia 50 rated at 100; tripod

Each April, common terns migrate from Africa to Israel to breed. This pair nested a few hundred metres away from the rest of the large colony on the beach near my home. They had adopted a disorientated chick that had wandered out to them, welcoming it with food and attention. This was unusual, because a stray chick would normally get pushed away. After a few hours, it returned to its own nest, which was just as well, as its adopted parents had their own unhatched eggs to attend to.

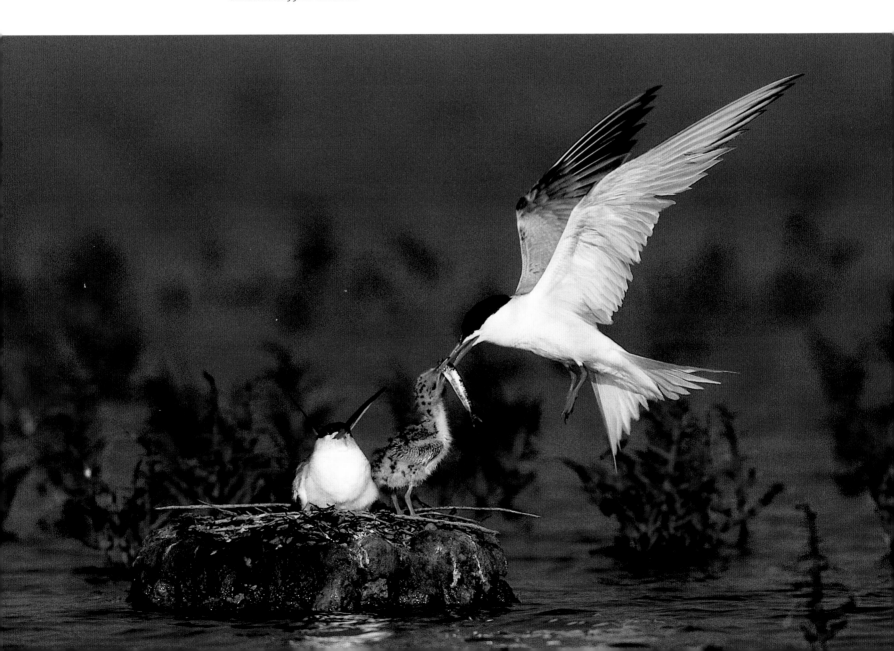

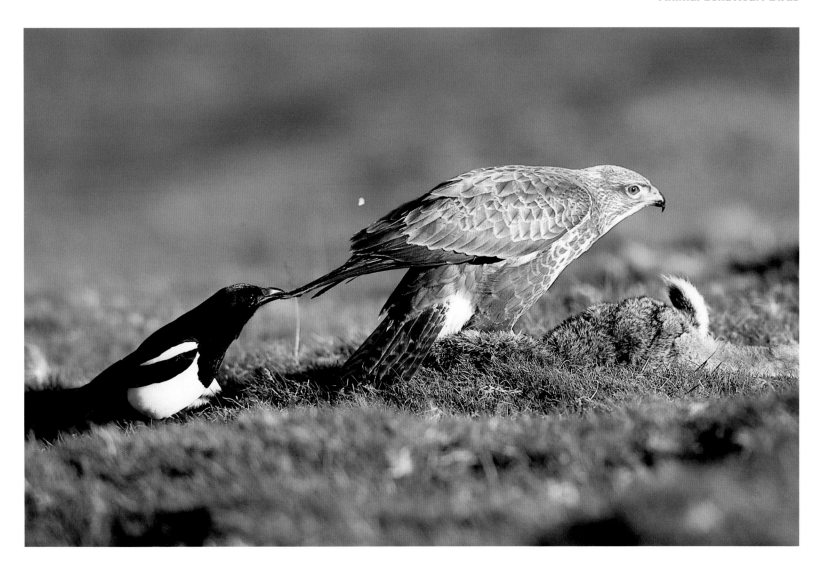

David M Cottridge
UK
HIGHLY COMMENDED

MAGPIE PULLING A COMMON BUZZARD'S TAIL-FEATHERS

Nikon F5 with 500mm lens; 1/250 sec at f8; Fujichrome Sensia 100; tripod

I staked out a dead rabbit in front of my hide in the hills surrounding Tregaron, West Wales, to attract common buzzards. Magpies and carrion crows would be the first to arrive, and the buzzards seemed to use them as a safety check before venturing forward. One particular magpie tentatively approached a feeding buzzard and pulled at its tail feathers. But with one aggressive turn of the buzzard's head, the magpie retreated. Only when the buzzard had gorged itself could the magpies and crows finish off the scraps.

Animal behaviour: Other animals

Subjects from among the cold-blooded animals photographed actively doing something.
These images frequently have interest value as well as aesthetic appeal.

WINNER

Ryo Maki
Japan

**BIGFIN SQUID
LAYING EGGS**

Nikon F4 with 16mm lens; 1/60 sec at f8; Fujichrome Velvia; two strobes

The sea around Mabul Island off the Malaysian state of Sabah, Borneo, is quite shallow, and many young creatures live inside the protected bay area. On one dive, I came across sunken palm trees and old palm fronds at a depth of about 10 metres. Many bigfin squid had congregated to nest. They used their tentacles gently to lay out their white eggs as though hanging out washing among the palm fronds.

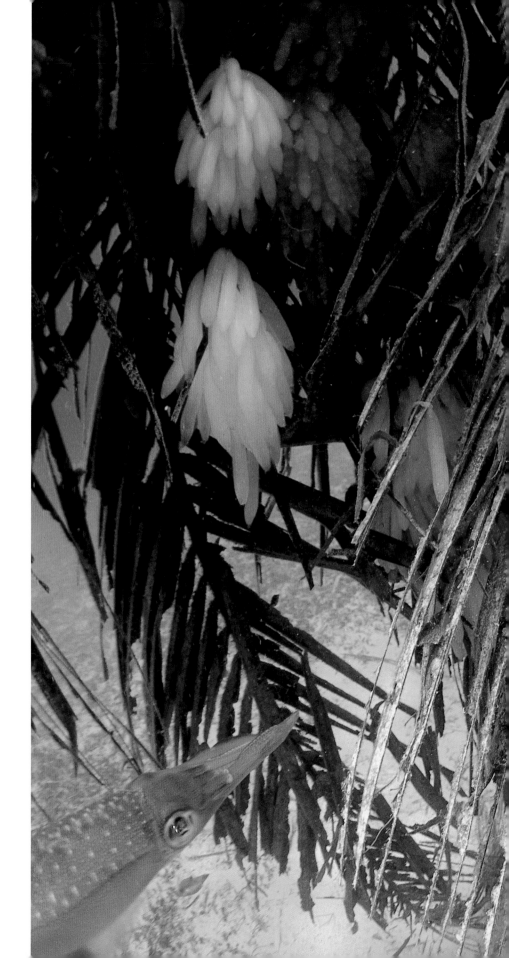

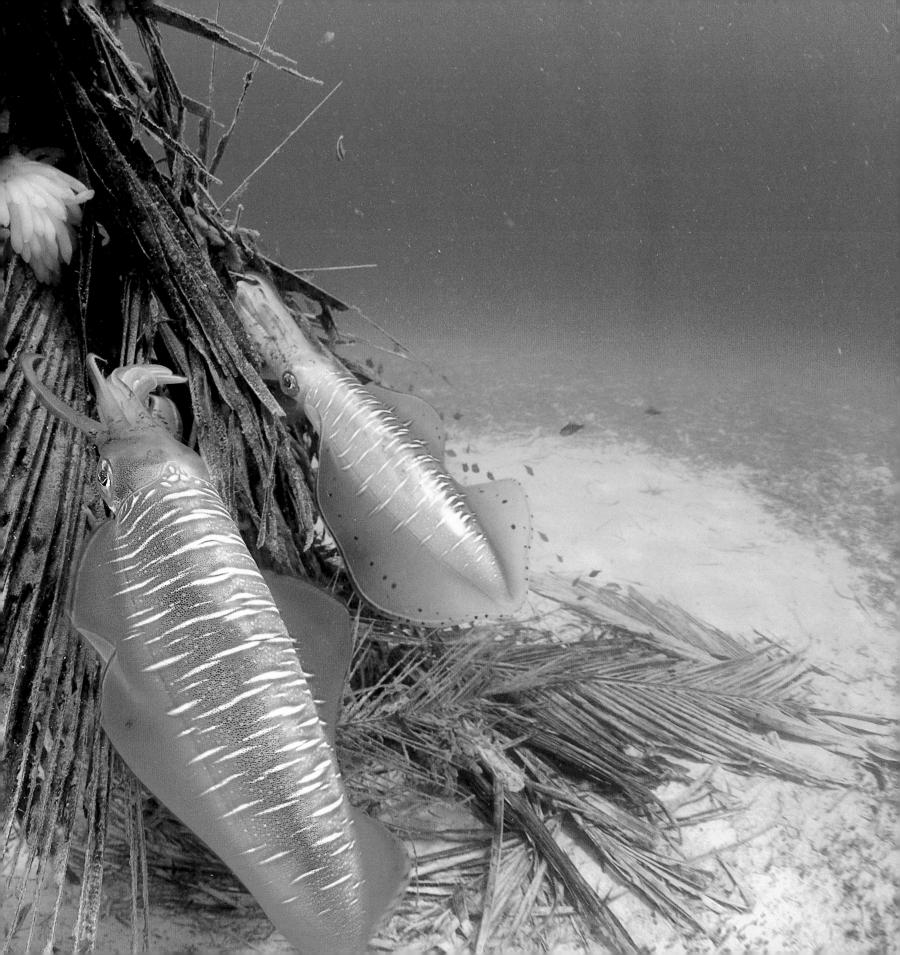

Martin Smith
UK
HIGHLY COMMENDED

FEMALE CROCODILE CARRYING HER YOUNG

Canon EOS 3 with 300mm lens;
1/125 sec at f8; Fujichrome Sensia

These three female Nile crocodiles and one male were at a nest in Madagascar. I sat six metres away, barricaded behind a few silver filming cases. One little crocodile hatched out and immediately set off in my direction, calling out when only four metres away from me. Its mother looked up and, climbing over the other adults' heads, trundled towards me. Picking up her new hatchling, she turned around in front of me and headed nestwards with head held high, leaving me to sigh with relief.

RUNNER-UP

Winfried Wisniewski
Germany

CROCODILE STRUGGLING WITH A WILDEBEEST

Canon EOS 3 with 100-400mm lens; Fujichrome Sensia 100

I was watching a herd of wildebeest cross the Mara River in the Serengeti National Park in Tanzania when a crocodile grabbed a half-grown one about 20 metres from the bank. The wildebeest managed to drag the crocodile nearly all the way out of the river, where the two fought for several minutes. Then the youngster's strength drained away and the crocodile pulled it into deeper water.

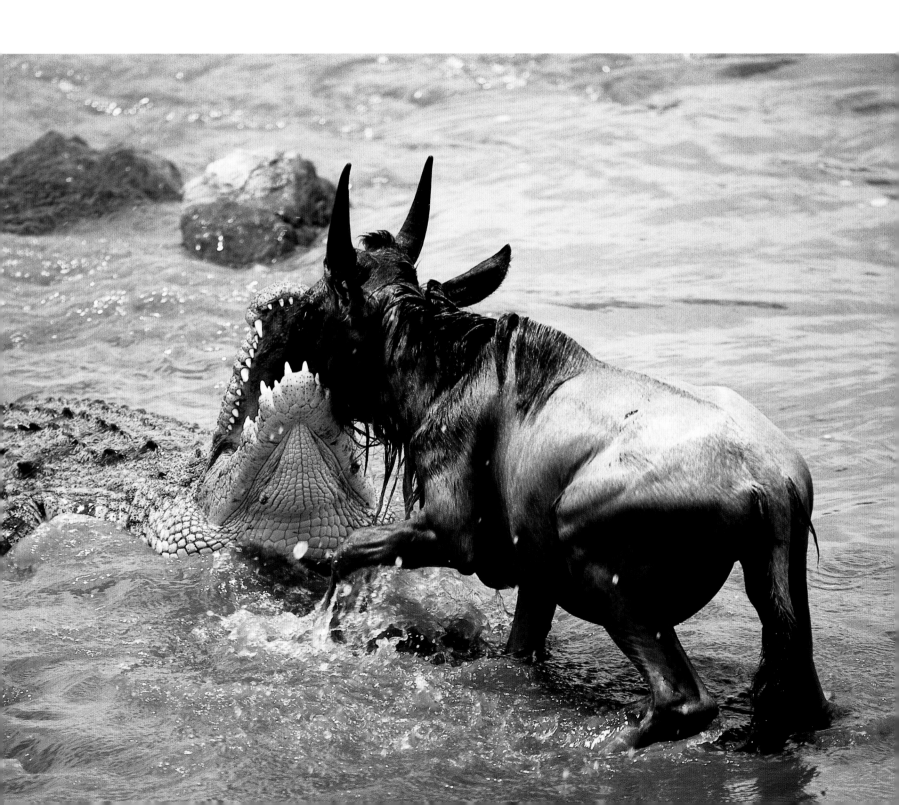

Thomas Endlein
Germany

**LESSER RED-EYED
DAMSELFLY
OVIPOSITING**

Canon EOS 1NRS with 180mm
macro lens and 1.4x extender;
Fujichrome Velvia; self-made
floating tripod

To maximize his chances of
fertilising the female's eggs,
a courting male damselfly
spends some time removing
other males' sperm before
inserting his own. Then he
guards her until they find a
suitable aquatic plant, just
below the surface, where she
lays her eggs while he still
holds her. To take pictures at
water-level, I used a
home-made floating tripod.

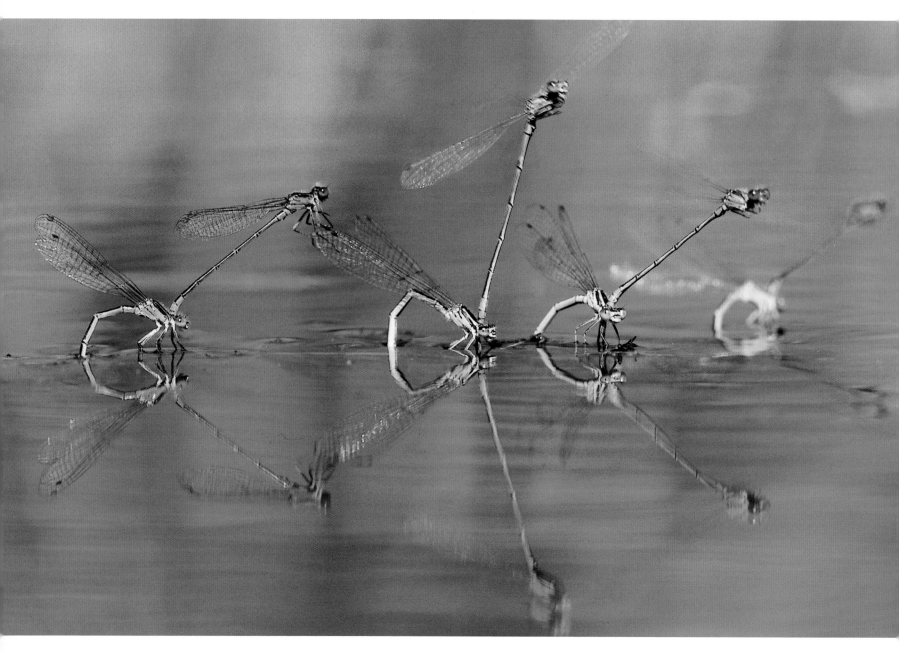

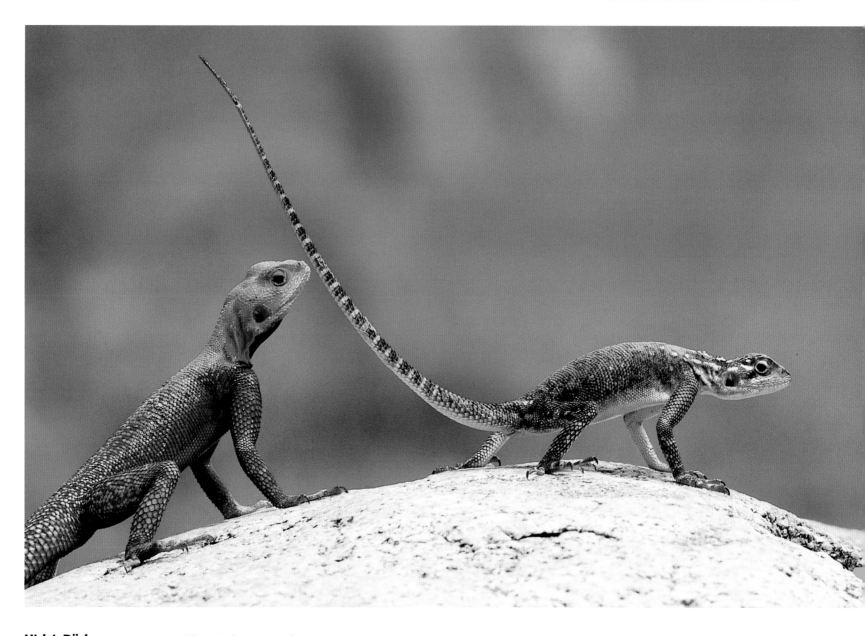

Ulrich Döring
Germany

**AGAMA LIZARDS
COURTING**

Nikon F90X with AF Nikkor
300mm lens; Fujichrome Sensia
II 100; beanbag

The male lizard's stunning colours intensify during courtship. He shows them off with a characteristic head-bobbing dance. The searing midday heat had turned the surface of this rock in Ruaha National Park, Tanzania, into a frying pan, but neither of the two lizards seemed to mind. I concluded that their 'dance' was, in fact, a mixture of courtship and movements to avoid burning their feet.

Felix Labhardt
Switzerland
HIGHLY COMMENDED

ADONIS BLUE BUTTERFLIES FEEDING ON A FOX-SCAT

Minolta Dynax 9xi with Sigma Makro 180mm lens; f11; Fujichrome Velvia; tripod

These Adonis blue butterflies were sucking minerals from a fox-scat in a dry meadow in the Jura hills in north-western Switzerland, in early June. Adonis butterflies, which are widespread over central and southern Europe, produce two generations each year, laying their eggs on clover – the first generation flying between May and June and the second between August and October. Only the males are this splendid blue; females are brown.

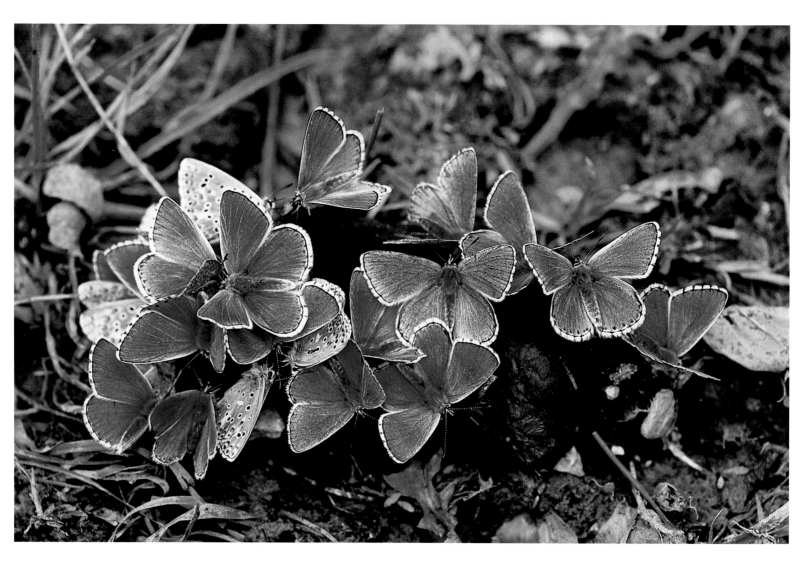

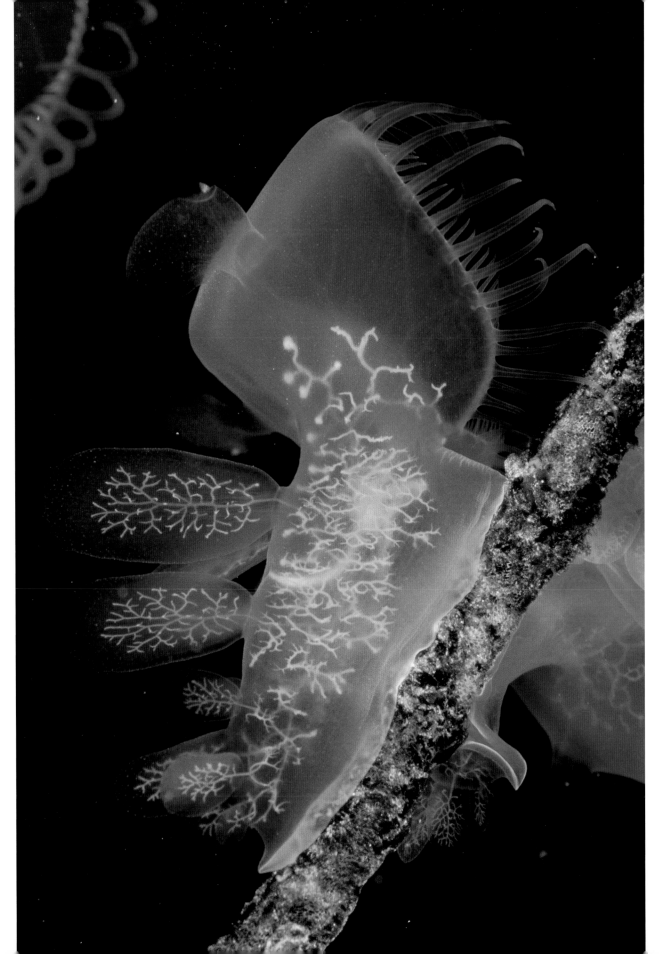

David Hall
USA
HIGHLY COMMENDED

HOODED NUDIBRANCH FEEDING

Nikonos RS with 50mm macro lens; 1/125 sec at f11; Fujichrome Velvia; 2 strobes

The hooded nudibranch – or sea slug – is an unusual, snail-like mollusc without a shell. Like all nudibranchs, this eight-centimetre-long species *Melibe leonina* is carnivorous. Unlike others, it uses an expandable 'oral hood' to capture its minute prey of planktonic crustaceans. Many nudibranchs are brilliantly coloured, but this species, which was photographed in the Queen Charlotte Strait, British Columbia, is virtually transparent. In this photograph, its oral hood is expanded, and a captured crustacean can be seen in its body.

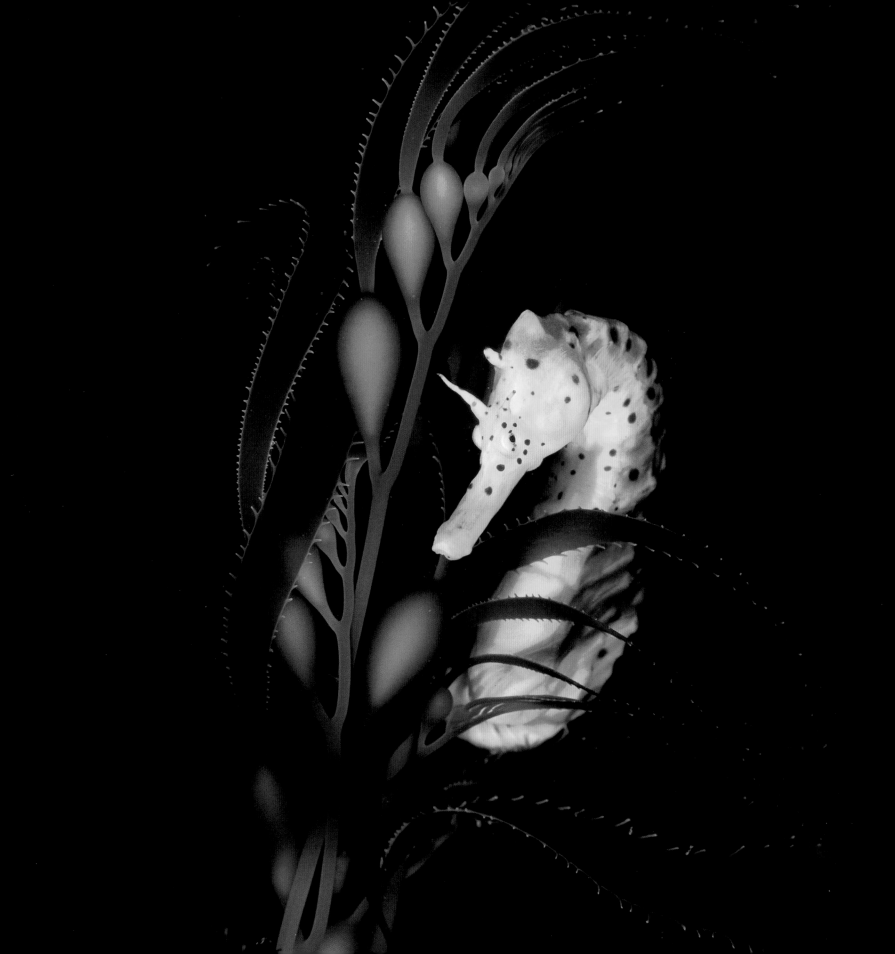

The underwater world

Pictures taken below the surface, illustrating marine or freshwater wildlife.

WINNER

David Hall
USA

POT-BELLIED SEAHORSE ON GIANT KELP

Nikonos RS with 50mm macro lens; 1/125 sec at f11; Fujichrome Velvia; 2 strobes

She was large for a seahorse – about 12 centimetres – but well camouflaged in the kelp until I shone my light on her. Most seahorses are confined to tropical seas, but this one is at home in cool waters (in this case, Tasmania). As with all seahorses, it is the male that carries the fertilised eggs, in his brood pouch, and cares for the young.

RUNNER-UP

Paul Nicklen
Canada

ATLANTIC WALRUS RESTING ON AN ICE-SHELF

Nikon F4 with 20mm lens; Fujichrome Provia 100 rated at 200; 2 strobes

Walruses don't need to venture far from ice-pans because rich clam-beds lie beneath them, 70 metres down. This one may have been diving for clams before resting. It would have been able raise its head to the surface to breathe. There are about 4,000 walruses on the pack-ice near northern Baffin Island, Canada.

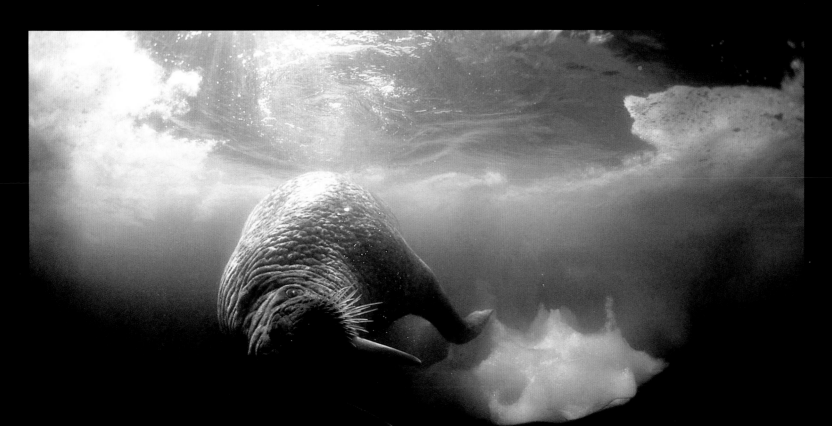

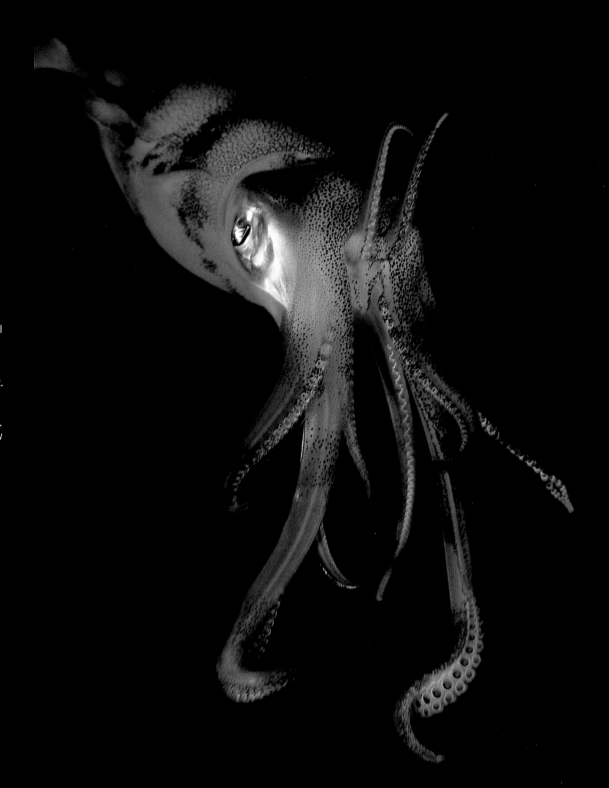

Michael AW
Australia
HIGHLY COMMENDED

BIGFIN REEF SQUID

Nikon F90X with 60mm
macro lens; 1/125 sec at f16;
Fujichrome Velvia; lighting

I was diving at Milne Bay in Papua New Guinea when I witnessed this flamboyant performance by one of the most intelligent animals in the sea. This squid approached to dance, seemingly mesmerised, in front of my dive light. The animal's ability to change colour is controlled by the most advanced neurological system in the animal kingdom. It has three layers of coloured cell structures, filled with coloured pigment. These are like miniature plastic bags that are expanded by radial muscles. Embedded above and below them are other kinds of cells, which behave like microscopic mirrors, enhancing the play of colours.

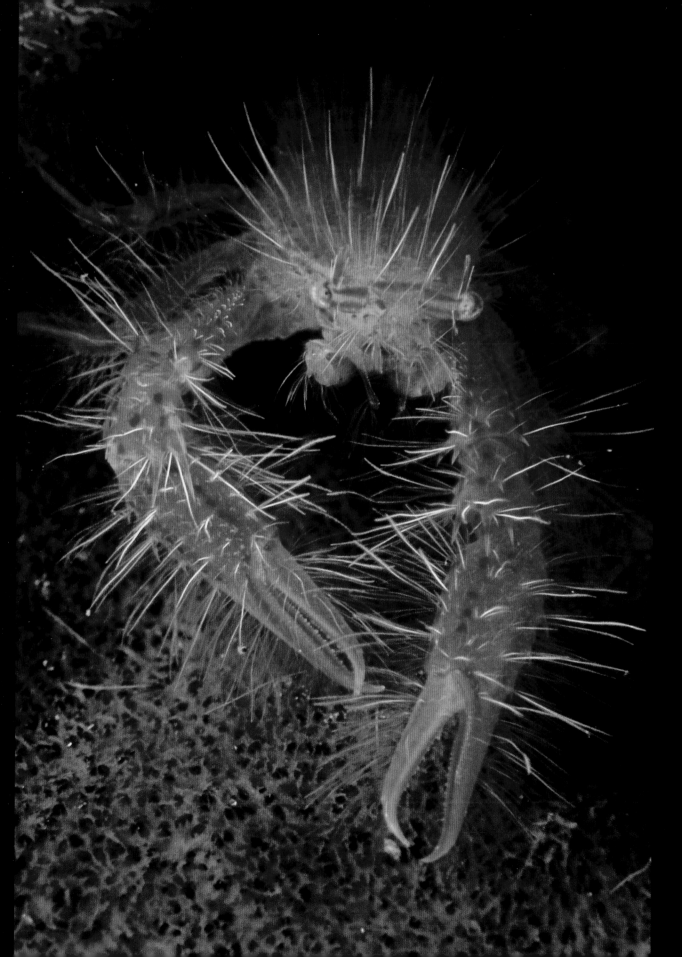

Neil Vincent
Australia
HIGHLY COMMENDED

FAIRY CRAB ON
A BARREL SPONGE

Nikon F801 with Nikkor 105 Mic
105mm lens; 1/125 sec at f22;
Fujichrome Velvia; strobes

While diving off Tulamben
on the Indonesian island of
Bali, a marine-biologist
friend led me to a barrel
sponge standing 1.5 metre
above the sandy sea floor. I
housed some interesting
inhabitants: three fairy
crabs, *Lauriea* sp, known
locally as 'Wally Craylette',
after the local guide who
discovered them the
previous year. These
crustaceans are only 12 to
20 millimetres long, and
though a contrasting colou
against the sponge, they
blend into the shadows of
its ribs. I spent hours trying
to photograph them - it wa
a matter of waiting for the
rare moment when they
were motionless and hopin
I still had enough air and film

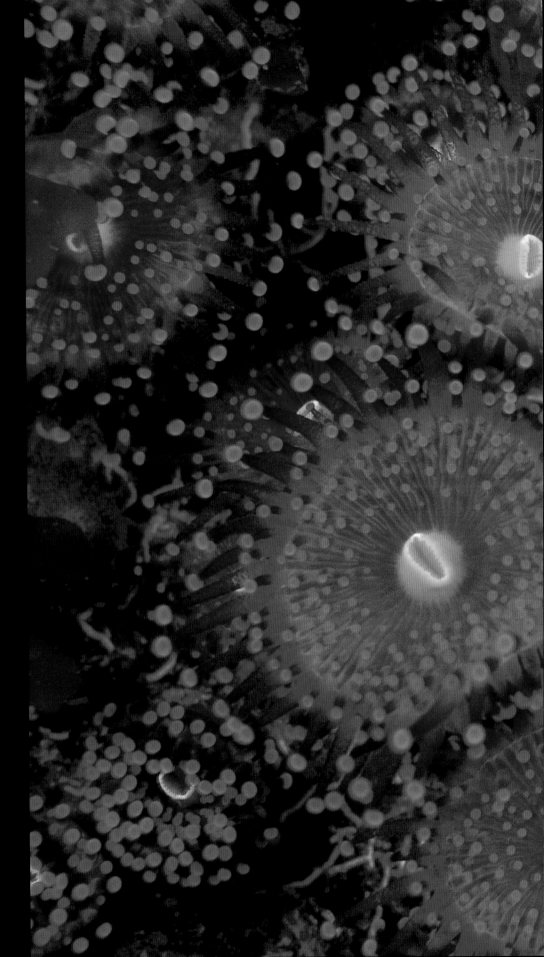

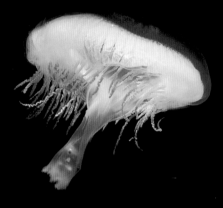

Karen Gowlett-Holmes
Australia
HIGHLY COMMENDED

JELLYFISH DRIFTING

Nikonos III with 28mm lens;
1/60 sec at f16; Fujichrome
Velvia; strobe

Onshore winds in Waterfall
Bay in south-eastern
Tasmania brought unusually
large amounts of normally
oceanic gelatinous plankton
close to shore. In the dense
soup were several of these
jellyfish, about 15 centimetres
across. Drifting in the swell
while holding a strobe, two
cameras and a sample bag
wasn't easy. The jellyfish
also reacted to the light by
swimming away. Oceanic
gelatinous plankton is one
of the most poorly known
groups of animals. Many
species – including this one –
have yet to be named.

Dan Welsh-Bon
USA
HIGHLY COMMENDED

FLUORESCING STRAWBERRY ANEMONE COLONY

Nikonos III with 35mm lens with
extension tube; 1/60 sec at f8;
Kodak E100S; lighting

Artificial lighting highlighted
the dramatic fluorescence
of this colony of strawberry
anemones *Corynactis
californica* in Monterey Bay,
California. These anemones
live on pier pilings and in
shallow subtidal waters, in
this case, five metres down
in a breakwater. Scientists
aren't sure exactly why
corals and their allies
fluoresce. The main theory
is that the fluorescent
pigments act as a sunscreen,
because corals evolved in
tropical, shallow waters.

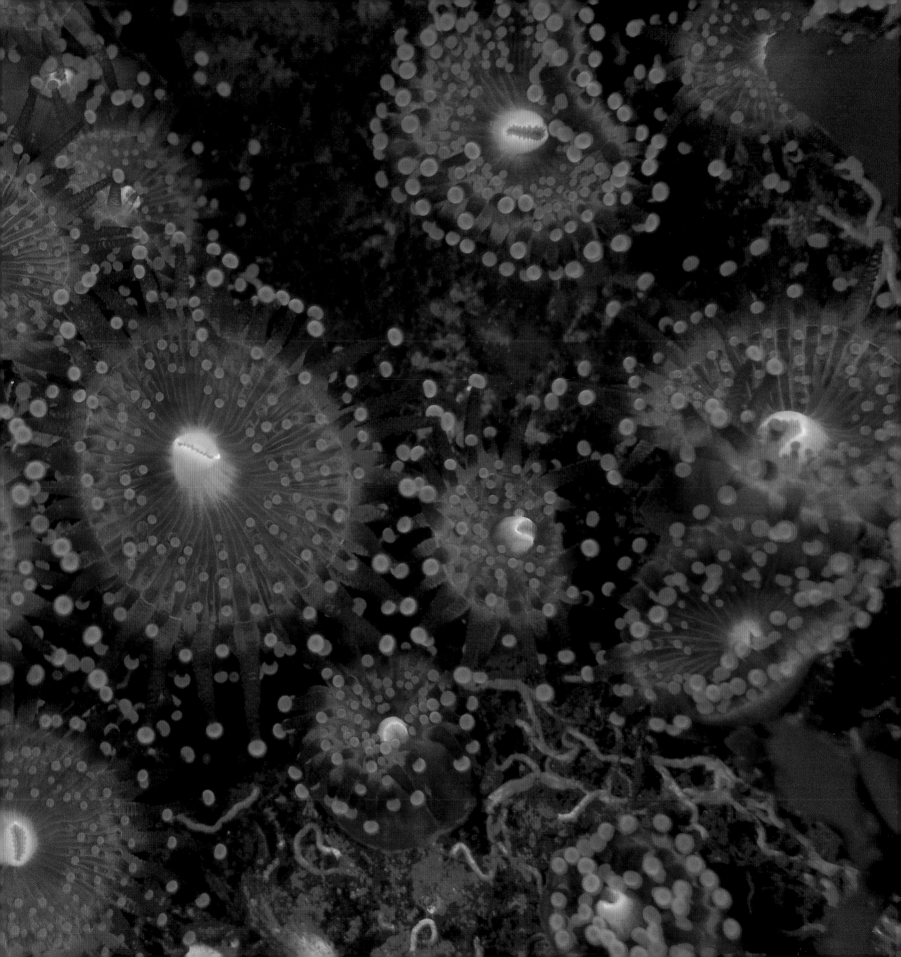

In praise of plants

Images that showcase the beauty and importance of flowering and non-flowering plants.

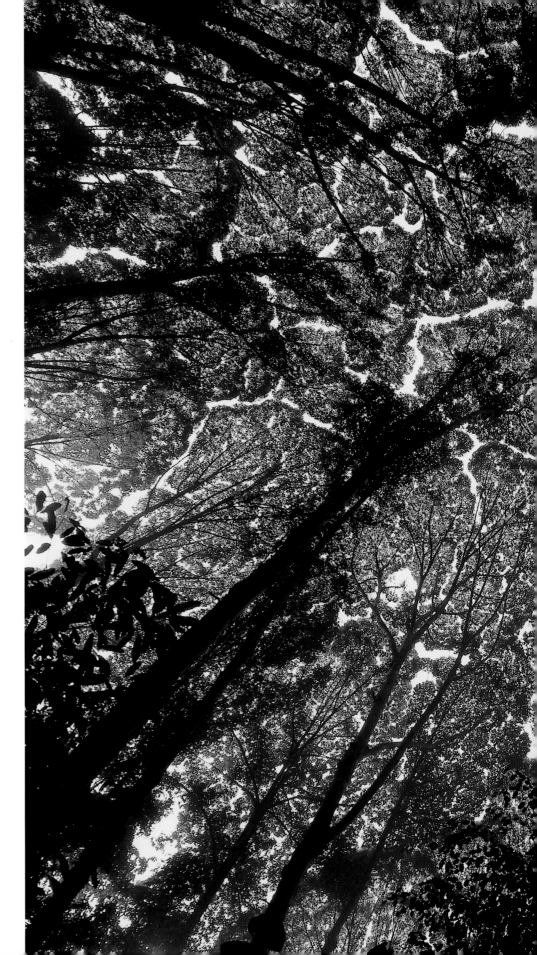

WINNER

Hans Strand
Sweden

RAINFOREST CANOPY

Linhof Technicandan with Schneider Super-Angulon XL 47; 6 sec at f22; Fujichrome Velvia; tripod

In the 1930s, this forest near Kuala Lumpur in Malaysia was clear-cut. So these kapur trees are part of the secondary growth. They're showing what's known as crown shyness. Somehow, the treetops sense each other's presence and avoid growing into neighbouring trees' branches. I took this shot at first light, at a spot in the forest where the canopy – perhaps 80 metres high – almost completely blocked the sky. To emphasise the height of the trees, I took the image almost straight up with a wide-angle lens.

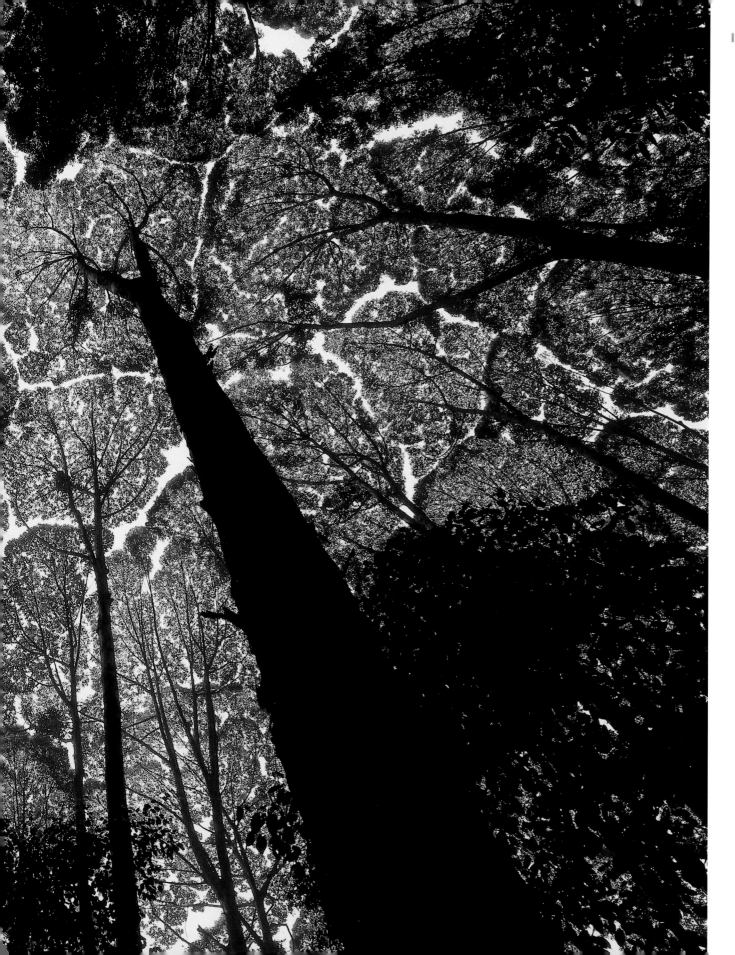

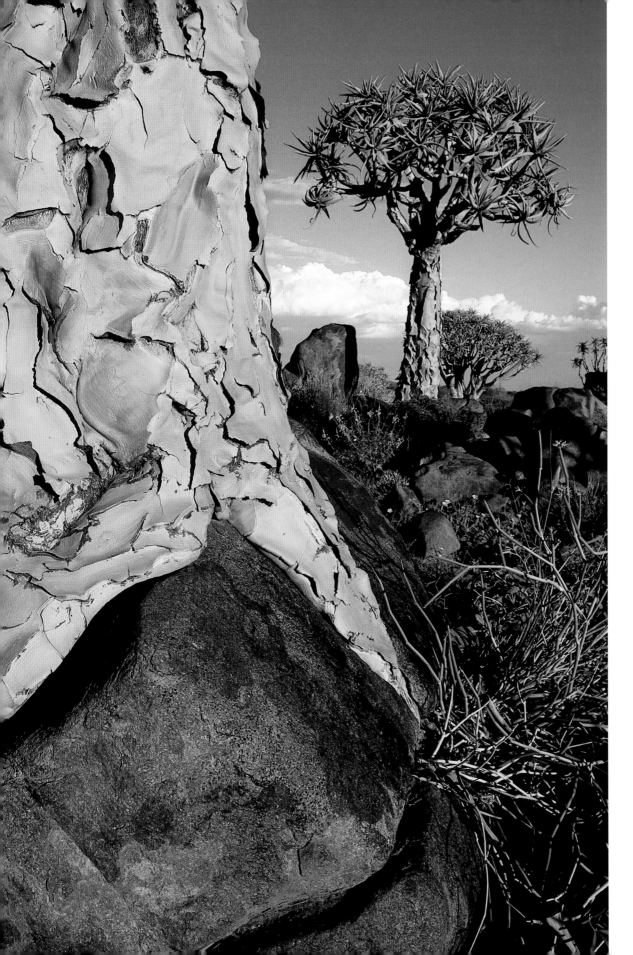

RUNNER-UP

Bror Johansson
Sweden

RWENZORI GIANT LOBELIA (right)

Canon FTb with 50mm lens; Agfachrome 100

These giant lobelias, which can grow up to four metres high, are common in Africa at altitudes above 3,800 metres. This one – at 4,000 metres in Uganda's Rwenzori Mountains, on the border with the Democratic Republic of Congo – is about 40 centimetres in diameter.

Thomas Dressler
Germany
HIGHLY COMMENDED

QUIVER TREE FOREST

Canon EOS 5 with 28-105mm lens; 1/10 sec at f22; Fujichrome Velvia; tripod

These are actually aloes that can grow up to nine metres high. The San, or 'Bushmen', used to make quivers for their arrows from the bark of the smaller branches, which can be hollowed out. This quiver tree forest, near Keetmanshoop in arid southern Namibia, is protected as a national monument. The picture was taken in the rainy season, as you can tell by the cumulus clouds, green vegetation and yellow *Tribulus* flowers.

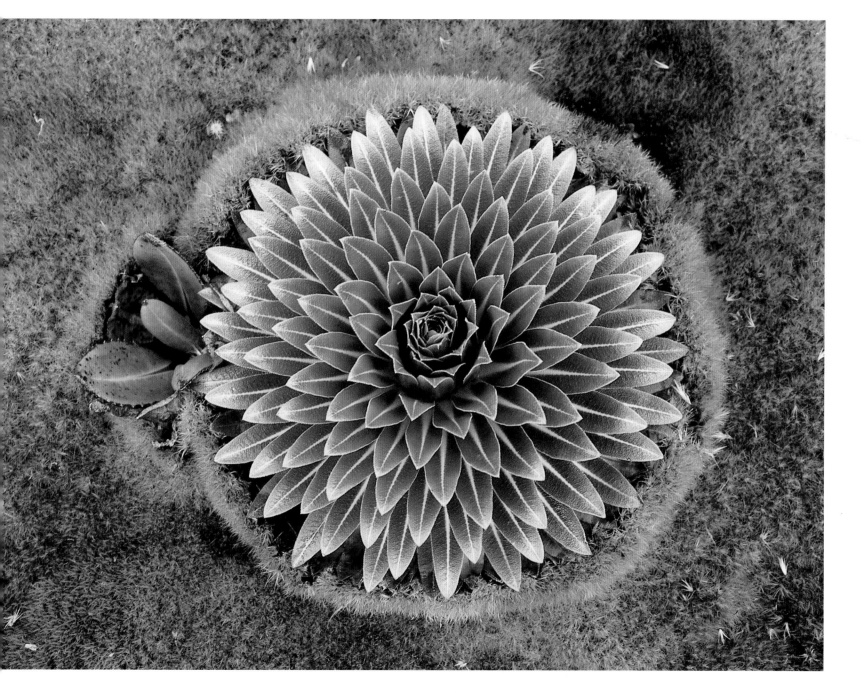

Sue Bishop
UK
HIGHLY COMMENDED

**ANDALUCIAN
WILDFLOWER MEADOW**

Nikon FG with Micro Nikkor
200mm lens; 1/60 sec at f16;
Fujichrome Velvia; diffuser filter
and tripod

Unlike farmers in some
other Mediterranean
countries, the ones in
Andaluciá, Spain, don't allow
wildflowers to grow among
their olive trees. So as more
olive groves are planted,
wildflower meadows are
becoming increasingly hard
to find. Among the flowers
in this glorious meadow
near the Sierra Gorda were
some very young olive trees.
They will be more
established now, and so
these flowers have probably
been ploughed up.

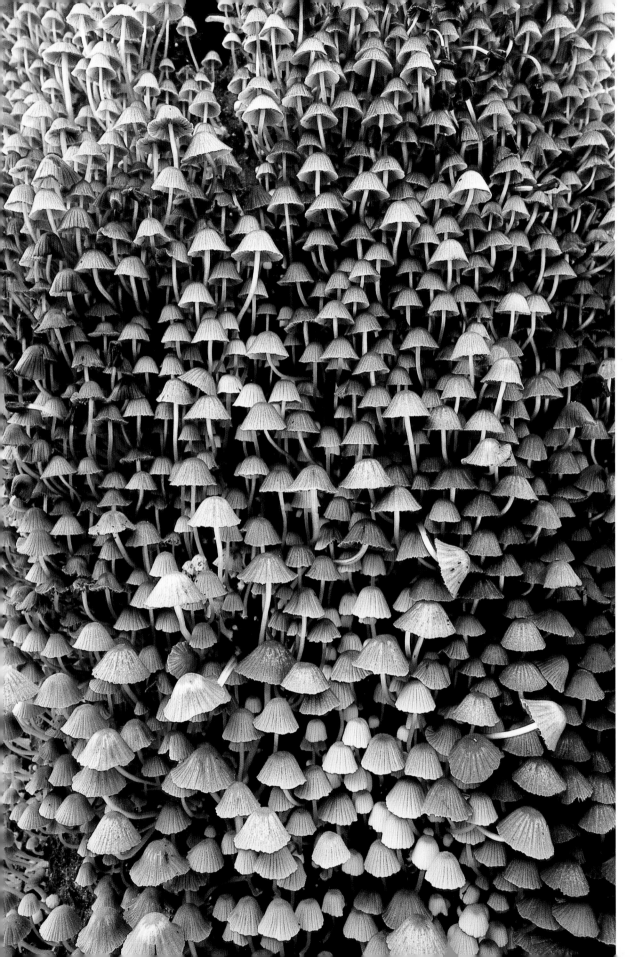

Paolo Cortesi
Italy
HIGHLY COMMENDED

**TROOPING
CRUMBLE-CAPS**

Pentax Z1P with 24mm lens;
8 sec at f22; Fujichrome Provia
100; tripod

These mushrooms are fairly
common in the Bosco
Panfilia wood near my home
in Italy. But I'd never seen so
many before. The rotting
base of a white poplar tree
was totally covered. When I
knelt down to get a closer
look, I was amazed by the
delicacy and soft texture of
the fruit bodies, which rarely
last more than 20 hours. I
used a wide-angle lens with
the minimum focal depth to
get a sense of the whole
while keeping each single
mushroom in focus.

**Murray S Kaufman
and Richard McEnery**
USA
HIGHLY COMMENDED

LUMINOUS MUSHROOMS ON A MOONLESS NIGHT

Nikon F5 with 105 micro lens; 90 mins at f8; Kodak E200 rated at 400; tripod

We came across these luminous mushrooms *Mycena illuminans* in a virgin lowland rainforest in Sabah, Borneo. It's believed that the light emitted by the fungi – through an oxidation process – attracts beetles and insects, which crawl on, over or through groups of the mushrooms. The insects, in turn, scatter the spores across the forest floor. It was impossible to get a routine light-meter reading from the mushrooms' faint glow, and so we decided to do a series of long exposures, ranging from 30 to 120 minutes. This 90-minute one captured the natural luminescence perfectly.

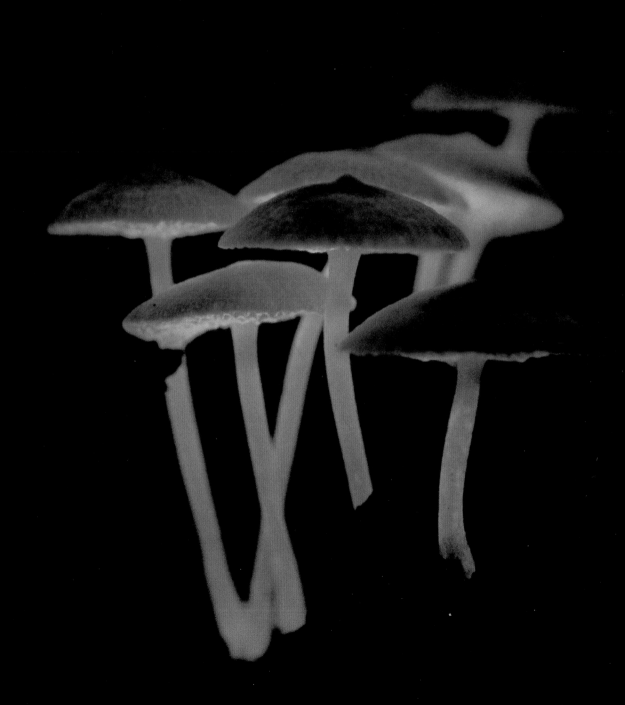

Thomas Endlein
Germany
HIGHLY COMMENDED

WATER CROWFOOT AT DAWN

Canon EOS 1NRS with 180mm macro lens; Fujichrome Velvia; home-made floating tripod

In July, these flowers completely cover some small ponds in Germany. Early in the morning, the low sun bathes them in a soft light. I emphasised the dark background of a forest behind this pond by underexposing the photograph, and to catch the reflections, I used a home-made tripod to mount the camera directly on the water.

Jan Töve Johansson
Sweden
HIGHLY COMMENDED

COTTONGRASS

Pentax 645N with 200mm lens; 1/25 sec at f32; Fujichrome Velvia

To me, photography is as much about what you exclude as what you include. The mountains at this spot in Jotunheimen, Norway, were reflected in the water where the cottongrass was growing. So instead of trying to show the whole scene, I concentrated on the plants and the reflections.

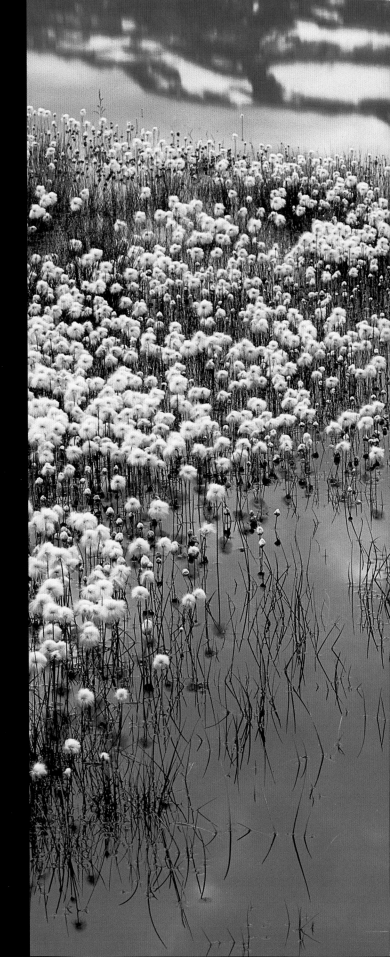

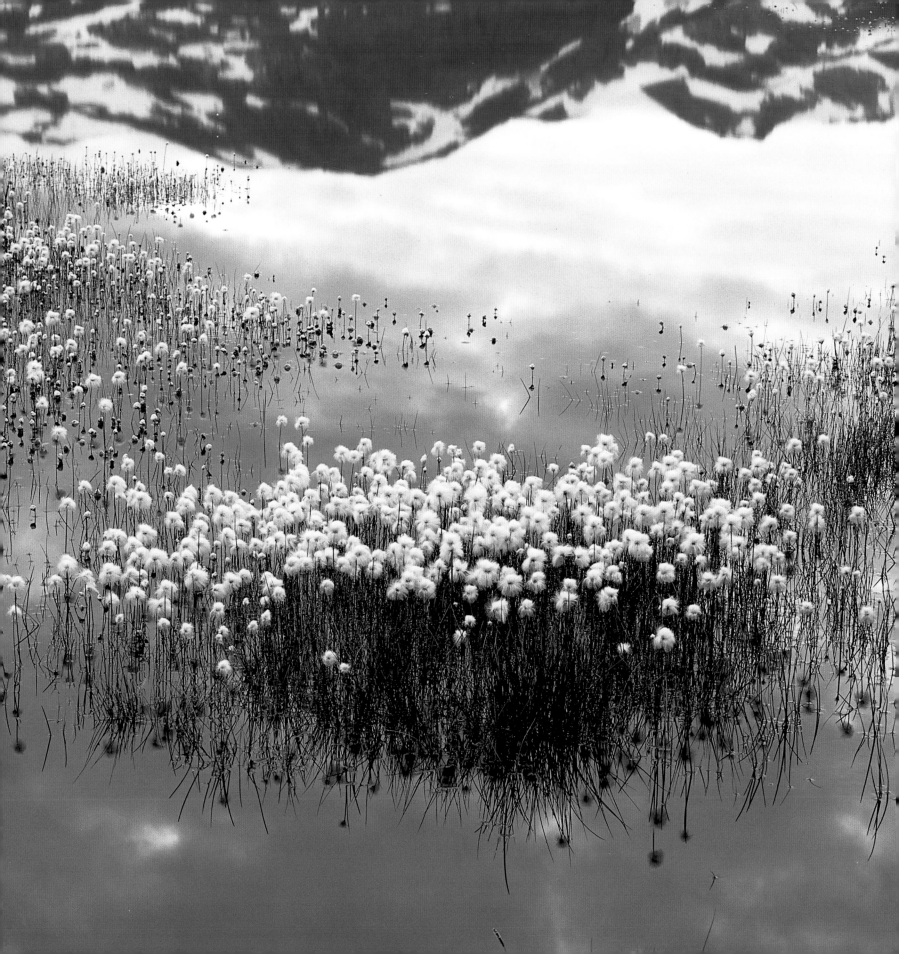

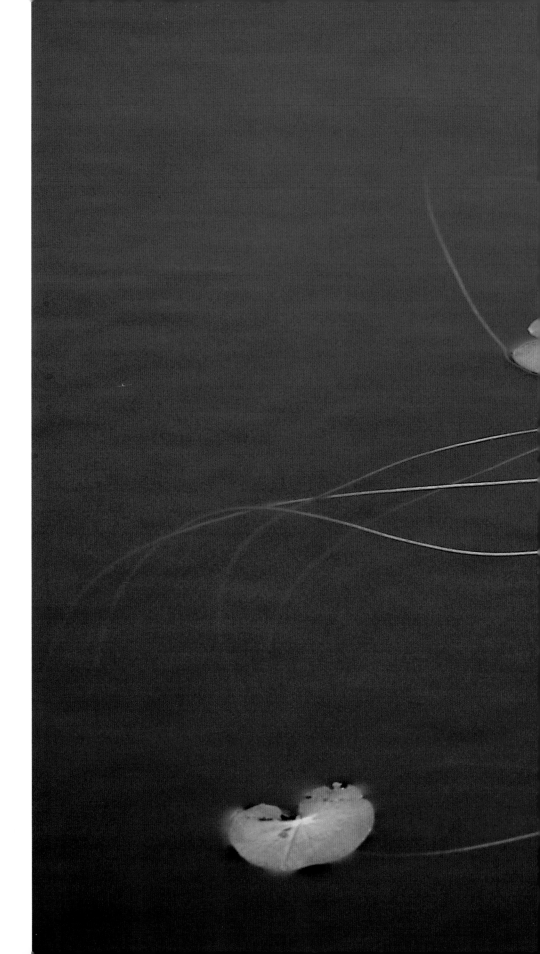

Jun Ogawa
Japan

JAPANESE WATER LILY

Nikon F3 with 80-200mm lens;
1/30 sec; Fujichrome Velvia

The flowers of *Nymphaea tetragona*, the smallest of all the water lilies, don't open until late afternoon. These were in a wetland area of Japan's Nikko National Park, a popular tourist attraction. It took me a while to work out exactly how to photograph the delicate colour of the leaves and the graceful roots.

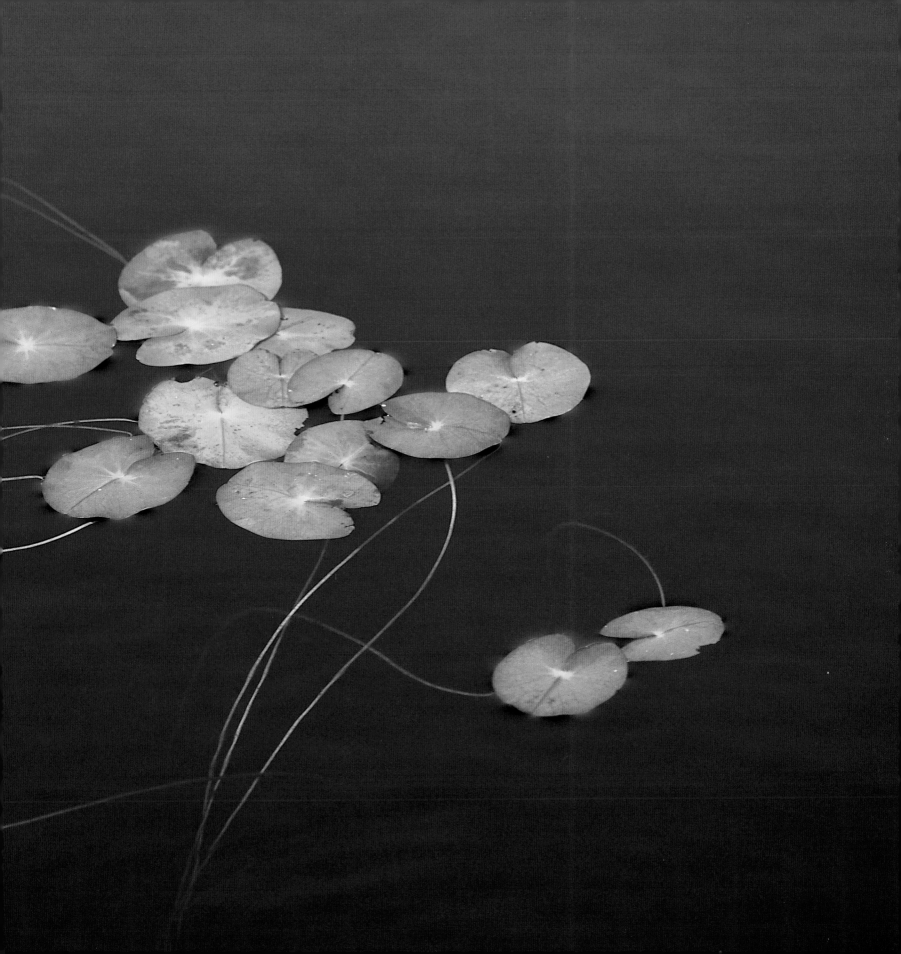

British wildlife

Wild plants or animals in rural or urban settings within the UK.

WINNER

Andy Newman
UK

SWAMP SPIDER CARRYING ITS EGG-SAC

Canon 50E with Tamron 90mm macro lens; 1/125 sec at f11 Fujichrome Sensia 100; monopod and two small flash guns

This swamp, or raft, spider can run fast, even when carrying her egg-sac for the couple of weeks that it takes for the hundreds of spiderlings to hatch. *Dolomedes fimbriatus* is Britain's largest spider and one of its rarest, restricted mainly to the Norfolk Broads and New Forest, Hampshire – where this one was photographed. Capable of catching small fish, it lurks on floating logs or weed in boggy ponds and streams. When it detects a ripple generated by trapped prey, the spider skates across the water surface for the kill. At the sign of an enemy, it dives under water.

Martin Zwick
Germany
HIGHLY COMMENDED

BLACK-LEGGED KITTIWAKES ON THEIR NEST

Pentax Z1P with 200-600mm lens; 1/250 sec at f6.3; Fujichrome Sensia II 100; tripod

The Isle of Colonsay off the west coast of Scotland is home to thousands of kittiwakes. On the west coast of the island, I found a gap in the cliff where I could climb down to eye-level with a small colony on the other side of the gap. The soft patterns in the eroded rock seemed to emphasise the harmony of this breeding pair and its chick.

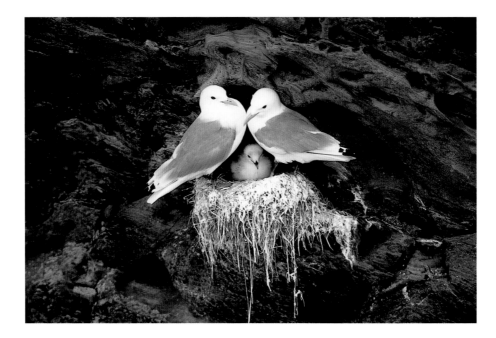

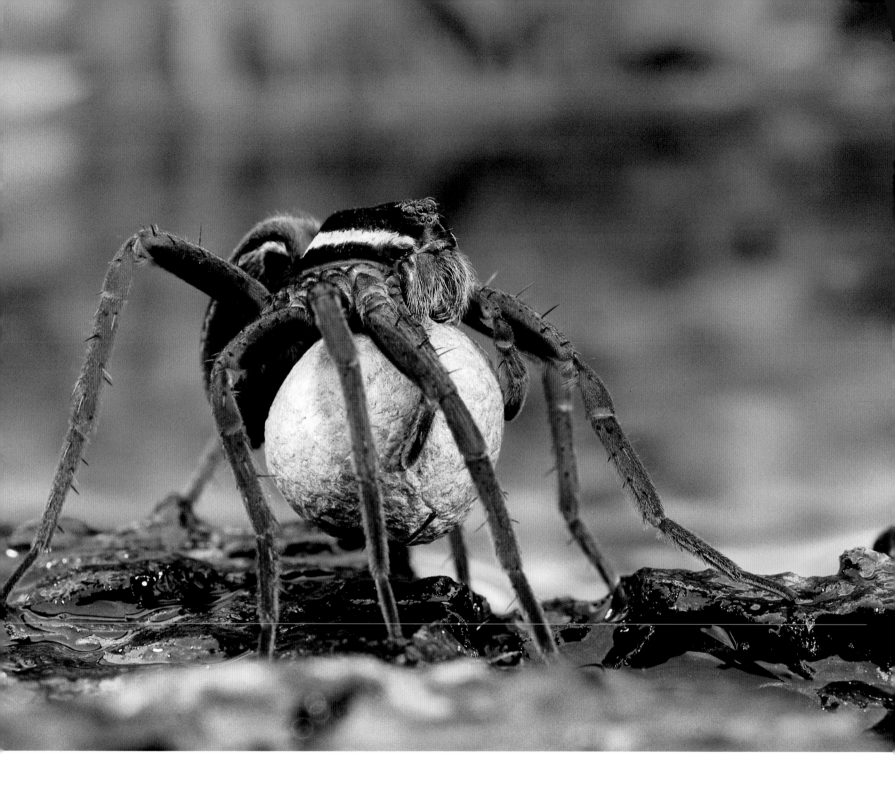

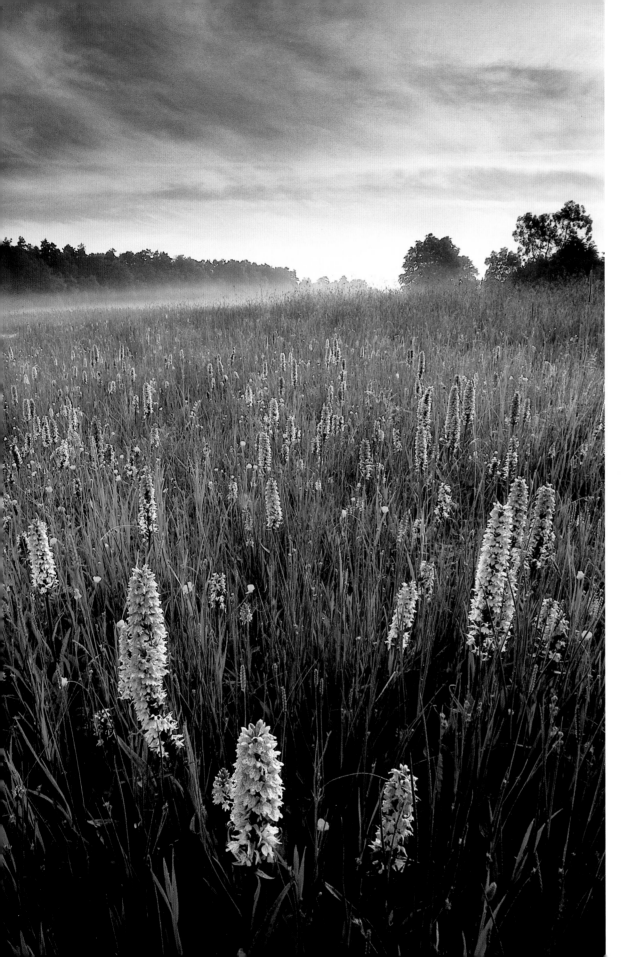

Steve Day
UK
HIGHLY COMMENDED

SOUTHERN MARSH, COMMON SPOTTED AND HYBRID ORCHIDS

Canon EOS 50E with 25-35mm lens; 4 sec at f16; Fujichrome Velvia

I have never seen so many orchids as in this superb field in Wiltshire. Some of the spikes were up to 30 centimetres high. At dawn, the flowers seemed to glow with reflected light and a lovely depth of colour. This field isn't deliberately managed as a wildlife site: the orchids are a byproduct of the farmer's traditional farming methods. Resisting pressures from European Union farming policies to be as productive as possible, he doesn't drain the field, avoids using pesticides, insecticides and artificial fertilisers and grazes it carefully. It's not just the orchids that benefit – insects and birds do, too.

Kenneth Crossan
UK
HIGHLY COMMENDED

RED DEER STAG IN WINTER

Nikon F90X with 300mm lens; 1/125 sec at f5.6; Fujichrome Velvia; beanbag

I waited all winter for the first proper snowfall, but it wasn't until early March that it came. This was my cue to go to a favourite deer-watching spot in Sutherland, in the far north of Scotland. In one of the bright spells between snow showers, this red deer stag passed by, the fresh snow clinging to his hooves.

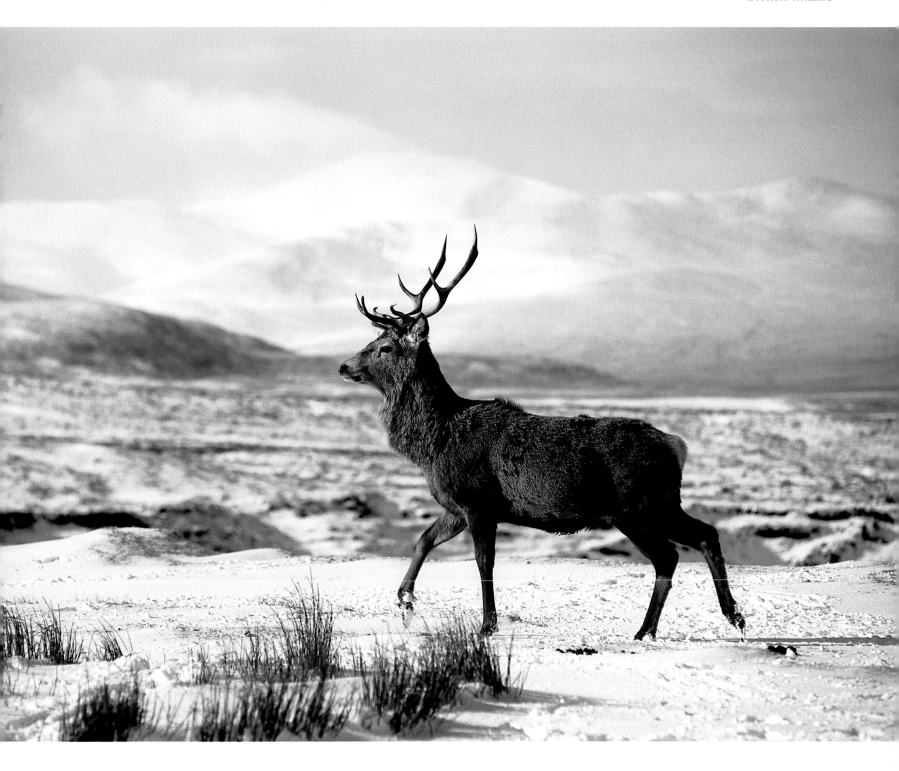

Urban and garden wildlife

Animals or plants in a garden or an obviously urban or suburban setting.

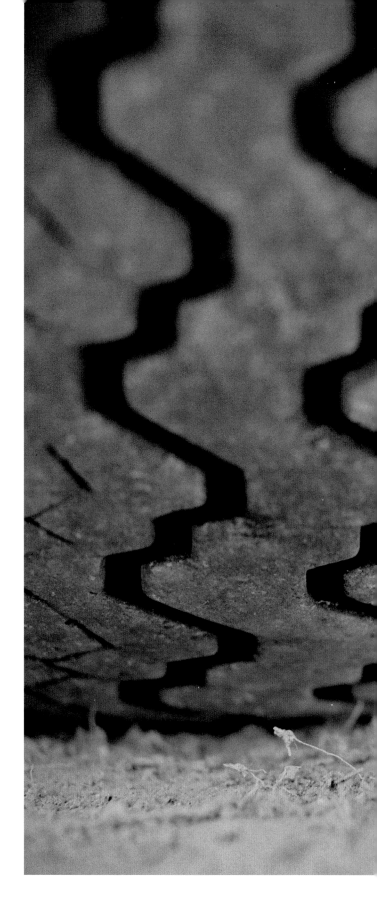

WINNER

Dale Hancock
South Africa
Winner

AFRICAN SCOPS OWL SHELTERING AGAINST A CAR TYRE

Canon EOS 1 with 35-350mm lens; 1/100 sec at f5.6; Fujichrome Velvia; beanbag

People often hear scops owls – which are very vocal – but rarely see one, especially in daylight and from such close quarters as this. This African scops owl was sheltering against one of our vehicle tyres on a typical South African hot, dry winter day. Unfortunately, the reason I could approach it so closely was that it was ill, and just a few hours after I took the photograph, it died.

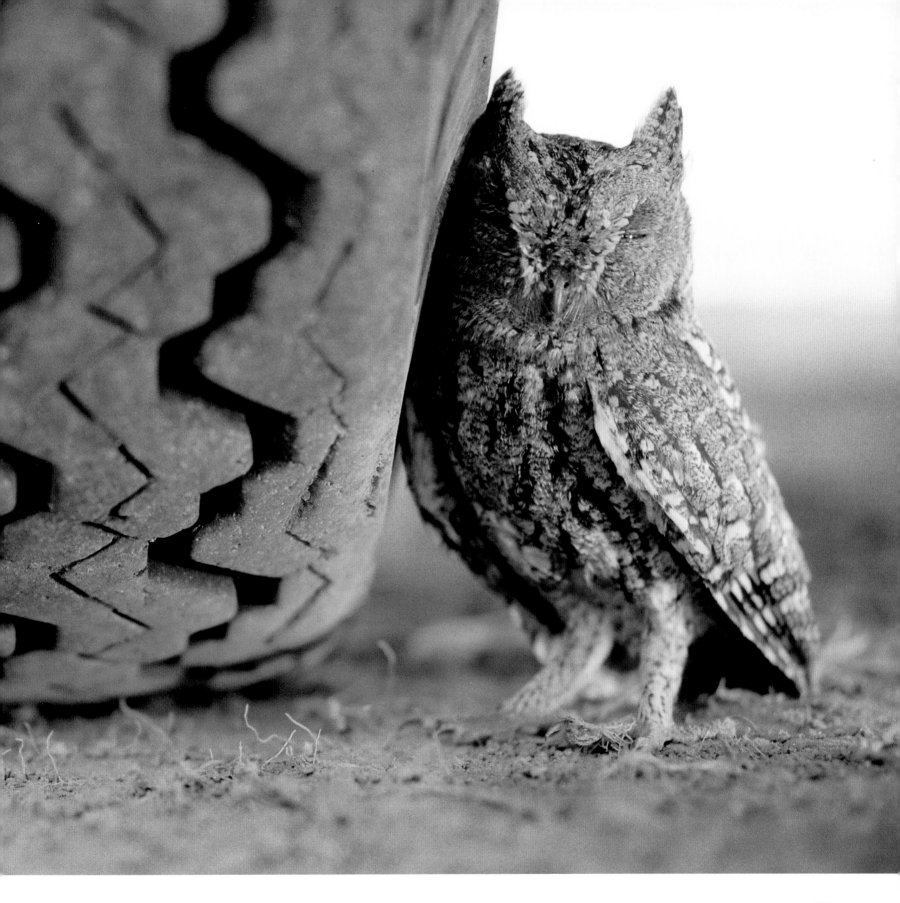

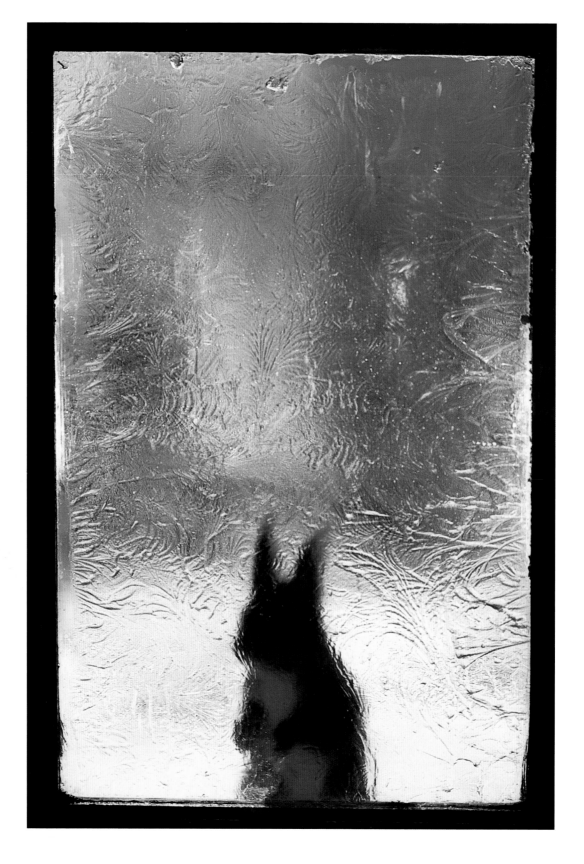

RUNNER-UP

Hannu Ahonen
Finland

**RED SQUIRREL AT
THE WINDOW**

Olympus OM1 with Zuiko
85mm lens; 1/125 sec at f5.6;
Fujichrome Velvia

In winter, near my home in
central Finland, there's not
much for the red squirrels to
eat. So I always put food out
for them. Sometimes, if I
hadn't yet got around to
putting food in the garden,
the squirrels would wait
there, coming up to the
house to look through the
windows. About 10 squirrels
came to feed regularly, and
they all survived the winter.
This four-year-old female
even built her nest in my
garden. She had four babies.

Enrique del Campo
Spain
HIGHLY COMMENDED

WHITE STORK ROOSTING

Nikon F90X with 400mm lens; 1 sec at f8; Fujichrome Sensia 100; tripod

White storks have adapted to urban life almost as well as feral pigeons. Their huge, twiggy nests on chimneys in Continental cities are a common sight. This stork, which I spotted in the old part of Alcana de Henares in Madrid, seemed in harmony with its architectural surroundings. I waited for 20 minutes, until the lights illuminating the church steeple were switched on, and then took this picture.

Armando Maniciati
Italy
HIGHLY COMMENDED

SOUTHERN COMMA BUTTERFLY SHELTERING

Nikon FE2 with 28mm lens; 1/8 sec at f16; Fujichrome Velvia; tripod

At the end of summer, when there was a sudden cold spell, this southern comma took shelter for a few days on the sash of one of my studio windows in Padova, Italy. It didn't move all the time it was there. Early one morning, I climbed a ladder and opened the window a little so that I could photograph the butterfly together with the reflection of the front of the building opposite.

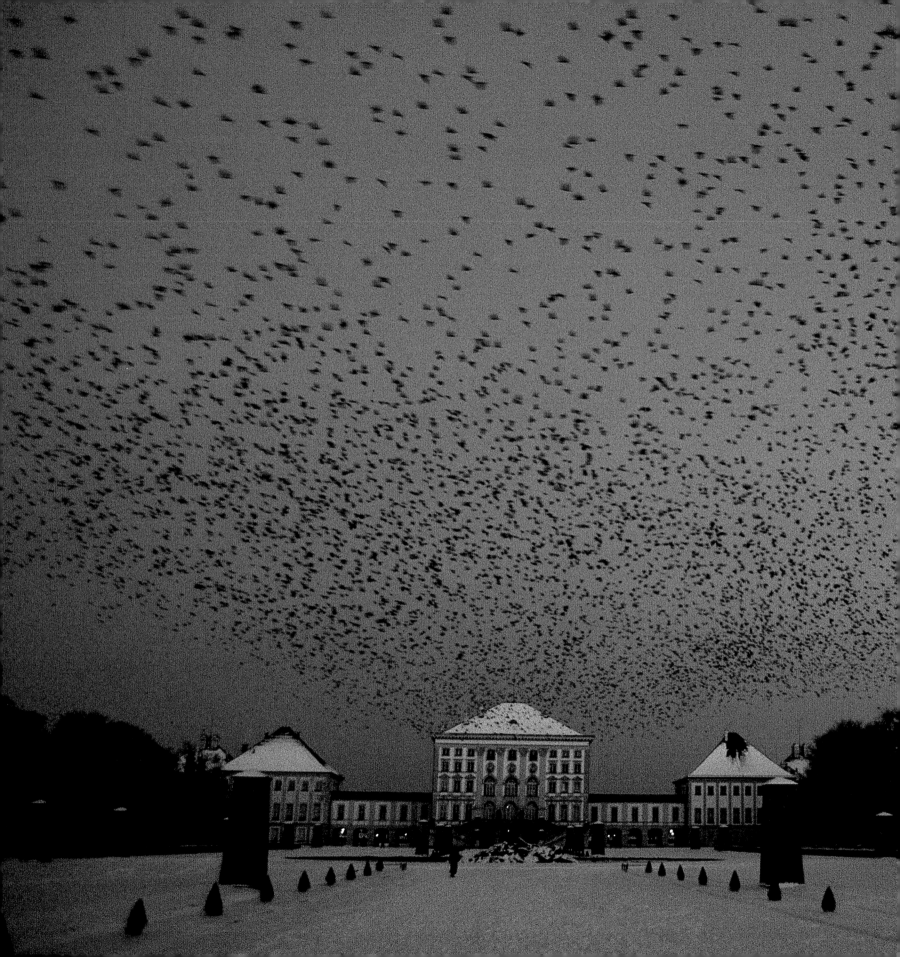

Thomas Grüner
Germany
HIGHLY COMMENDED

ROOKS FLYING TO THEIR ROOST

Canon EOS 50E with 28-80mm lens; 1/30 sec at f2.8; Kodachrome 200

Each year, about 2.3 million people visit Nymphenburg Castle in Munich, but in winter, rooks replace the tourists. Every evening, they fly from their daytime foraging grounds around Munich, filling the skies for half an hour or so as they head for their tree roosts in the park.

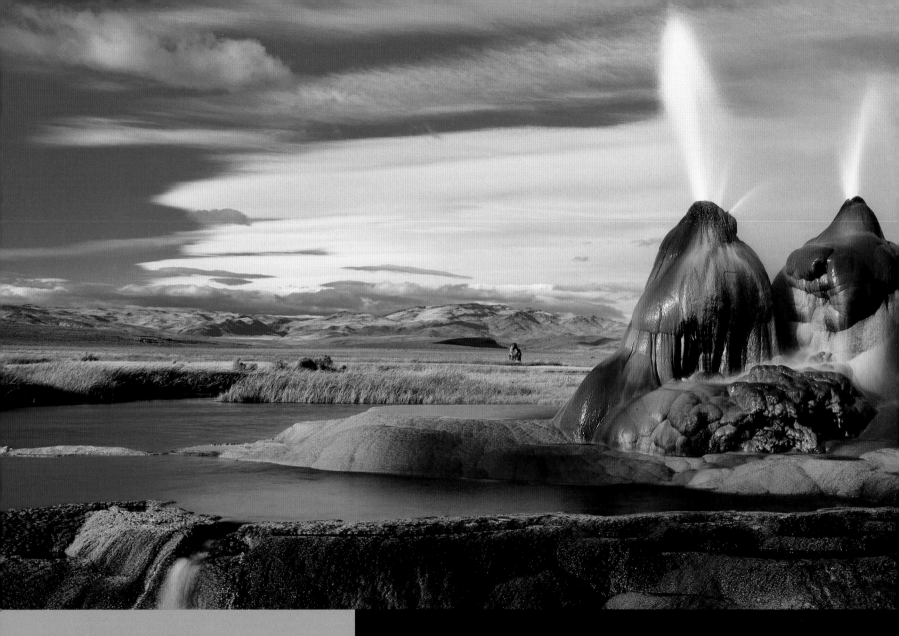

Wild places

Landscapes that convey a feeling of wildness or create a sense of awe or wonder.

WINNER

Jeremy Woodhouse
UK

BLACK ROCK DESERT GEYSERS

Fuji 617 with 105mm lens; 1/4 sec at f45; Fujichrome Velvia 50 rated at 40; polarising filter

Northern Nevada is well known for its geysers and hot springs. These man-made drill-wells in the Black Rock Desert were probably never capped. Boiling water perpetually spouts out under great pressure from a geothermal spring, and mineral deposits have, over the years, formed the cones and steps.

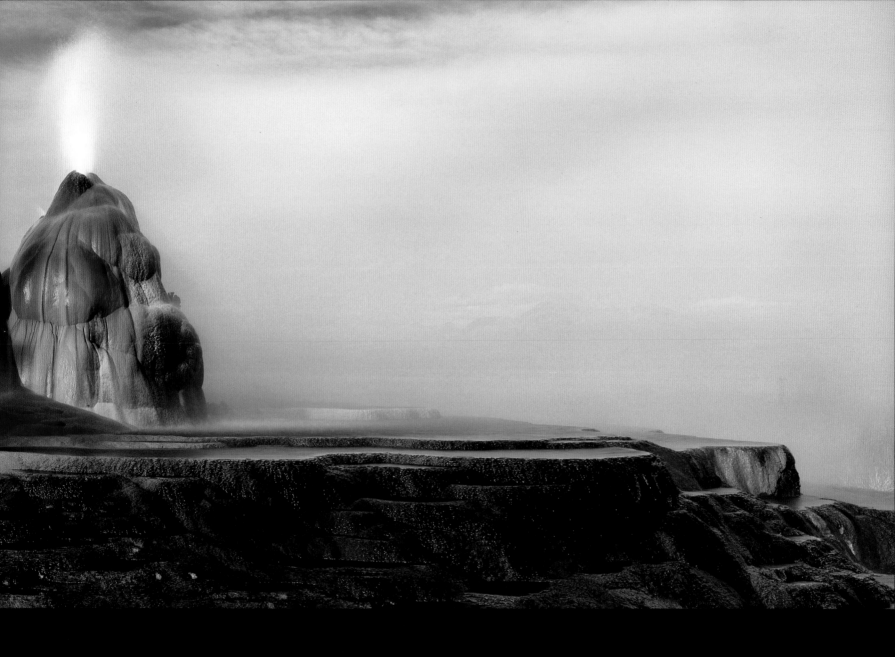

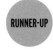

RUNNER-UP

Sven Zellner
Germany

**AUSTRIAN ALPS
AT DAYBREAK**

Nikon F4S with 28mm lens; 1 sec
at f16; Fujichrome Velvia; tripod

One night, guided by only
the dim light of the stars, I
climbed steep, rough alpine
trails in Austria's Hohe
Tauern National Park,
reaching Gerlos Lake just
before dawn. The only thing
that interrupted the
mountain stillness was the
sound of a rock avalanche,
and while it was still dark, I
set my camera up so that I
was ready to shoot when
the light was perfect. Then I
sat down to wait for dawn.

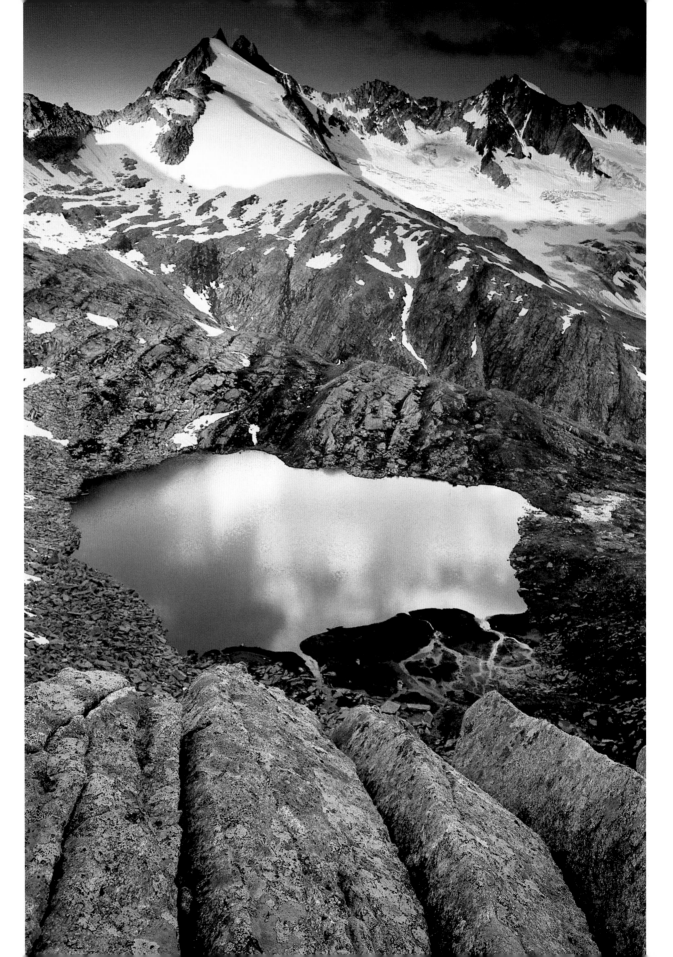

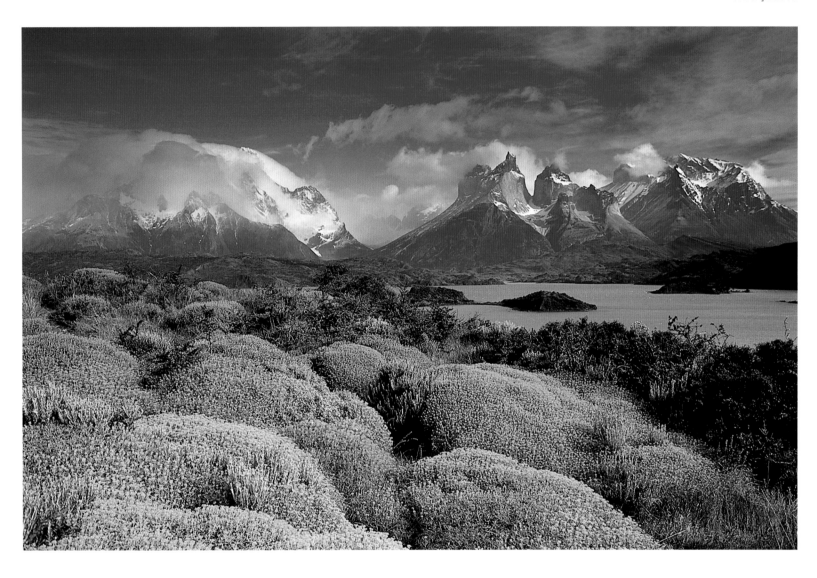

Berndt Fischer
Germany
HIGHLY COMMENDED

PATAGONIAN PEAKS

Nikon F5 with Nikkor 28mm lens;
1/15 sec at f22; Fujichrome Velvia;
polarising filter and tripod

January is a summer month in Chile. The shrubs of *Mulinum spinosum* around the Lago Pehoé in Torres del Paine reserve were in flower, but a heavy rainstorm prevented photography. Then the constant wind suddenly cleared the cloud-laden sky, and the peaks of Cuernos del Paine were briefly visible.

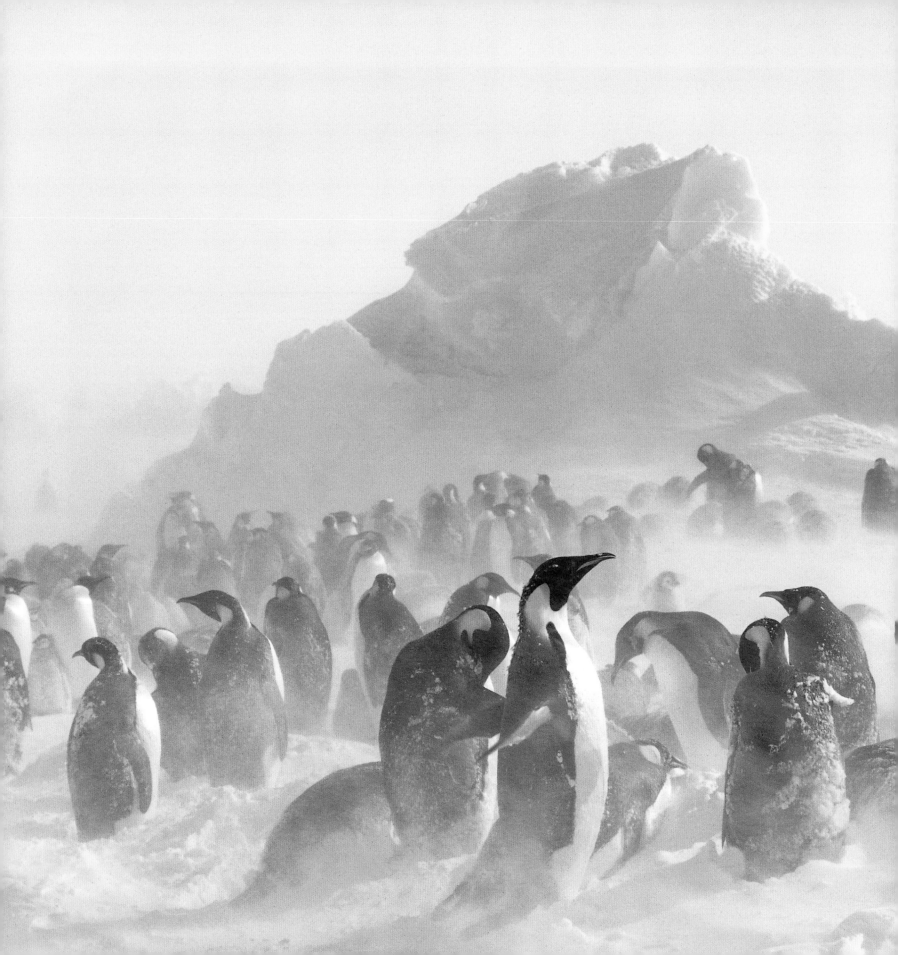

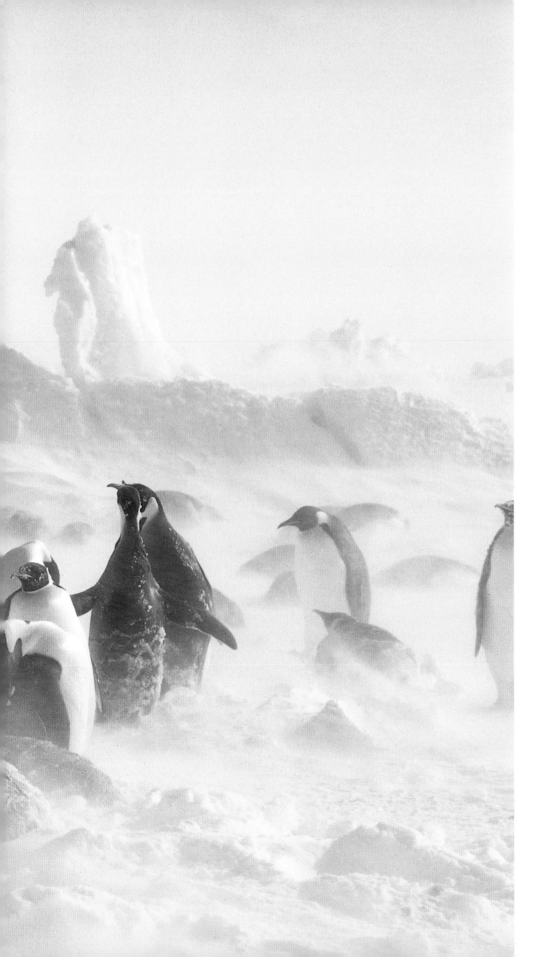

Fritz Pölking
Germany
HIGHLY COMMENDED

**EMPEROR PENGUINS
IN A SNOWSTORM**

Nikon F5 with 80-200mm lens;
1/250 sec at f8; Fujichrome
Sensia 100; tripod

I spent 20 nights in a tiny
tent in temperatures of 20
to 30 degrees below zero to
get this glimpse into the
world of emperor penguins.
This picture, near Antarctica's
Dawson-Lambton Glacier,
was taken during a heavy
November snowstorm. The
penguins were probably as
unhappy as I was with the
weather, but the picture does
show the conditions these
birds have to survive in.

Hans Strand
Sweden
HIGHLY COMMENDED

ICEBERG LIT BY
THE MIDNIGHT SUN

Linhof Technicardan with
Schneider Super-Angulon XL 47;
5 sec at f22; Fujichrome Velvia;
tripod

This iceberg at Greenland's
Disko Bay is blocking the
mouth of the most
productive ice-fjord in the
world. Land-ice pours into it
at the rate of about 30
metres a day. The fjord's
mouth is only 350 metres
deep, and so any icebergs
deeper than that – this one
is at least 400 metres deep –
get stuck. The ice behind
builds up, and then, every
five days or so, the iceberg
crumbles under the
pressure. All the smaller
icebergs that had been
queuing up behind then
float out to sea. The iceberg
that sank the *Titanic* was
probably delivered from
these waters.

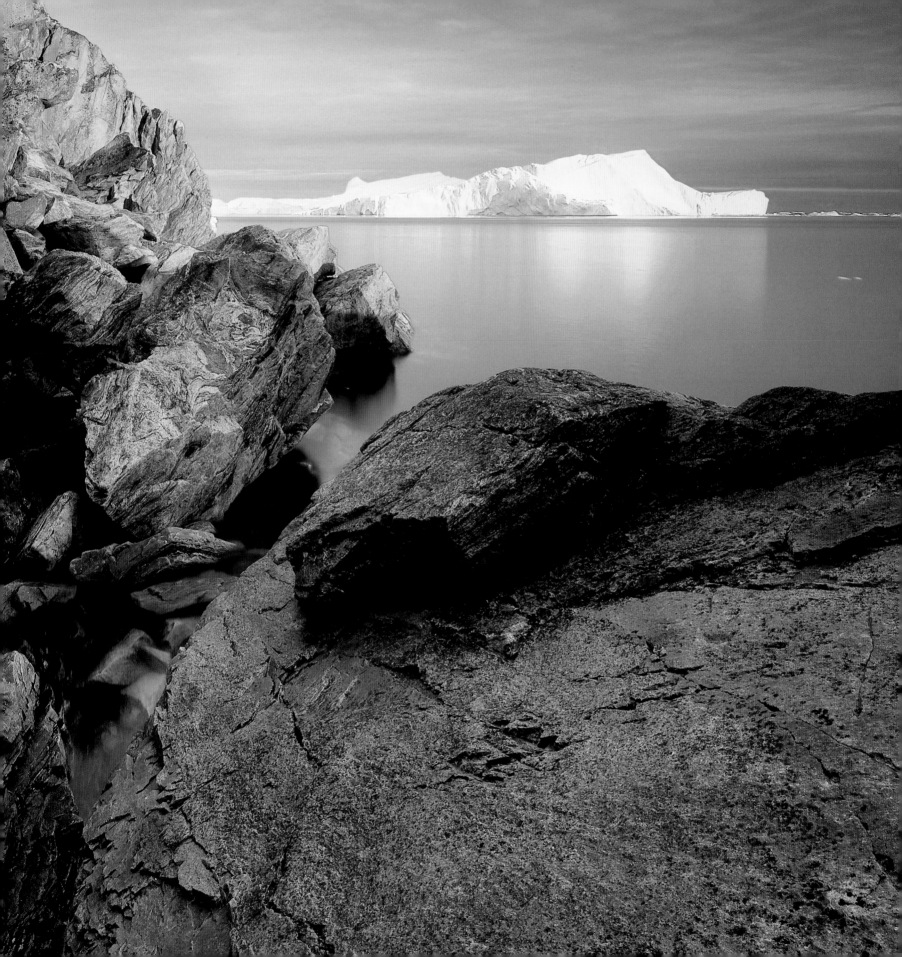

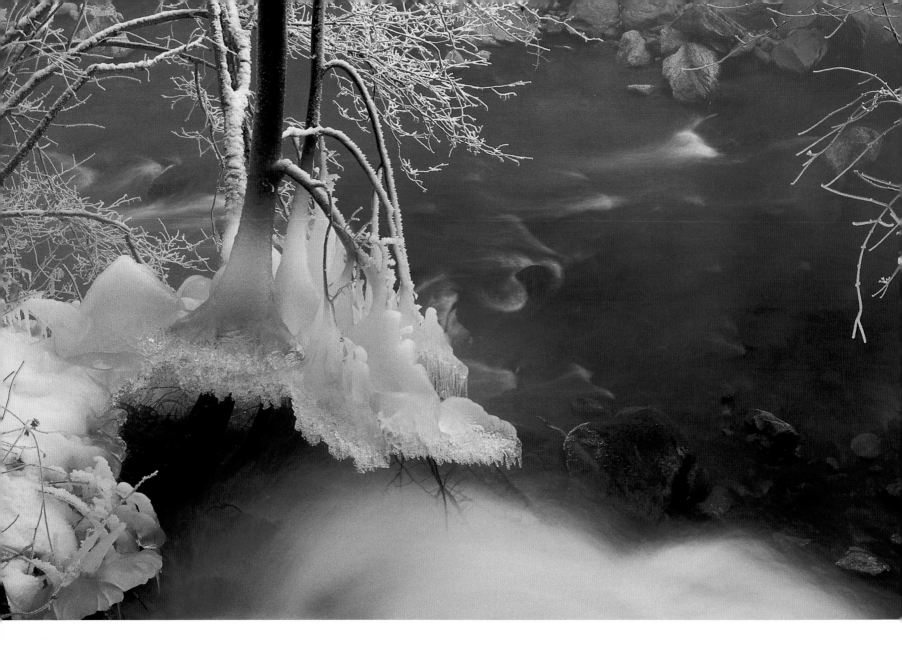

Adriano Turcatti
Italy
HIGHLY COMMENDED

RIVER ICE CURLS

Canon EOS 5 with 35-70mm lens;
1/15 sec at f16; Fujichrome Provia
100; tripod

Italy's Stelvio National Park,
on the Swiss border, is a
vast alpine wilderness. It's
home to large numbers of
mammals, including ibex,
red deer, chamois and
brown bears. About a tenth
of the park is permanently
covered in ice. Here, the
slow-flowing river had
created curls of ice on its
surface.

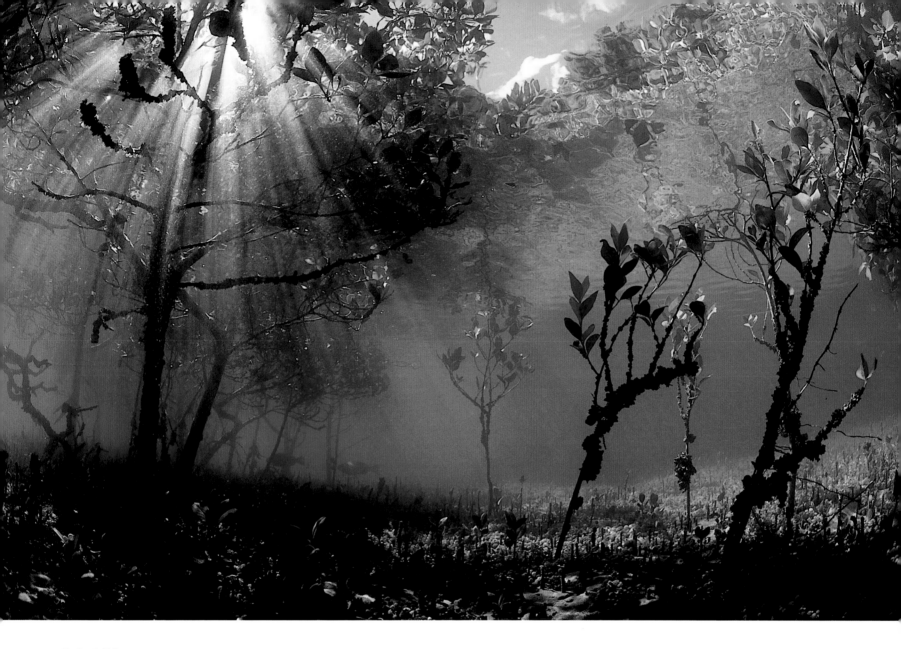

Pete Atkinson
UK
HIGHLY COMMENDED

MANGROVE ESTUARY UNDER WATER, NORTHLAND, NEW ZEALAND

Subeye Reflex with Nikon R-UW AF 13mm fisheye lens; 1/125 sec at f8; Kodak E100VS

Along the Northland coast of New Zealand, there are still many mangroves, the only trees able to cope with living in salt water. At high tide, the water can be clear, and in places, the shallows feel like a sunlit forest. The mangrove ecosystem is an important breeding ground for many fish and invertebrates, and the swamps help protect coasts from erosion and siltation. But they are among the most threatened of all habitats.

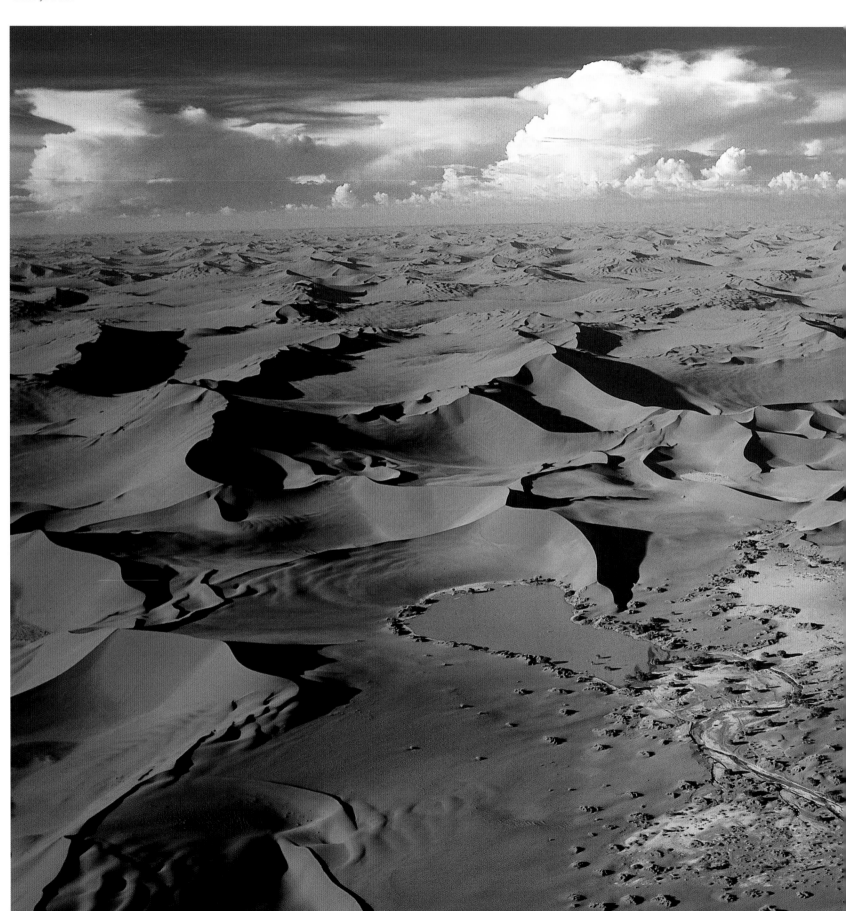

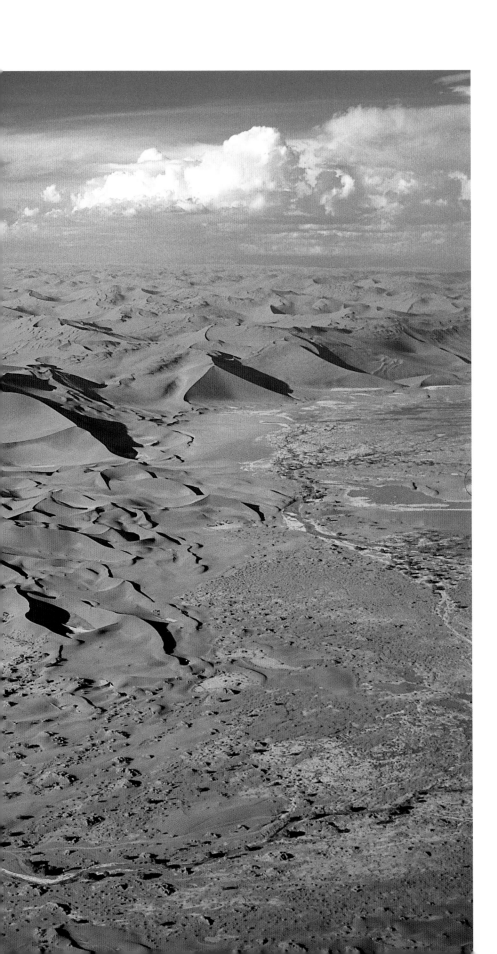

Wynand du Plessis
South Africa

NAMIBIAN OASIS

Nikon F90X with Tokina
20-35mm lens; 1/250 sec at f5.6;
Fujichrome Velvia; polarising filter

It rains about once every eight years in Namibia. If the rain in the escarpments 90 kilometres to the east is particularly heavy, the floodwaters may end up here – running in hundreds of streams over the clay-pan and between the towering dunes. It was quite a surprise when there was a flood this year, because the last time it happened was in 1997. Before that, there had been no floods since the mid-1980s.

Jose Delgado
Spain

'HOO-DOOS' STONES

Pentax 645 with 80-160mm lens;
1/14 sec at f32; Fujichrome Velvia;
tripod

In Utah's Bryce Canyon
National Park, erosion has
carved 'Silent City', an
awesome array of fantastic
shapes – the so-called
hoo-doos. It's like a colossal
amphitheatre full of Gothic
cathedrals, each crowned
with glowing spires.
Local painters say the
formations are 'legend
people' turned to stone by
supernatural beings.

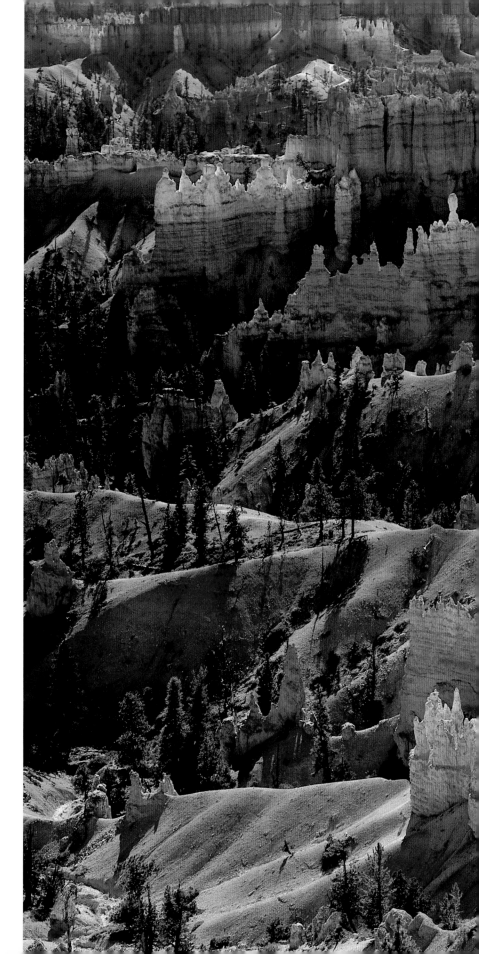

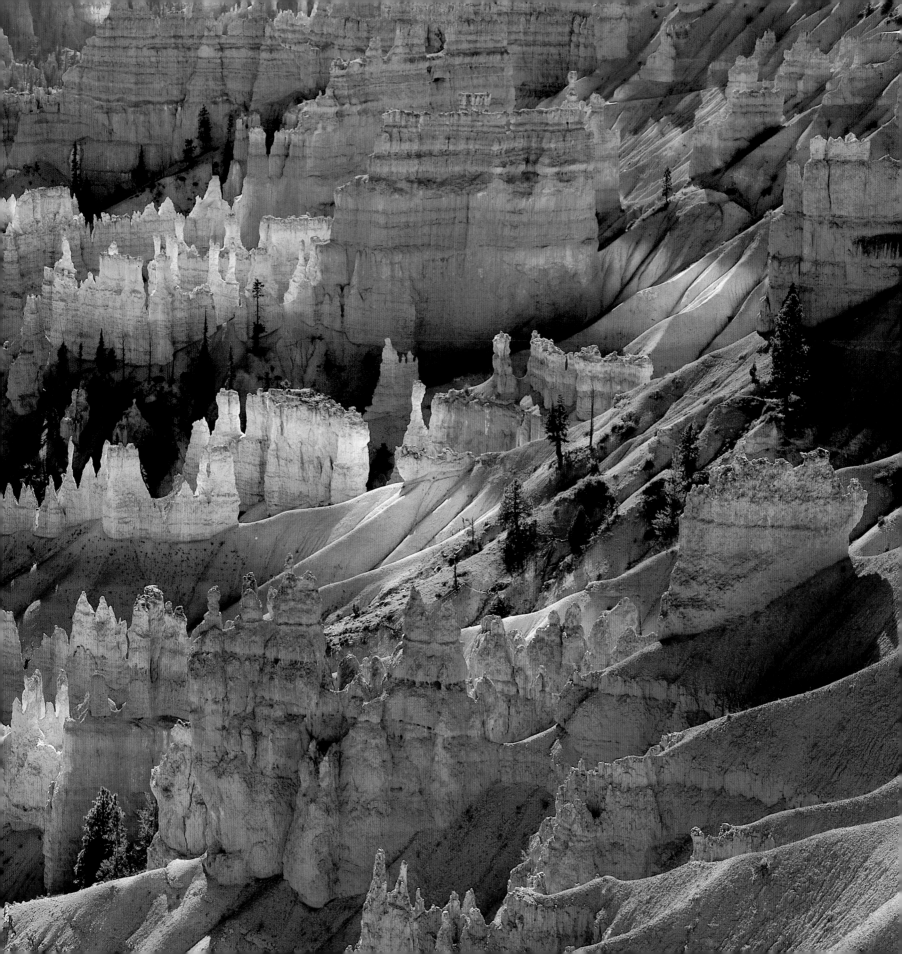

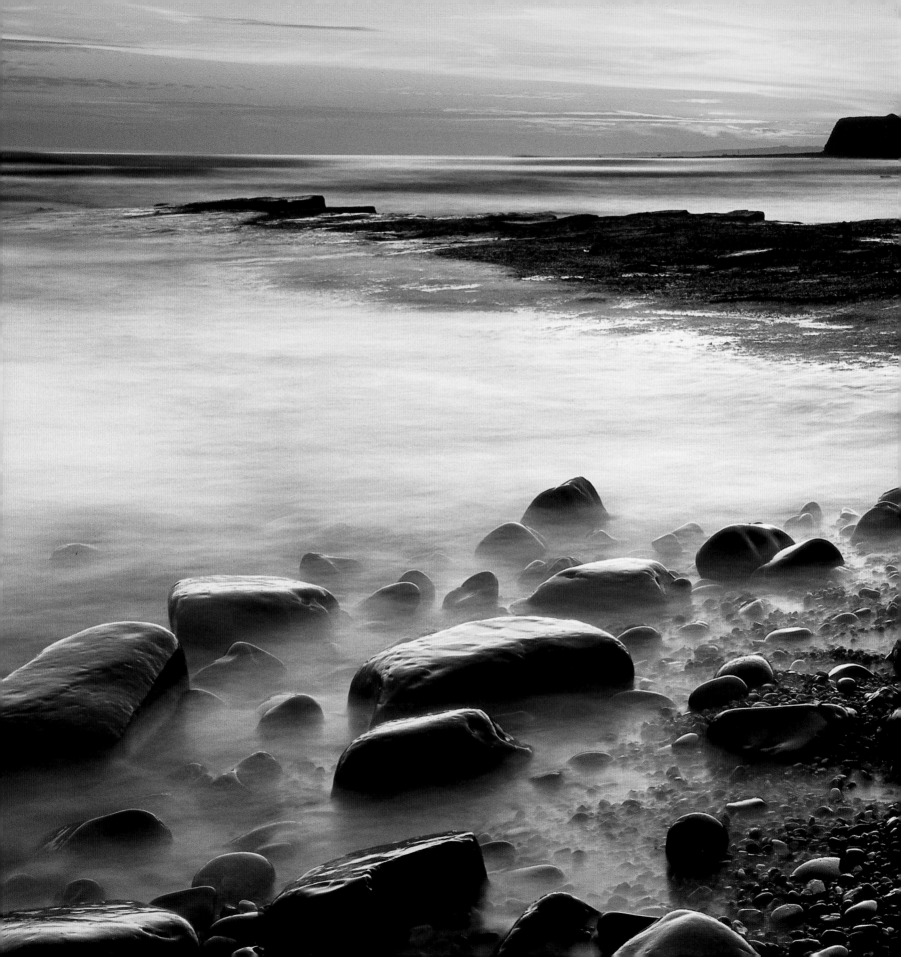

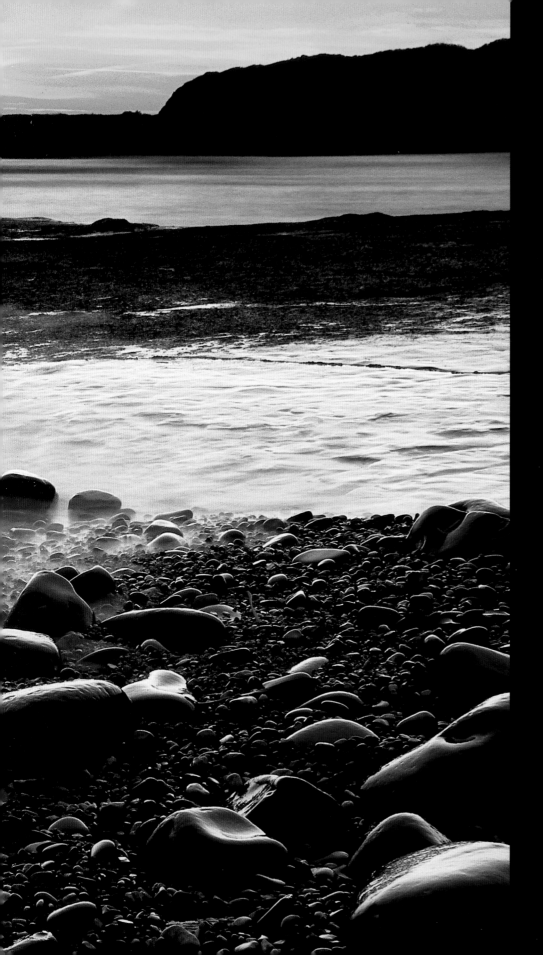

Guy Edwardes
UK
HIGHLY COMMENDED

**SHORELINE BOULDERS
AT DUSK**

Canon EOS 5 with 35mm lens;
8 sec at f16; Fujichrome Velvia;
polarising filter and tripod

In winter, at the north shore
of Dorset's Kimmeridge Bay
in England, the sun sets
directly out at sea.
I photographed this scene
about 20 minutes after the
sun had gone down. The
afterglow provided colour,
and the low light levels gave
an exposure that blurred the
movement of the water as it
washed over the shoreline
boulders.

93

Composition and form

Illustrating natural subjects in abstract ways.

WINNER

Jim Petek
USA

BOHEMIAN WAXWINGS EATING MOUNTAIN ASH BERRIES

Pentax P21 with 80-200mm lens; 1/125 sec at f2.8 Fujichrome Provia 100

Red Lodge, Montana, is at the foot of the Beartooth Mountains near Yellowstone National Park and is full of mountain ash trees. These are laden with orange berries in autumn, providing an important food source for Bohemian waxwings migrating south. Travelling in large flocks, the birds stay in the area until they have eaten all the berries. Then they resume their journey to their wintering sites elsewhere in Montana, southern California, northern Arizona and New Mexico.

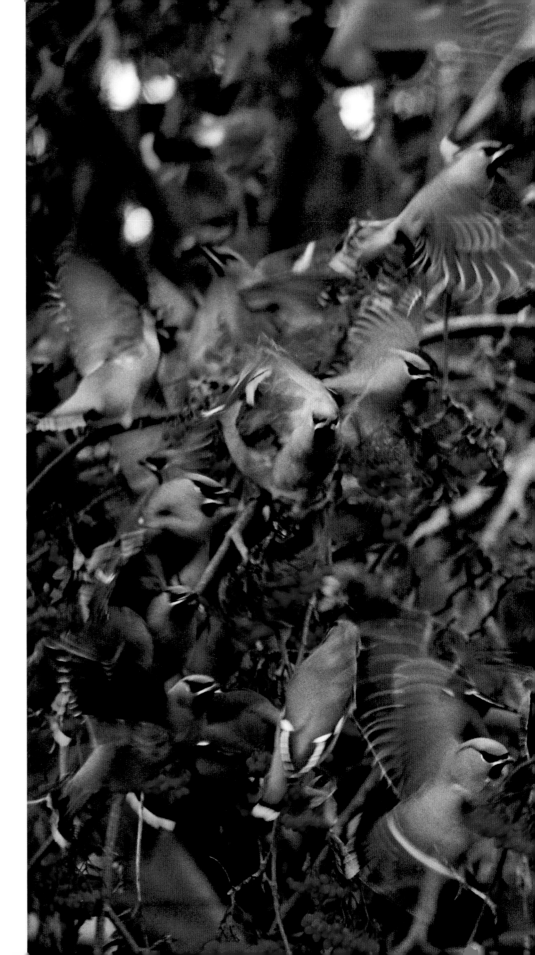

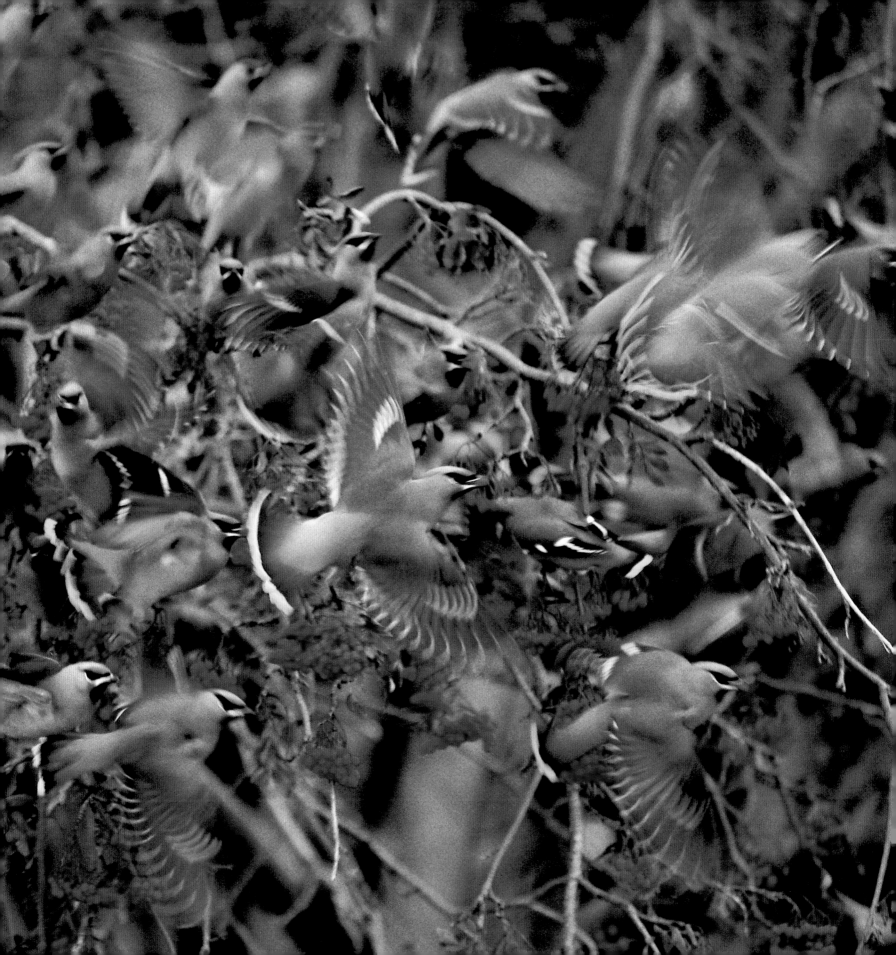

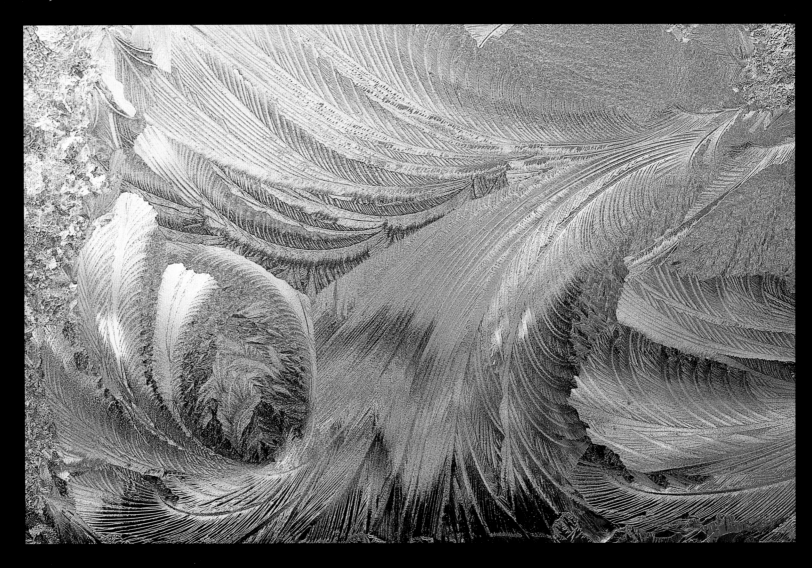

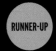

Helen A Jones
Canada

**ICE CRYSTALS
ON GLASS**

Nikon 801s with Nikkor
105mm Macro lens; f8;
Fujichrome Velvia

On one very cold February
night – it was about 20
degrees below – this
intricate design of ice
formed on a window pane in
my house. The feathery
image appeared as the
rising sun began to glow
through the ice. I had to take
the picture immediately,
because I didn't have long
before the ice melted.

Mark Sunderland
UK
HIGHLY COMMENDED

SANDSTONE CANYON

Deardorff with Schneider
Symmar-S 150mm lens; 20 sec at
f45; Fujichrome Velvia; tripod

Lower Antelope Canyon is
a deep fissure carved
through the sandstone by
violent flash-floods. On this
sunny afternoon in late
August, the swirling walls
were illuminated by
reflected sunlight. At the
bottom of the canyon, away
from the searing heat of the
Arizona summer, it was
quiet and cool. It seems
strange that such a harsh
environment can yield an
image that looks almost soft
to the touch.

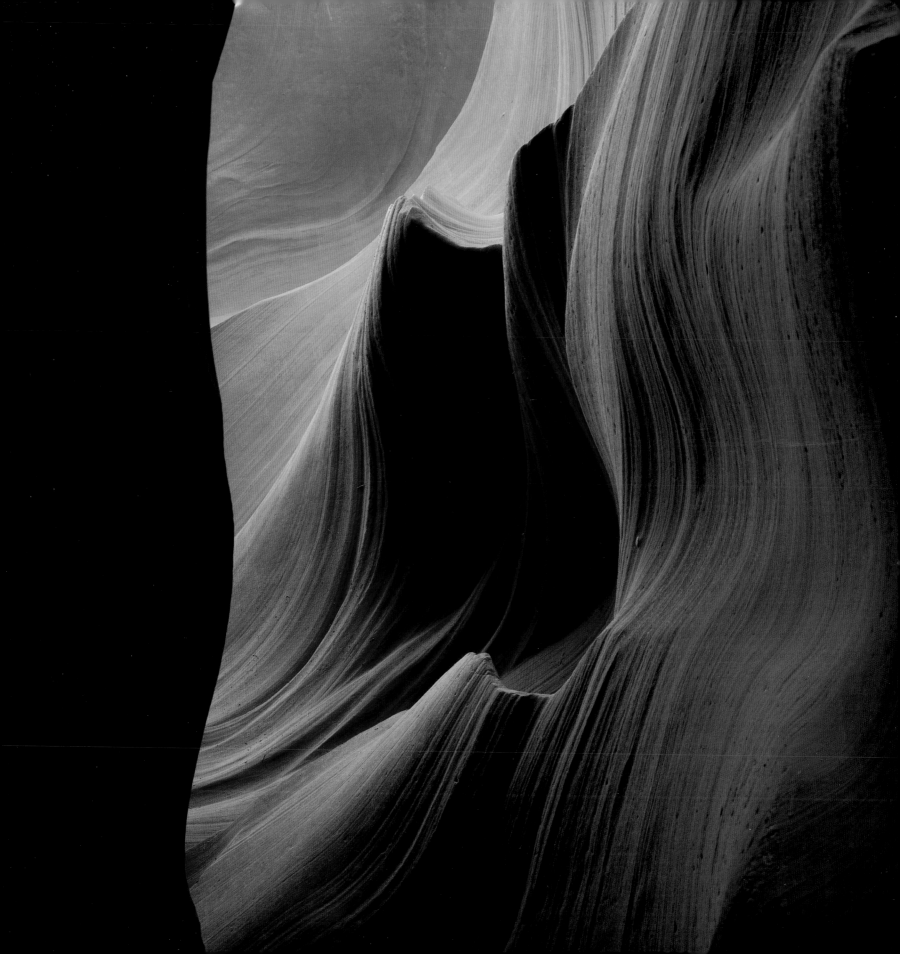

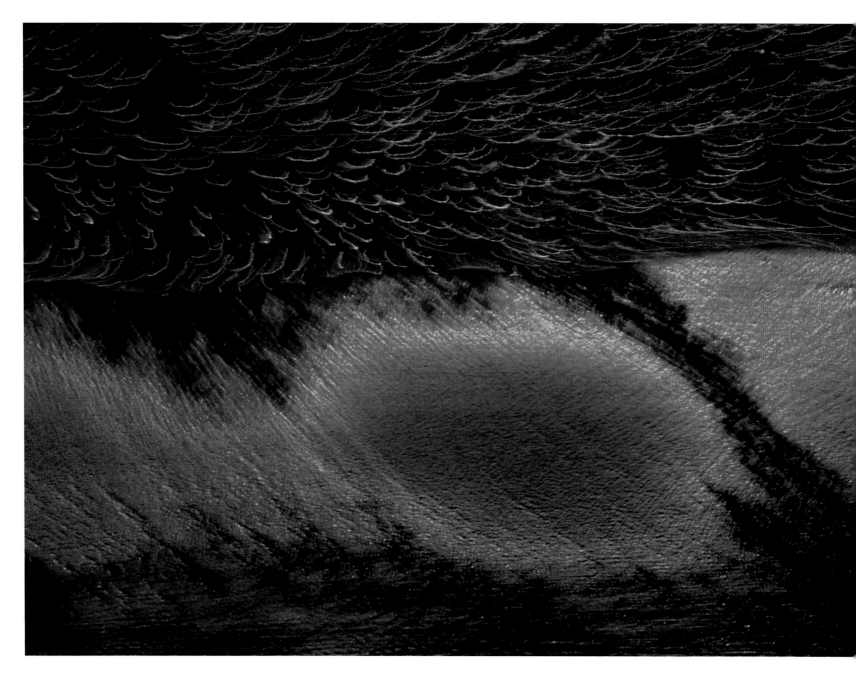

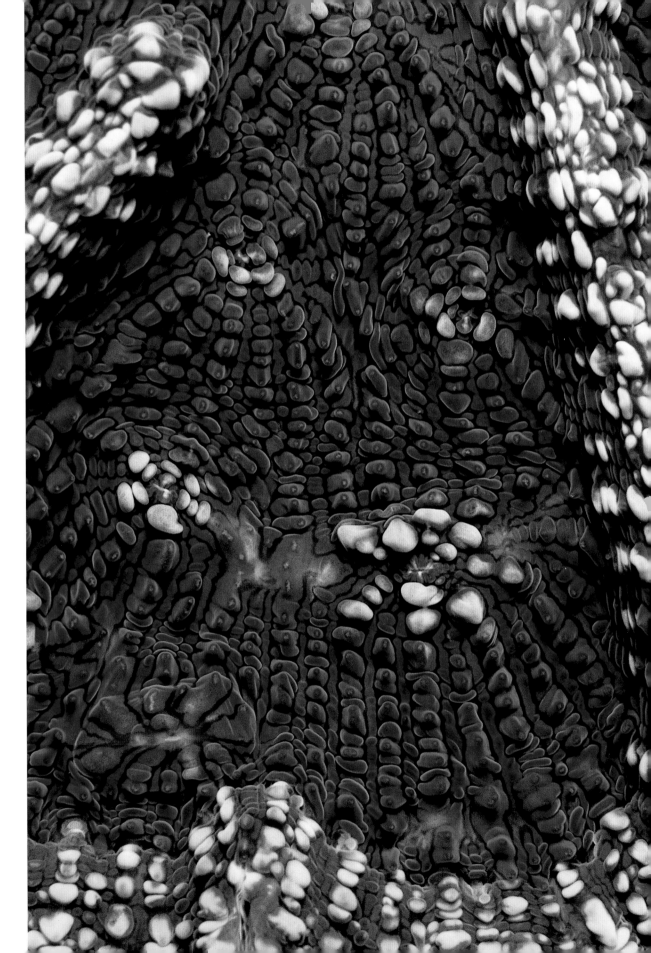

Ivor Fulcher
UK
HIGHLY COMMENDED

CACTUS CORAL

Nikon 8008 with 105mm macro lens; 1/60 sec at f22; Fujichrome Velvia; strobe

Colours that appear luminous under water tend to come out dull when photographed with a strobe light. So I was surprised that the luminous green of this one – taken at a dive spot called Castle Canyon, on Roatan, one of the Honduras' Bay Islands – came out so well. This stony coral, known as a cactus coral, grows in plates up to 30 centimetres across, often beneath overhangs in the reef. I didn't notice the ridges and grooves of this five-centimetre section until the photograph was developed.

Helmut Moik
Austria
HIGHLY COMMENDED

SURF PATTERN ON THE SHORE

Nikon F4S with 300mm lens and TC 2.0E; 1/125 sec at f5.6 Fujichrome Velvia; tripod

The exceptional colours created by the setting sun have made Strand Hill beach in Connemara, in Galway, Ireland, world famous. I was one of more than 100 people there on this occasion. A light wind started and, as the sun dyed the water and sand blood red, the wind pushed waves towards the beach, where fish-scale patterns formed on the surf. The picture was taken when only a sliver of sun remained on the horizon.

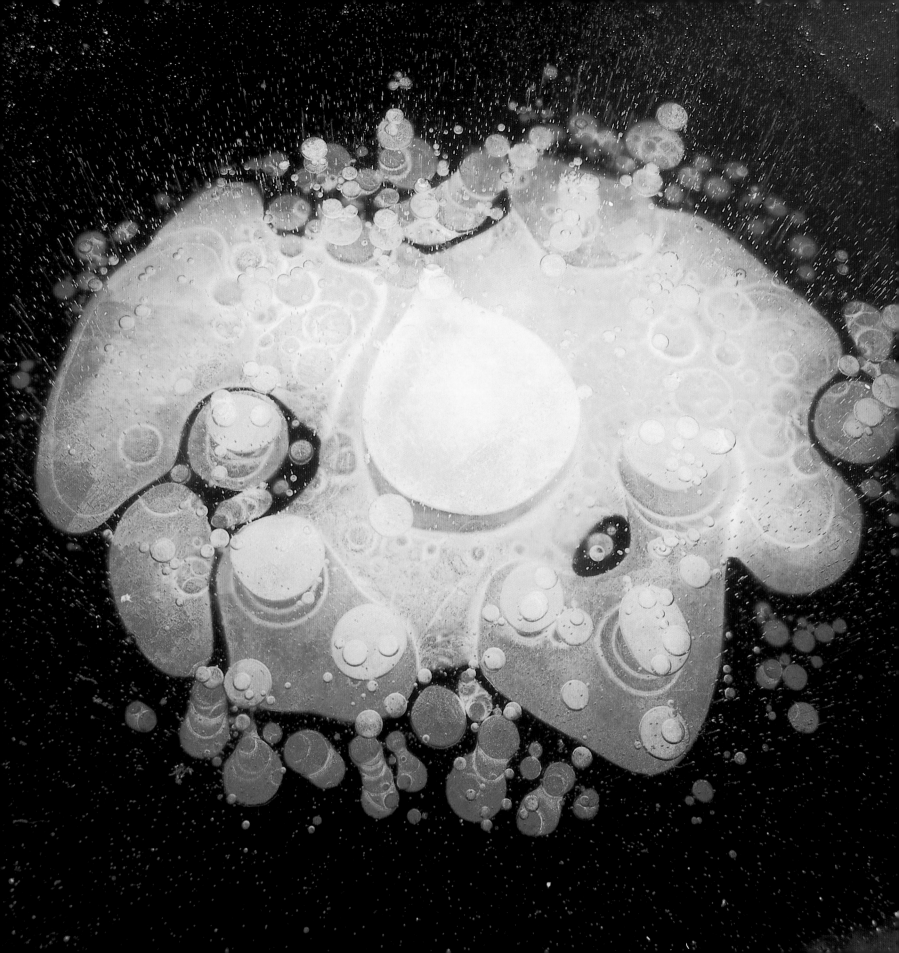

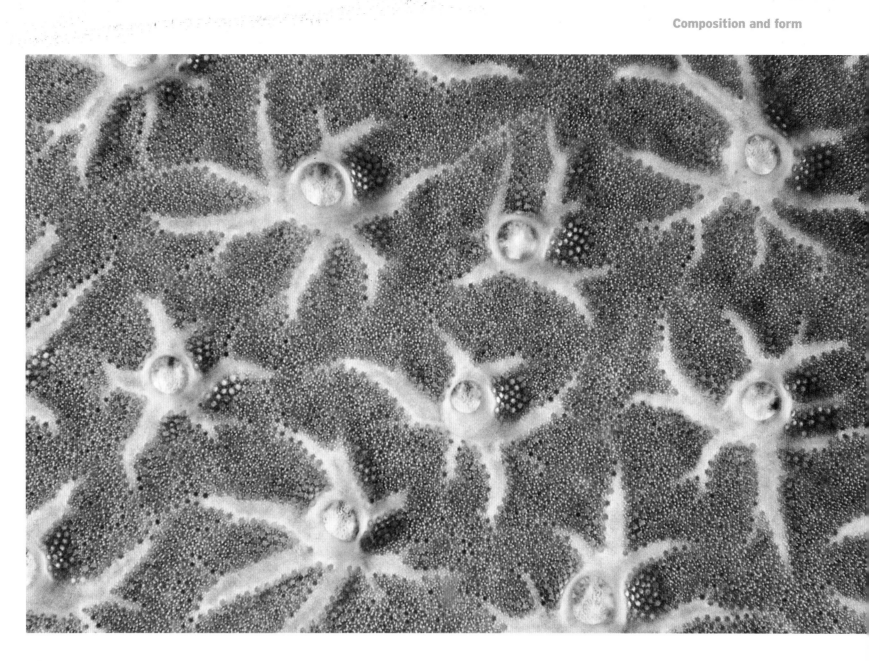

Pål Hermansen
Norway

ICE DETAIL

Hasselblad 203 FE with 150mm
lens; 5 minutes at f22;
Fujichrome Astia

Blue light is prominent
during Norway's short
winter days, and it gives ice
a really cold appearance. In
the days before the snow
comes, the lakes are frozen,
and you can see magnificent
small 'worlds' in the ice. I
found this one near my
home in Ski.

**Burt Jones and
Maurine Shimlock**
USA

ENCRUSTING SPONGE

Nikon N90 with 100mm macro
lens; 1/60 sec at f16 Fujichrome
Velvia; strobes

While we were exploring a
newly sunk wreck in
Indonesia, we noticed that,
even though the ship had
been under water for less
than a month, sponges and
ascidians had already begun
colonising its surface. We
were particularly struck by
the colour and pattern of
this animal. We've never
seen it since on any of the
other reefs that we've dived
in the South Pacific, artificial
or natural.

Jose Luis Gonzalez
Spain
HIGHLY COMMENDED

CORKWING WRASSE EYE

Nikon F4 with 105mm lens; 1/60
sec at f32; Fujichrome Velvia; flash

While diving in Vigo Bay in
Galicia, north-western
Spain, a corkwing wrasse
swam past. I was charmed
by his strident colours and
intricate patterns. Through
my viewfinder, I was
reminded of a painting and
was especially attracted to
his jewel-like eye set on a
coat of vivid colours.

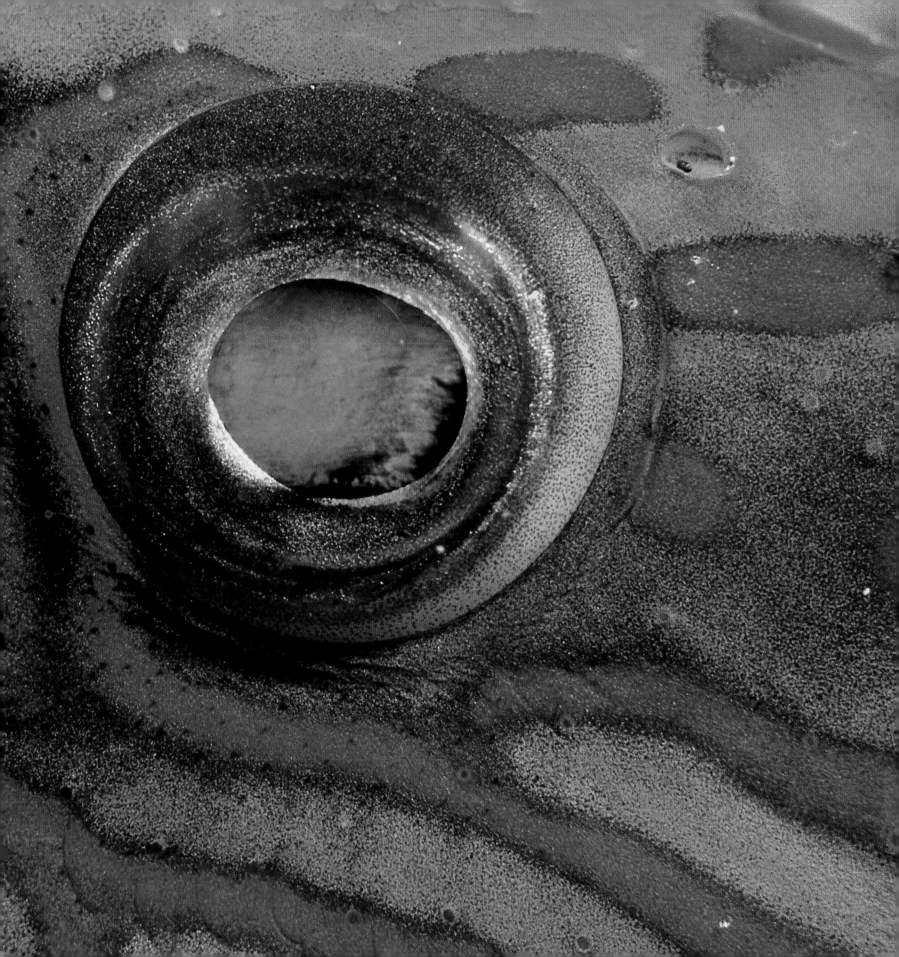

The world in our hands

Images that illustrate, symbolically or graphically, human dependence on the natural world or the human capability for damaging it.

RUNNER-UP

Tom Campbell
USA

GREAT WHITE DRIFT-NET VICTIM

Nikon F3 with 24mm lens; 1/125 at f8; Kodachrome 64

Drift-nets are 'walls of death' up to a kilometre and a half long and suspended in the water to a depth of 25 to 30 metres. In oceans worldwide, they indiscriminately kill thousands of animals every day. Recent restrictions on the use of drift-nets in California's Santa Barbara channel have helped cut the number of victims there, but many, such as this female great white shark, still perish.

WINNER

Mike Powles
UK

GIANT PANDA

Nikon F5 with Nikkor 80-200mm lens; 1/250 sec at f5.6; Fujichrome Sensia 100; tripod

When anyone approached, this giant panda at the Wolong Nature Reserve in China would grasp the bars and peer through the door, apparently looking for companionship. The panda is part of a captive-breeding scheme whose aim is to reintroduce the animals into some of their former strongholds. At the moment, there are only about 1,200 giant pandas left in the wild.

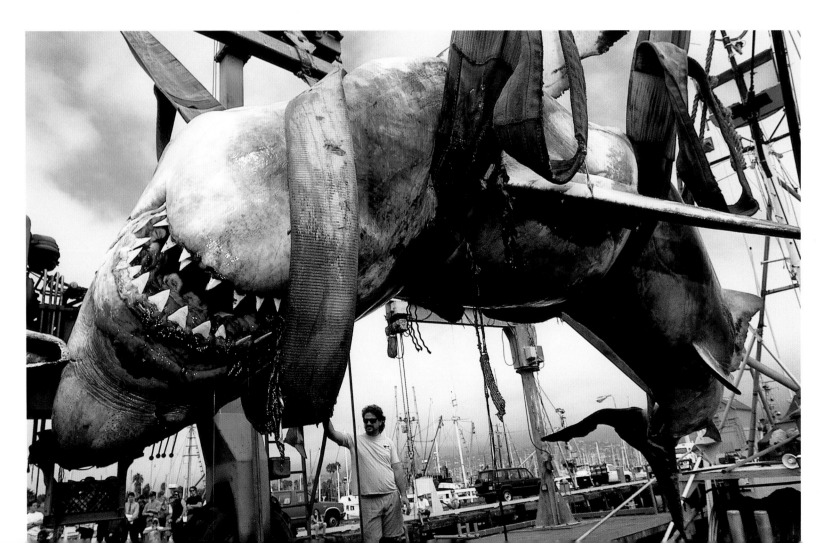

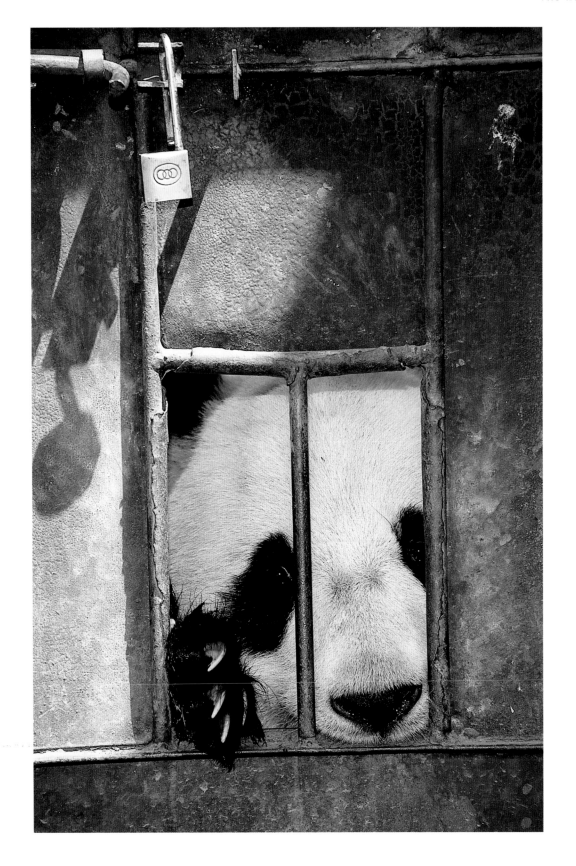

David Woodfall
UK

RAINFOREST BURNT FOR CATTLE-GRAZING

Fuji 617 with 90mm lens; 1/2 sec at f22; Fujichrome 50

The Imataca Forest in Venezuela is said to be managed in an ecologically sustainable way, but in fact, all large trees – mahogany in particular – have been logged. The remaining secondary forest is then burnt and used for large-scale cattle-ranching. In the past 30 years, an area 30 kilometres wide has suffered this fate. Occasionally, large tropical rainforest trees remain on grass swards grazed by cattle. All of this has been sanctioned by the Venezuelan government.

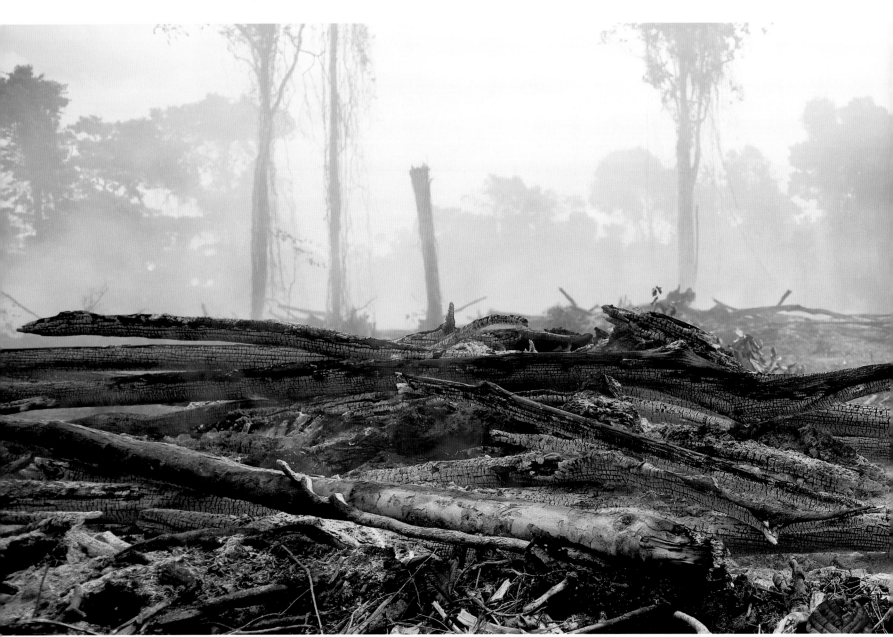

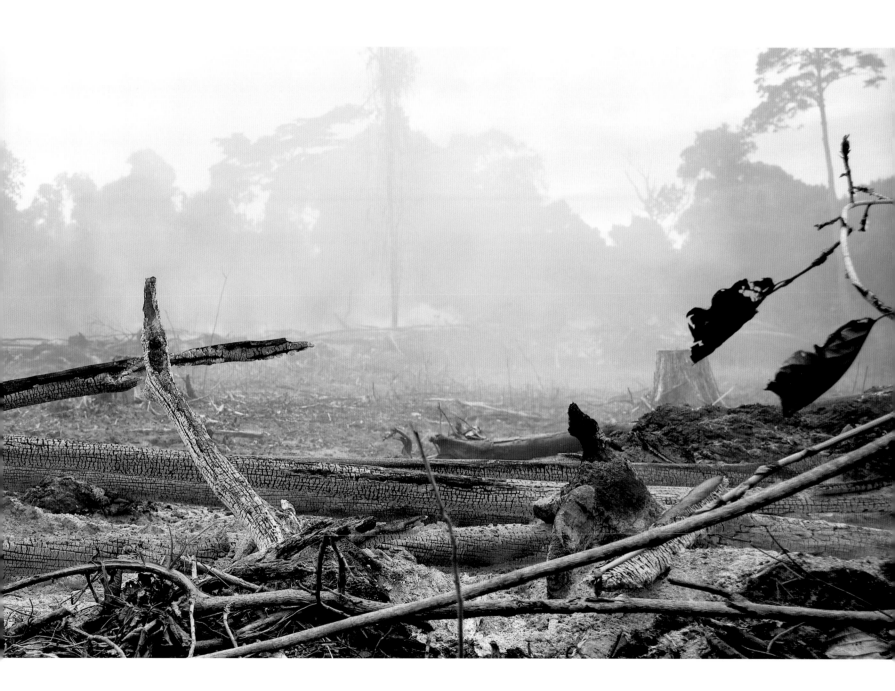

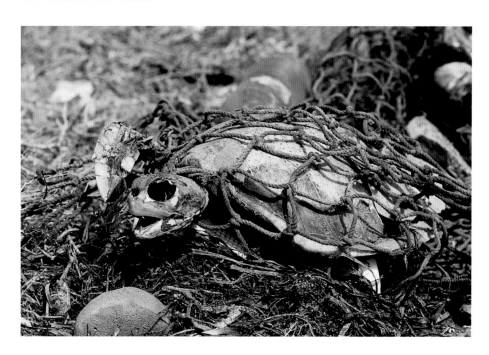

Daniel Schär
Switzerland
HIGHLY COMMENDED

DECAYED TURTLE IN A FISHING NET

Leica R7 with 100mm macro lens; Kodachrome 64

While walking along the beach in Banc d'Arguin National Park in Mauritania, we found various stranded animals, including this turtle, which had been suffocated in a drag-net before being washed up. The fishing industry along this coast is very important to the Mauritanian economy, and drag-netting is quickly superseding more traditional fishing methods.

Helmut Pum
Austria
HIGHLY COMMENDED

FAWN SAVED BY A FARMER

Canon EOS 3 with 70-200mm lens; 1/125 sec at f8; Fujichrome Velvia

I know a local farmer who has built a 'game protector', which he uses when he mows his meadows. This simple, highly effective device saves many animals that lie low in fields, such as birds, hares and, as in this case, a roe deer. A projecting bar nudges the crop surrounding the animal and scares it away from a grisly death.

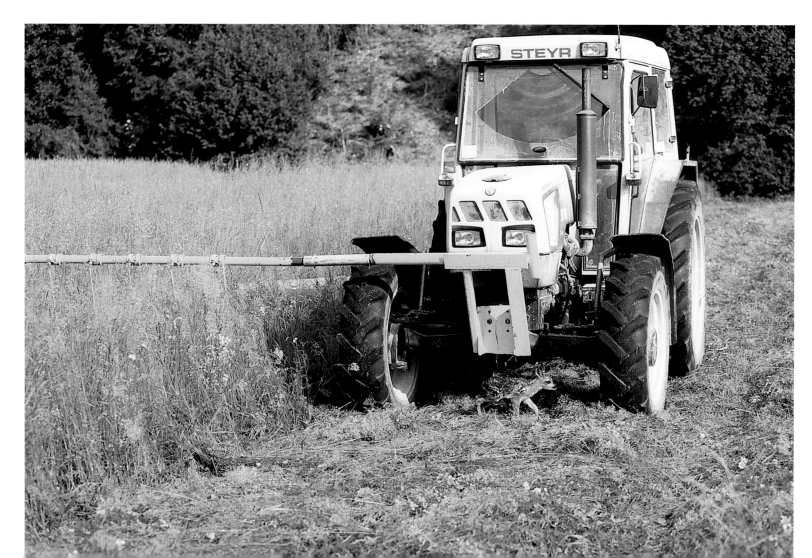

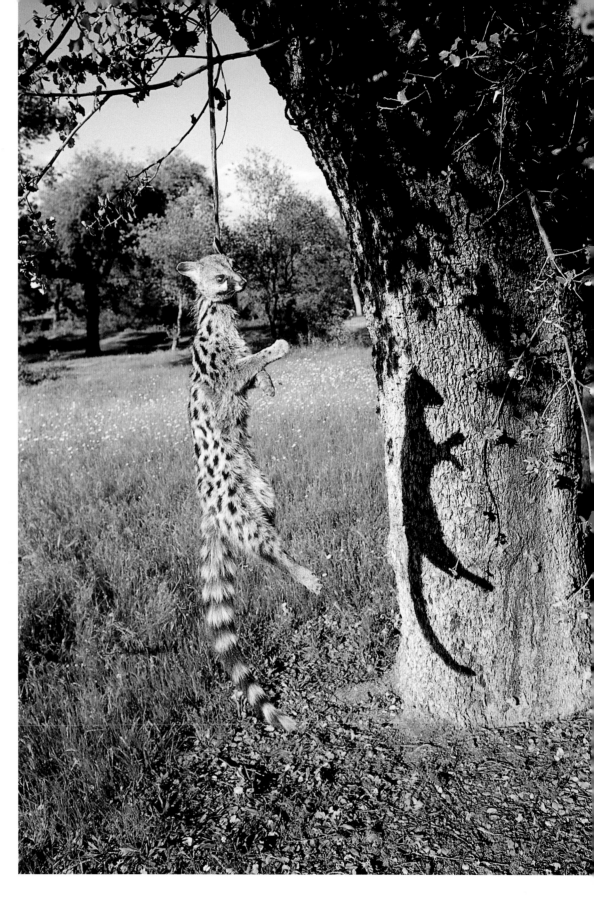

Jorge Sierra
Spain
HIGHLY COMMENDED

GENET POISON OR SNARE VICTIM

Nikon F90X with Nikkor 28mm lens; 1/125 sec at f8; Ektachrome E100

The illegal use of poison, particularly to kill foxes, seems to be on the rise again in Spain. Poison was a big problem 15 to 20 years ago, and it killed a lot of wildlife. Things had improved over the past 10 years, but now it seems that poison bait is making a comeback. I was driving through a private hunting reserve in the south-western province of Toledo, near Extremadura, when I saw this genet, a protected species. It could have been killed by poison or by a snare.

Animal portraits

Wildlife up close - intimate
images from nature

WINNER

Ingo Arndt
Germany

**HANUMAN LANGUR
FAMILY RESTING**

Minolta with 500mm lens;
1/250 sec at f5.6; Fujichrome
Sensia 100; tripod

This family was part of a
group of 13 langurs that I
followed for a total of eight
weeks at the edge of the
Great Indian, or Thar, Desert,
in north-western India. After
a while, the langurs
accepted my presence.
When I came across this
family sitting in a pool of
first light, the langurs
glanced up briefly, and as
soon as they recognised me,
they continued to behave
as normal.

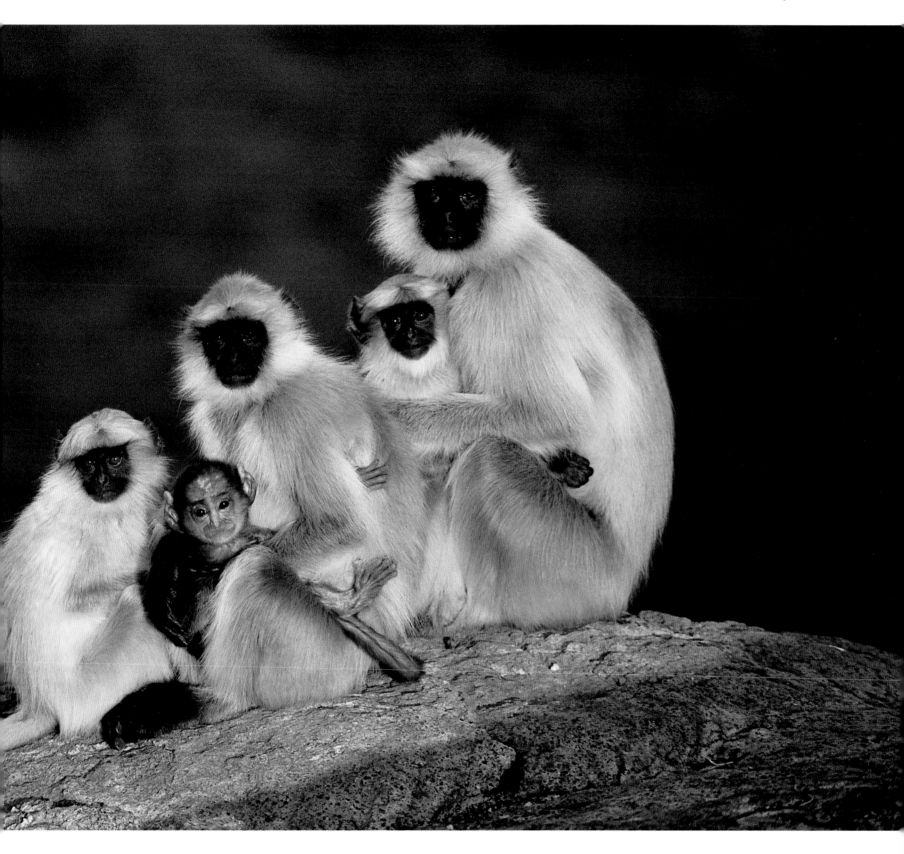

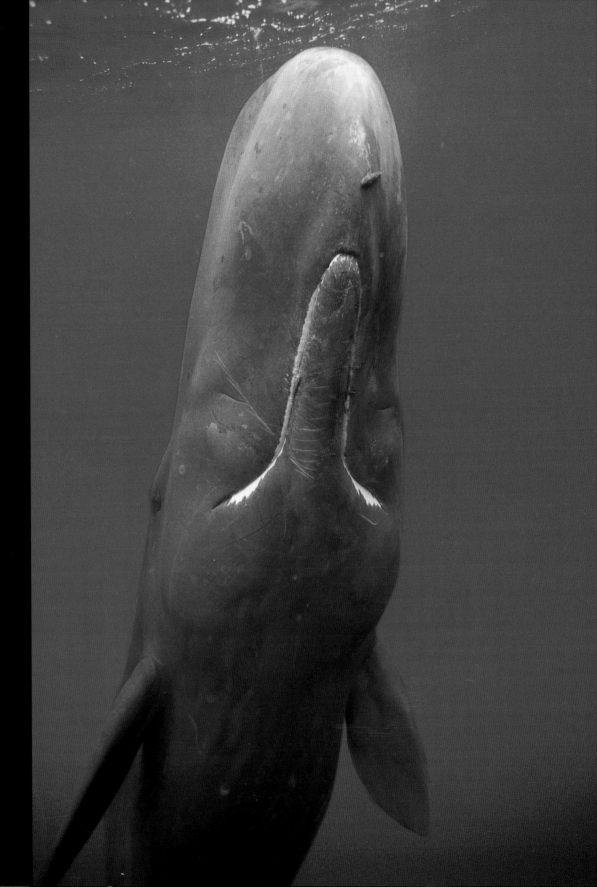

Thomas Haider
Austria

SPERM WHALE INVESTIGATING THE PHOTOGRAPHER

Nikon F90X with 18mm lens; 1/250 sec at f5.6; Kodak Ektachrome E200

A sperm whale's head can be up to six metres long – a third of its total body length. Its eyes are near the widest part of the head, and so the whale's binocular vision is restricted. The only way it can improve depth perception is to look downwards, past the narrow mouth along a tight angle, as this juvenile female in the northern Gulf of Mexico is doing.

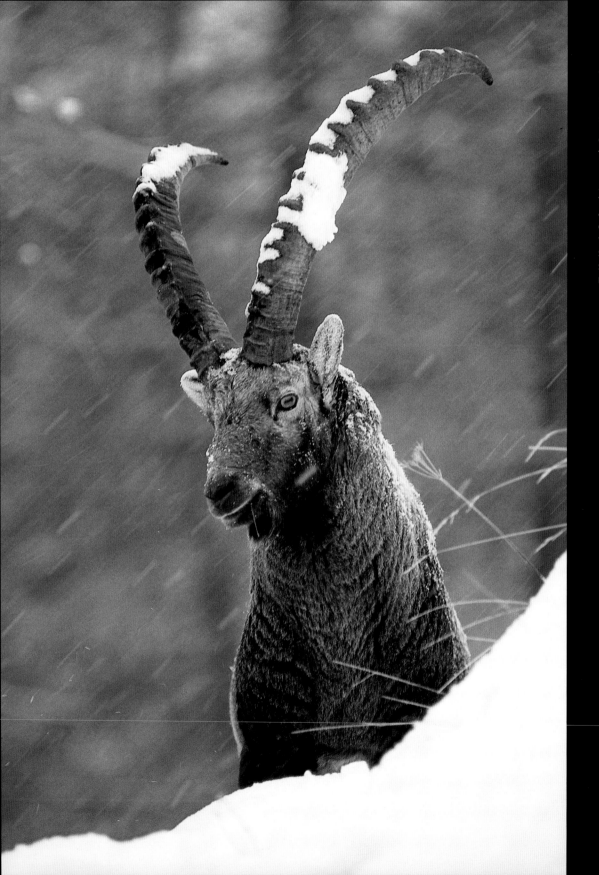

Giuliano Crameri
Switzerland
HIGHLY COMMENDED

IBEX IN A SNOWFALL

Canon EOS 1N with 300mm lens;
1/60 sec at f4; Fujichrome Velvia

Ibex live high up in the Swiss
Alps all year round. I wanted
to photograph ibex in winter
and so had to wait for the right
conditions. Then, one day,
when there was a freezing
snowstorm, I climbed up the
slopes and discovered this
majestic male.

Kennan Ward
USA

POLAR BEARS COOLING OFF AFTER PLAY

Nikon F4 with 20-35mm lens; monopod

These Canadian polar bears in Churchill, Manitoba, have just spent several hours play-fighting. Polar bears are insulated from the cold by their black hide and thick layer of blubber. Vigorous activity can make them overheat, and the bears needed a break from their games to cool down. Spacing themselves out evenly across the ice-floe means that, if one of them starts to move around again, the others have enough time to respond.

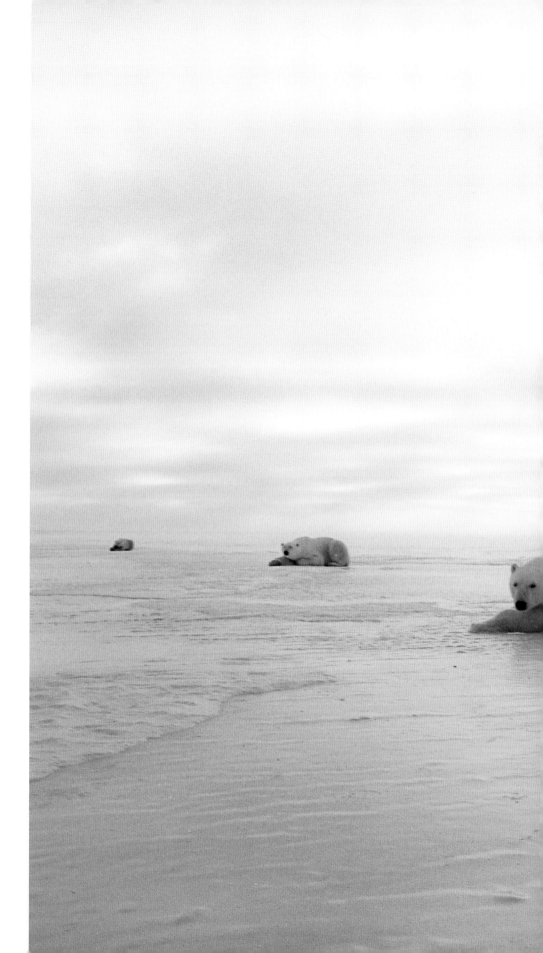

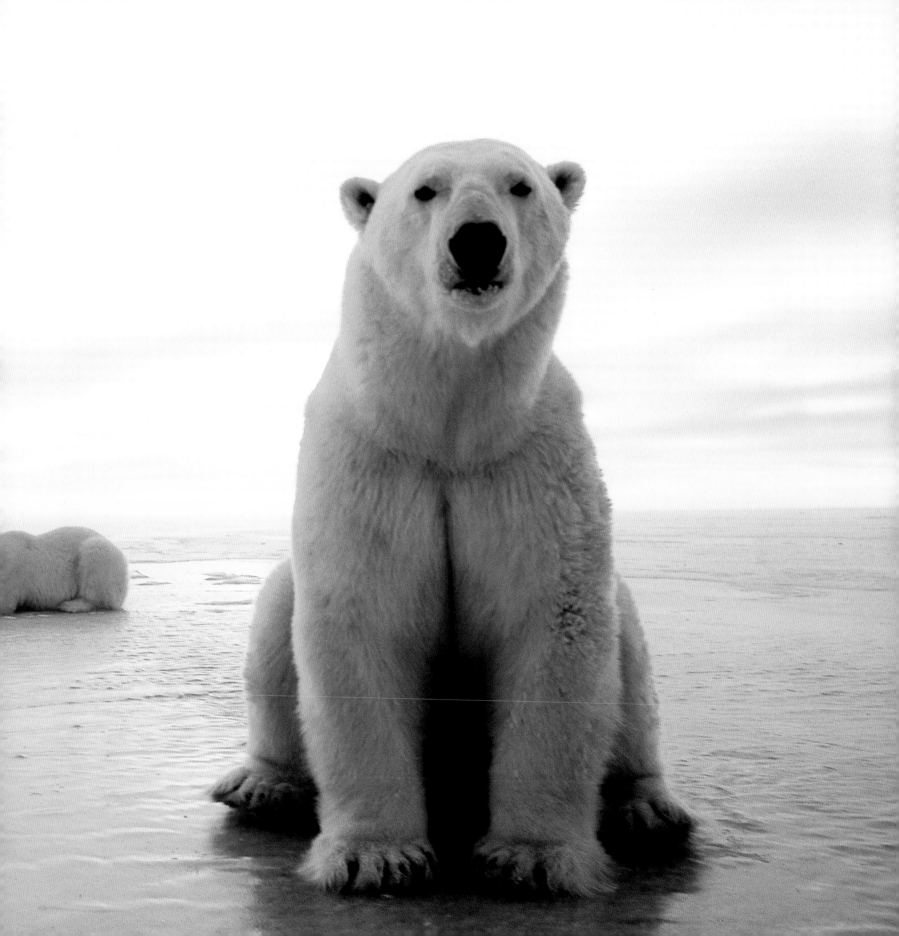

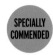

SPECIALLY COMMENDED

Raoul Slater
Australia

RED-NECKED WALLABY JOEY WATCHING THE PHOTOGRAPHER

Canon F1 with 500mm lens and 50mm extension tube; 1/60 sec at f4.5; Ektachrome Elite 100; wildpod

When a wallaby joey first pokes its bald head out of the pouch, it is very nervous and trembles at the slightest noise. Within a few weeks, though, its confidence has grown, and it becomes tremendously curious. This joey, brought by its mother to my friends' back yard near Tathra National Park in southern New South Wales, was due to leave the pouch in a week or so.

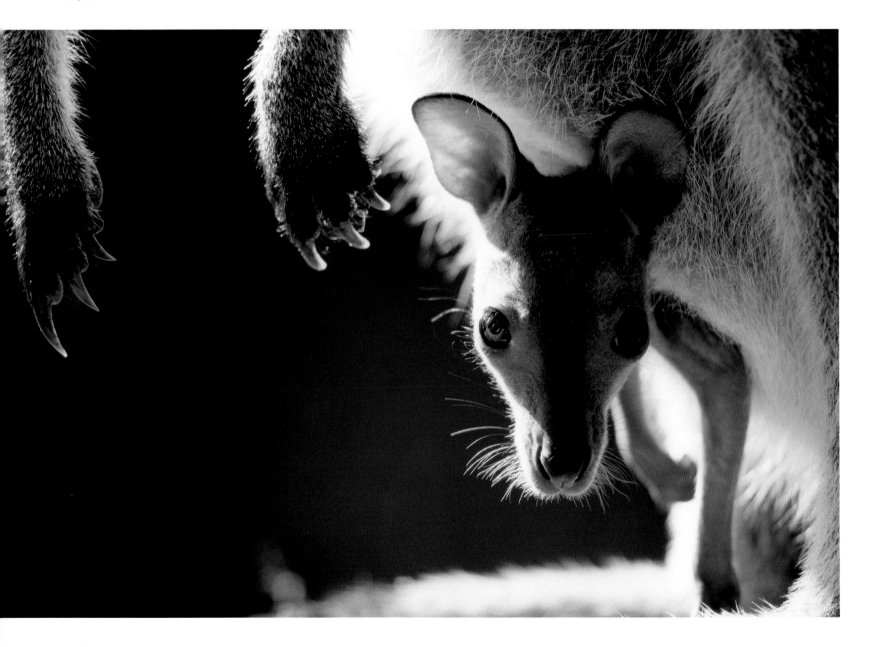

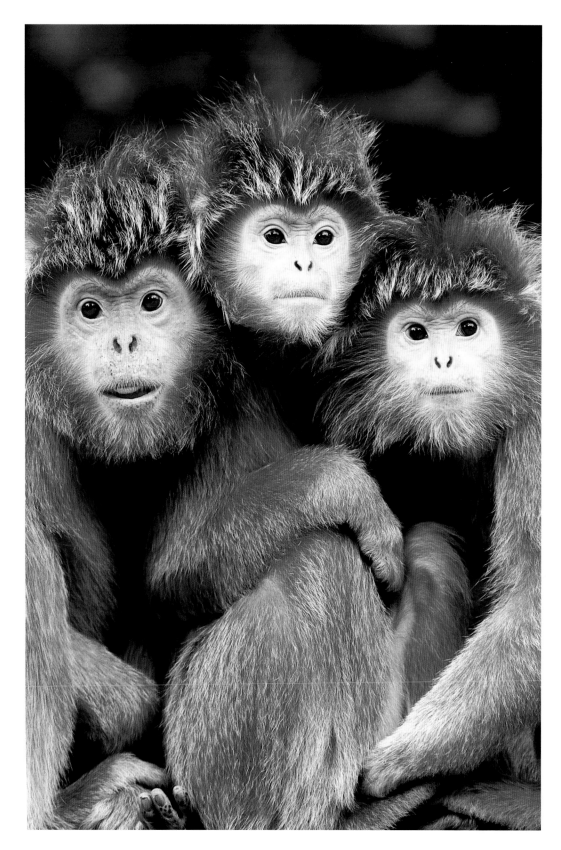

Christian Hütter
Germany
HIGHLY COMMENDED

SILVER LEAF MONKEYS HUDDLING

Nikon F5 with 600mm lens and 1.4x teleconverter; 1/30 sec at f5.6; Fujichrome Sensia 100; tripod

Silver leaf monkeys belong to the leaf monkey family, all of which have large, multi-chambered stomachs specialised for breaking down the cellulose content of leaves. This species occurs from China to Indonesia, in mangroves and coastal forests. Like many other South-east Asian monkeys, silver leaf monkeys are endangered mainly because of habitat loss. These three were photographed one cold morning in Apenheul Primate Park in Apeldoorn in the Netherlands.

Stefan Preis
Germany
HIGHLY COMMENDED

COMMON SHORE CRAB EMERGING FROM THE SAND

Nikon F4 with 105mm macro lens; 1/30 sec at f11; Fujichrome Velvia; table tripod

It took this crab on a beach on Germany's North Sea island of Amrum at least 10 minutes to come out of the sand. Then, after I took the photograph, it spent another few minutes inching towards the water's edge. The crab's stealth came to nothing, though – as I walked away, I looked back and saw a gull swoop down and grab it.

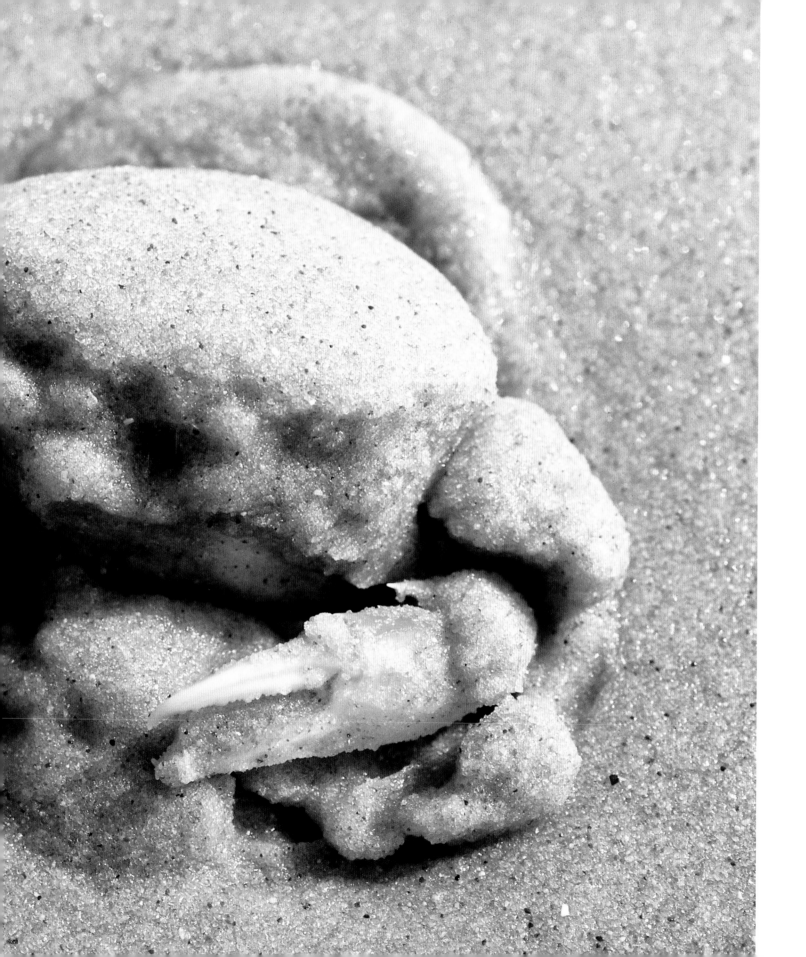

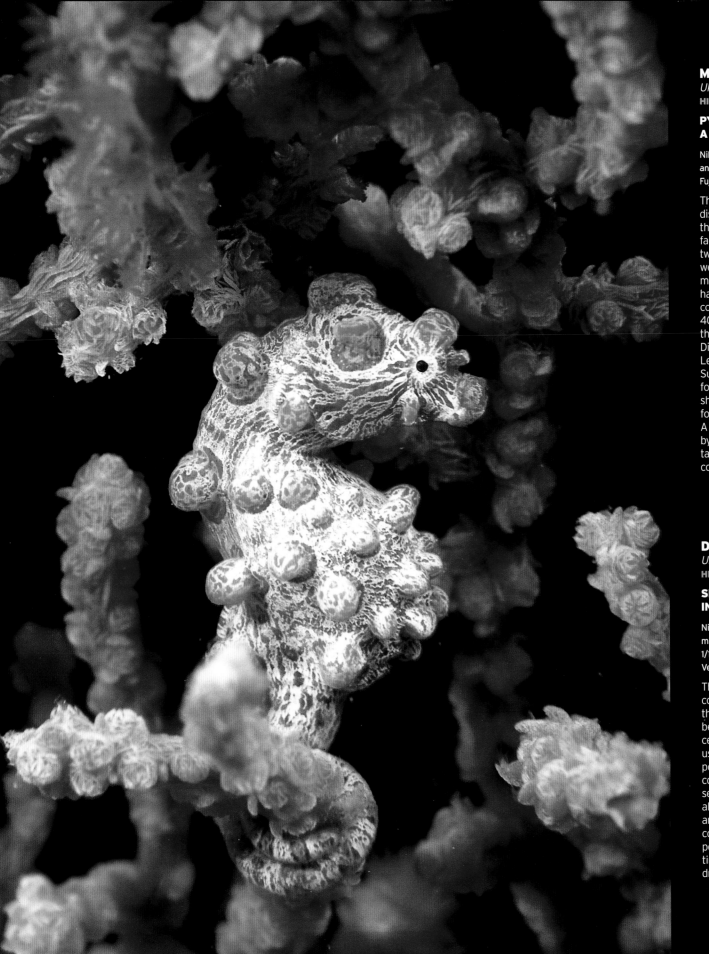

Malcolm Hey
UK
HIGHLY COMMENDED

PYGMY SEAHORSE ON A SEA-FAN

Nikon F90X with 105 macro lens and +4 diopter; 1/60 sec at f22; Fujichrome Velvia; 2 flash guns

The pygmy seahorse was discovered as recently as the 1970s. It's not just the fact that they are less than two centimetres long and well camouflaged that makes pygmy seahorses so hard to see. The sea-fan corals they live on grow 16 to 40 metres down, where there's very little light. Diving in Indonesia's Lembeh Straits off North Sulawesi, I would search first for Muricella coral and then shine a lamp over it, looking for signs of movement. A seahorse moves around by quickly unwrapping its tail and grabbing the next coral branch.

David Hall
USA
HIGHLY COMMENDED

SPINYHEAD BLENNY IN STAR CORAL

Nikonos RS with 50mm macro lens and 2x teleconverter; 1/125 sec at f22; Fujichrome Velvia; 2 strobes

The spinyhead blenny is a common Caribbean fish, though it's often overlooked because it's only two centimetres long and is usually found in abandoned polychaete wormholes in coral. This one off St Vincent seemed quite curious, allowing me to get up close and frame it with the star coral polyps. Like the polyps, the blenny feeds on tiny planktonic animals that drift past.

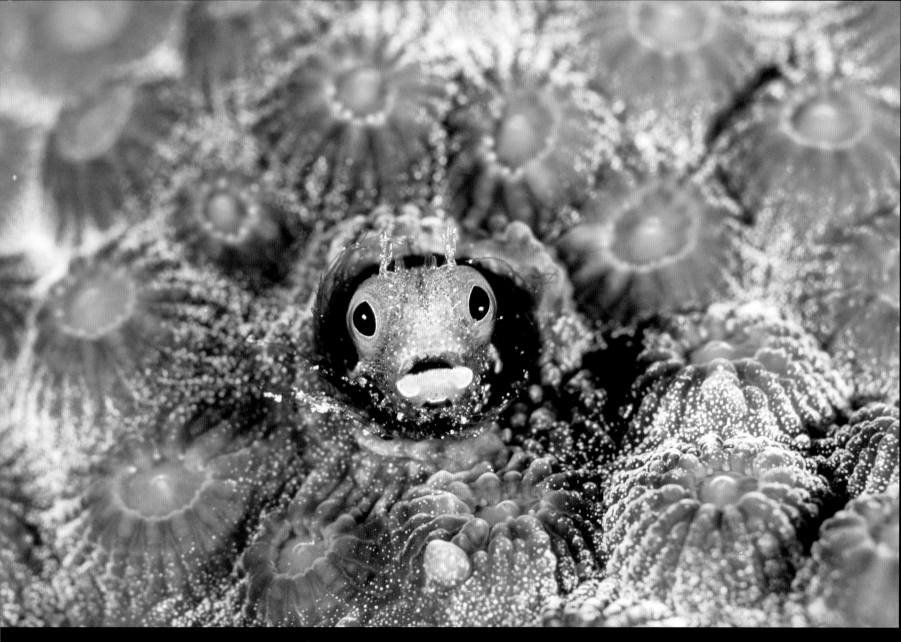

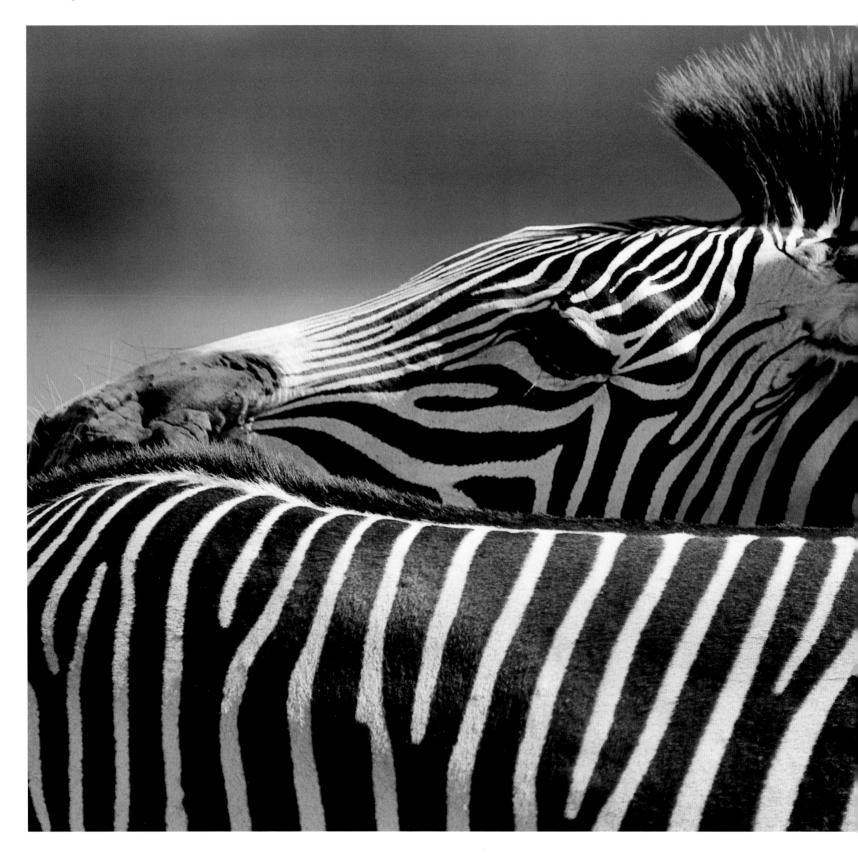

Karl Ammann
Switzerland
HIGHLY COMMENDED

GREVY'S ZEBRA SCRATCHING

The Grevy's zebra is the largest of all living wild horses, with a maximum shoulder height of 1.6 metres. It got its name after being presented to Jules Grevy, the President of France from 1879 to 1887, by Emperor Menelik of Ethiopia. It's now classified as endangered and is only found in a few areas in Ethiopia and Kenya. I photographed this stallion in Kenya's Samburu National Reserve.

Nick Garbutt
UK
HIGHLY COMMENDED

RING-TAIL LEMUR AND INFANT

Nikon F5 with 300mm lens; f4; Fujichrome Velvia 50 rated at 80; beanbag

For the first two weeks or so after birth – towards the end of August and early September – baby ring-tail lemurs cling to their mother's underside. Then they move up to ride on her back. I was in Berenty Reserve, southern Madagascar, at the end of September, by which time all the babies were riding like miniature jockeys. They can hold on not only when the mother is walking, but also when she's running along the ground or bounding through the forest canopy.

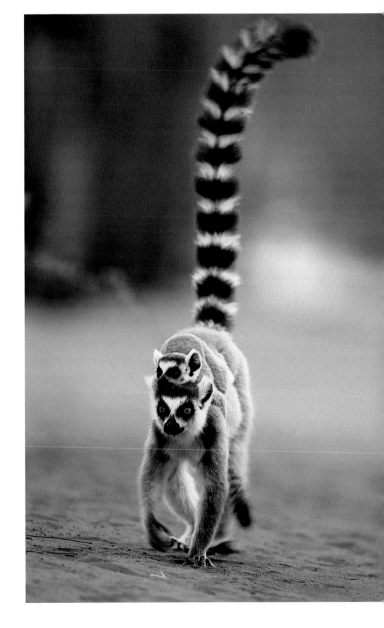

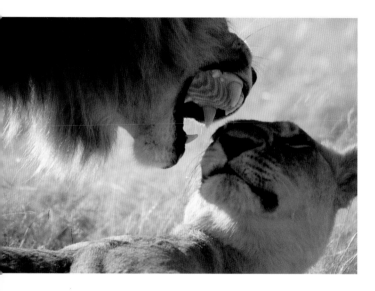

Peter Muehlbacher
Germany
HIGHLY COMMENDED

LIONS MATING

Canon EOS 1000 FN with 75-300mm lens; 1/250-1/500 at f5.6; Kodak Elite Chrome 200

The lions were in the Savuti area of Botswana's Chobe National Park. They mated almost every 20 minutes for the three hours we watched them. The male would initiate mating by grooming and then mounting the female. Sometimes she would take the lead, rubbing against him or crouching in front. At the end of each mating, the male would bite the lioness's neck and they would both fall into the grass for a rest. Later, the lions discovered our campsite and carried on mating behind the tent all night long.

Izabela Adamczyk-Martin
UK
HIGHLY COMMENDED

LION AT DUSK

Nikon F90X with 300mm lens; 1/250 sec at f5.6; Kodachrome 64; beanbag

The lion must be one of the most photographed of animals, but this young male epitomised for me the wild, aloof serenity of the species. He had recently awakened, and in the early sun of Kenya's Maasai Mara, I tried hard to establish eye contact with him. He would have none of it, though, and gazed imperiously beyond me, his mane ruffled by the wind.

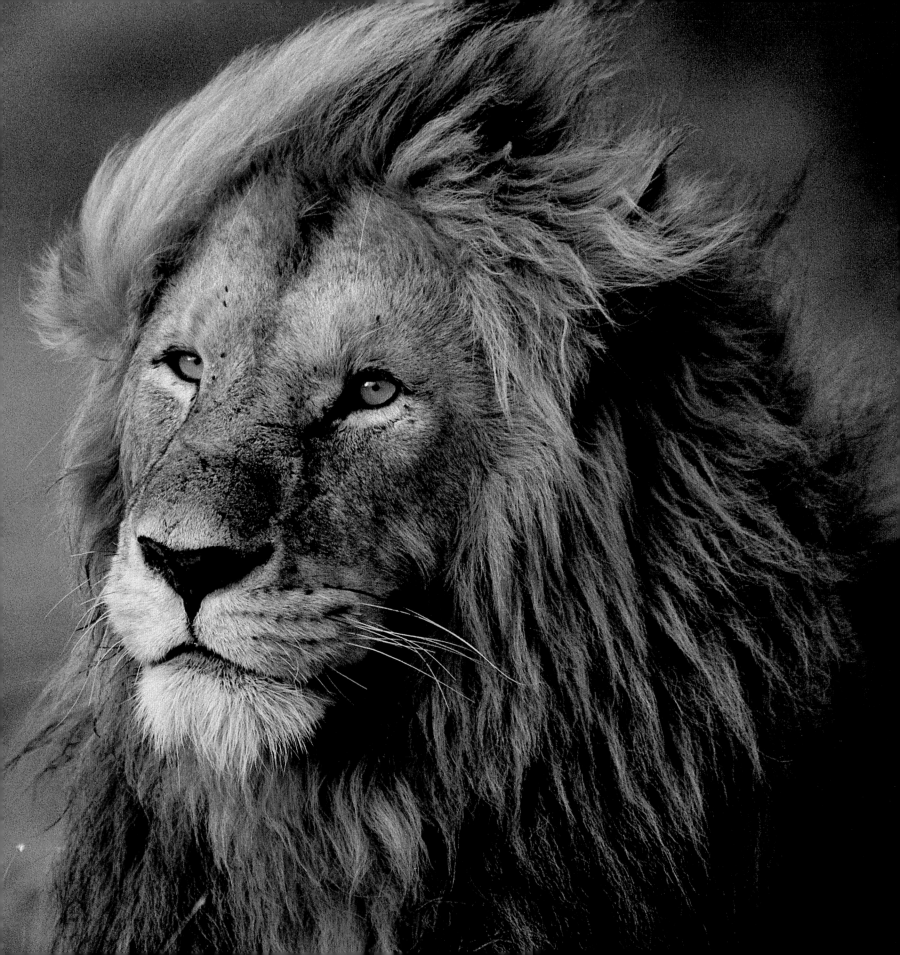

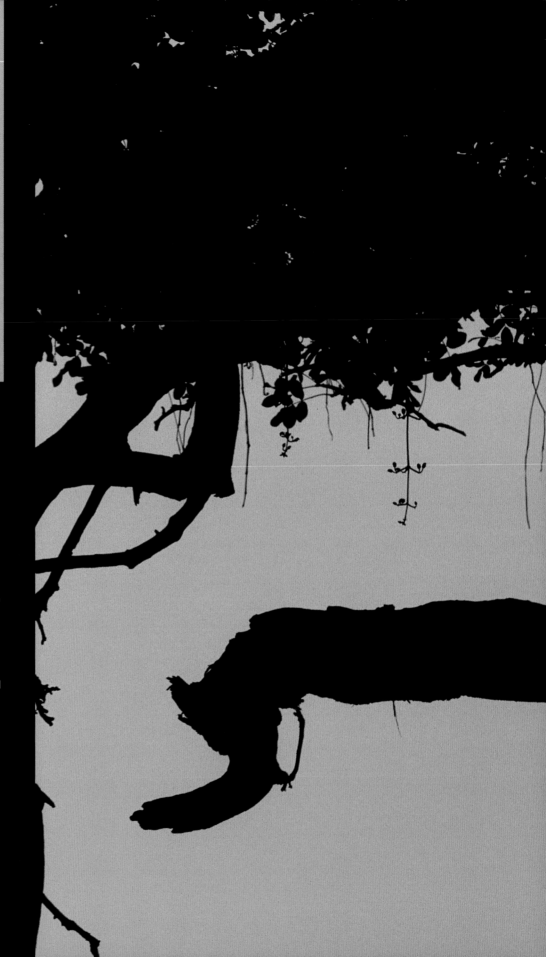

From dusk to dawn

Wildlife captured on film in the hours between sunset and sunrise (the sun may be on but not above the horizon).

WINNER

Mike Mockler
UK

LEOPARD AT DAWN

Nikon F5 with Nikkor 75-300mm lens; Fujichrome Sensia 100; beanbag

One evening, when I was leading a safari group in northern Tanzania, we found a leopard with a small cub. Sensing that her den might be near, I took the group back there at first light the following morning. To my delight, the leopards were there again, in a tree. The female seemed to have watched dawn from the branch.

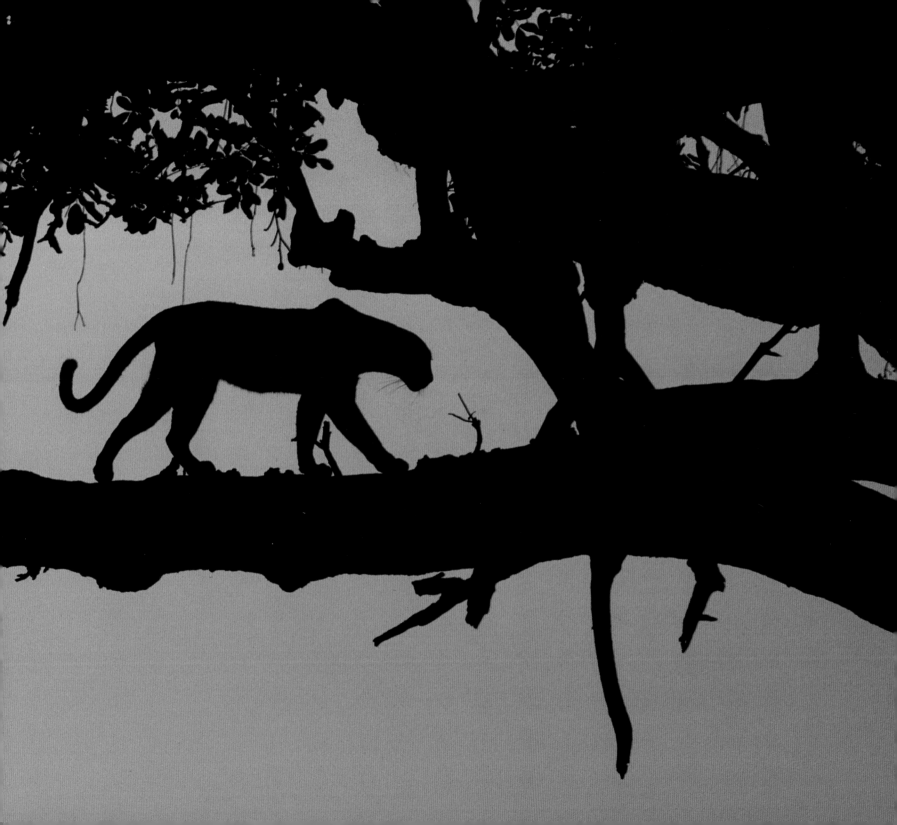

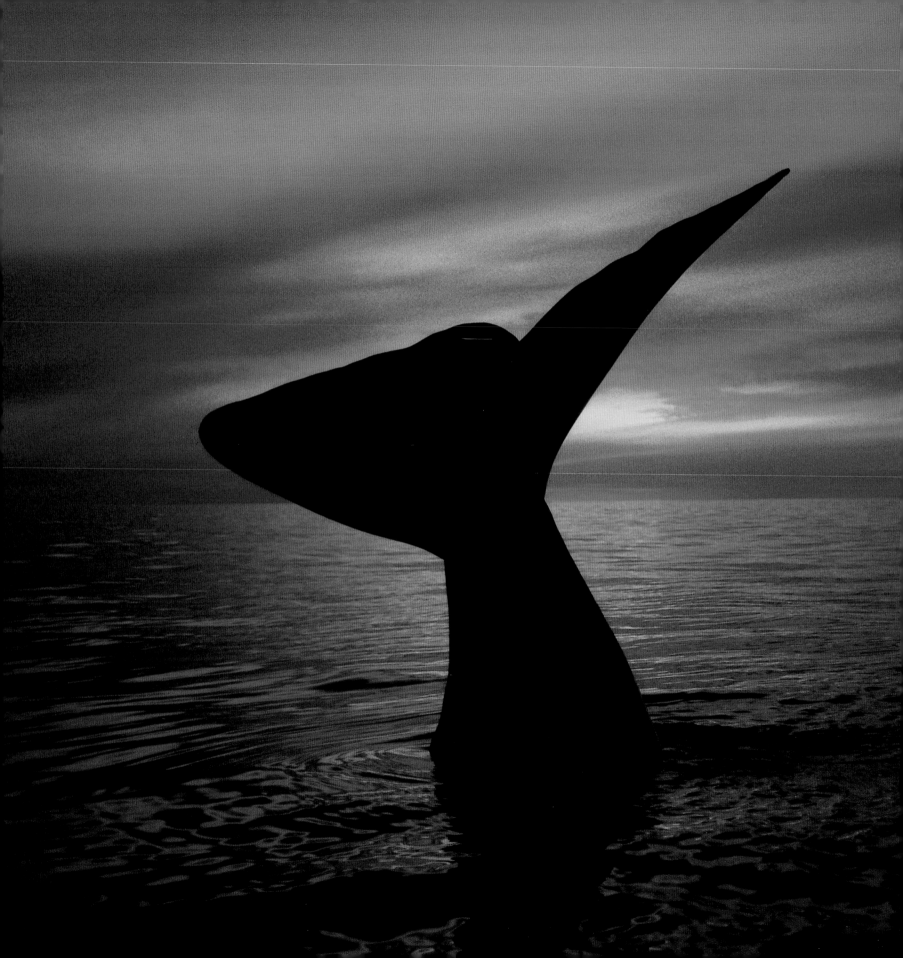

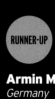
RUNNER-UP

Armin Maywald
Germany

SOUTHERN RIGHT WHALE FLUKE

Nikon F4 with 35-70mm lens;
1/30-1/60 sec at f2.8; Fujichrome
Sensia II 100 rated at 200

I was so inspired after a whale-watching trip to the Valdes Peninsula in Argentina that I immediately planned my return visit. I couldn't get over seeing the southern right whales doing 'head-stands', when they wave their flukes high out of the water for up to two minutes. Are they playing, communicating under water, or controlling their temperature? No one knows exactly. I imagined taking a dramatic photograph of a fluke against a vivid sky, but when I returned a year later, it took five weeks before a whale granted my wish by head-standing against a spectacular sunset.

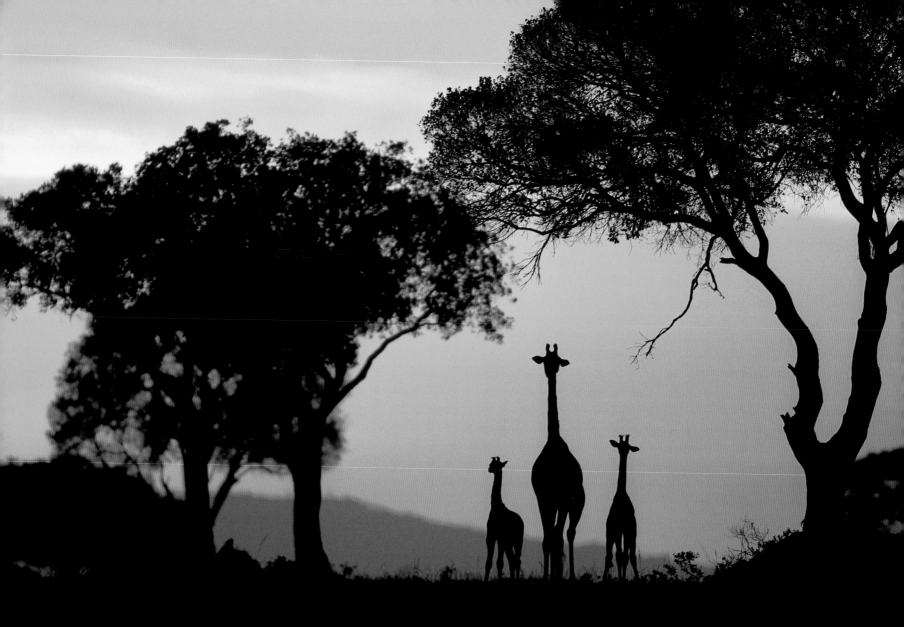

Gabriela Staebler
Germany
HIGHLY COMMENDED

**GIRAFFE FAMILY
AT SUNRISE**

Canon EOS 3 with 600mm lens;
1/250 sec at f4; Fujichrome 100;
tripod and beanbag

Twins are rare among
giraffes, and so I don't know
if these two youngsters in
the Maasai Mara in Kenya
were related. Sometimes, a
giraffe will babysit a
youngster while its mother
drinks or feeds, but I
couldn't see any other
giraffes nearby. When they
left the woodland and
headed towards the open
plains, I positioned myself so
that they were silhouetted
against the red sky. Then I
waited until the calves were
on either side of the female.

Janos Jurka
Sweden
HIGHLY COMMENDED

**OSPREYS AT
FULL MOON**

Canon EOS 1 with 300mm lens
and 2x extender; 1/15 sec at f5.6;
Fujichrome Velvia; tripod

For the past 10 years at
least, this pair of ospreys
has nested in the same pine
tree near Väsman Lake,
close to my home in
Sweden. It's not easy getting
the perfect combination of
full moon, the ospreys in a
good position and the bluish
light of dawn. It took me
three seasons.

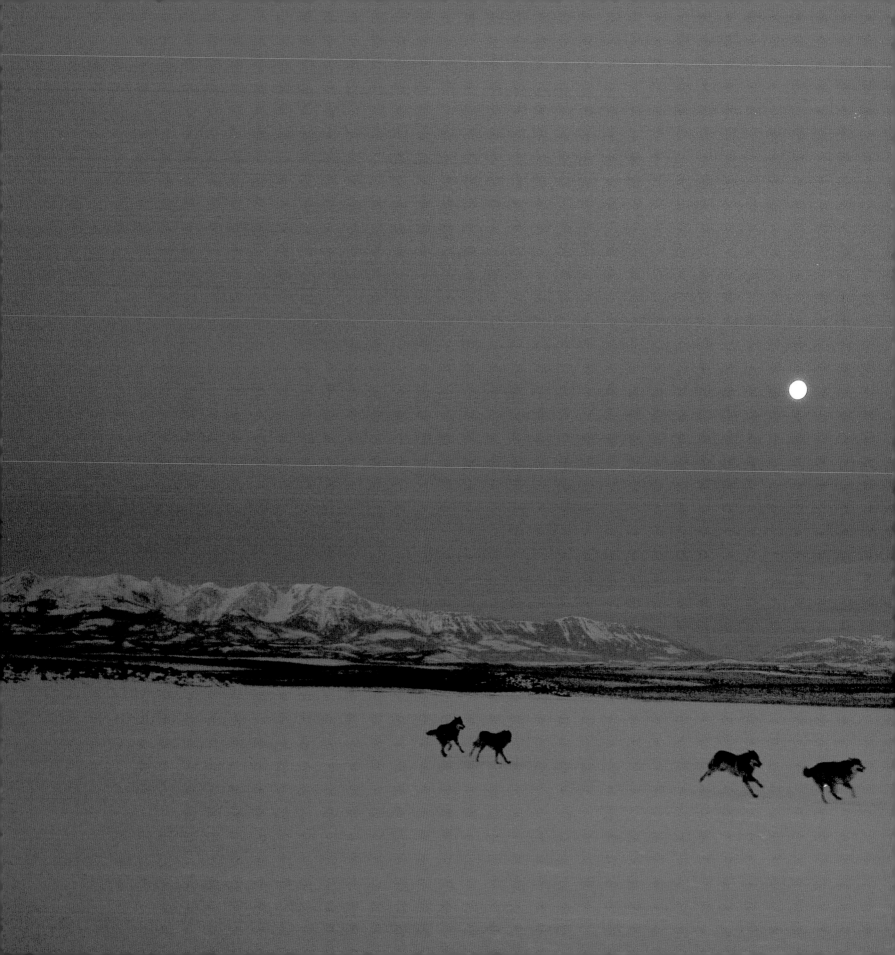

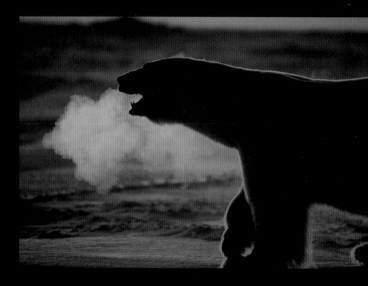

Daniel J Cox
USA
HIGHLY COMMENDED

GREY WOLF PACK RUNNING ACROSS A FROZEN RESERVOIR

Nikon F5 with Nikkor 80-200mm lens; 30mm lens; Fujichrome Provia

This captive grey wolf pack was running at dawn across a frozen reservoir in Shields Valley in south-western Montana near the Crazy Mountains. There are fewer than 100 wolves in Montana, but the number of wild wolves seems to be on the increase. Their main prey are deer, moose and caribou.

Paul Nicklen
Canada
HIGHLY COMMENDED

POLAR BEAR AT SUNSET

Nikon F4 with 500mm lens; 1/250 sec at f4; Fujichrome Velvia

This male bear was travelling across the sea-ice near Ellesmere Island in north-eastern Canada in search of seals under the ice. Scientists estimate that a polar bear can smell a seal lair up to 20 kilometres away, depending on the direction of the wind. In the breeding season, the most dominant males fight each other, and this bear had blood on his nose from such a fight. It was 2.30am, the sun was just setting, and at 40 degrees below, I could only shoot one roll of film before the camera batteries froze.

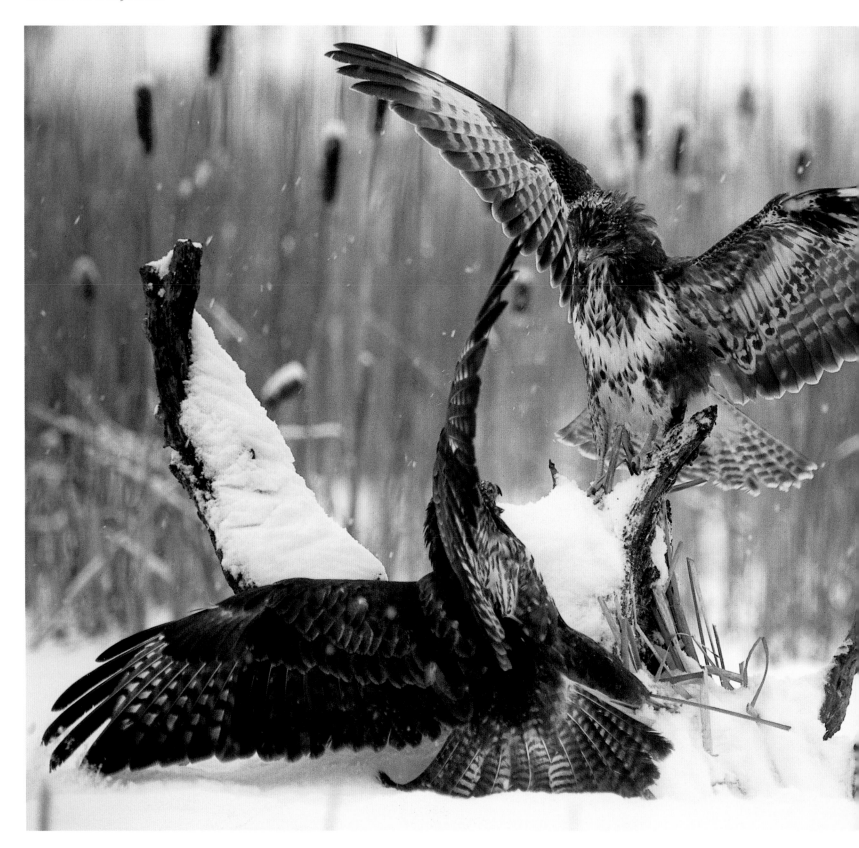

WINNER

Vincent Munier
France

**COMMON BUZZARDS
FIGHTING**

Nikon F801s with 300mm lens and
14x teleconverter; 1/200 sec at f4;
Fujichrome Sensia 100; tripod

It was a very cold February
in the Vosges Mountains of
eastern France when I set
up my hide next to the
frozen marsh. Food was in
short supply, and so it
wasn't long before common
buzzards were attracted
to the dead field mouse that
I had staked out. This pair
didn't stop fighting for a
full 20 minutes, and it
was only after I'd taken a
few photographs that I
realised the extreme cold
had flattened my camera
batteries.

The Eric Hosking Award

Vincent Munier

This Award was introduced in
1991 in memory of Eric Hosking –
Britain's most famous bird
photographer – and goes to the
best portfolio of six images taken
by a photographer aged 26 or
under. Its aim is to encourage
young and aspiring photographers
to develop their skills in wildlife
photography and give them the
opportunity to showcase their
abilities. This year's winner
is Vincent Munier from France.

Vincent Munier

Vincent Munier attributes his passion for wildlife to
his father, who works tirelessly to protect the
environment in his home region of Les Vosges, in
eastern France. Since the age of 13, when he spent
many nights waiting under a fir tree in Les Vosges to
catch sight of displaying capercaillies, Vincent has
always taken a camera with him wherever he goes.
He has studied migrating common cranes, which are
among his favourite birds, and has travelled to
Namibia and Canada to photograph the wildlife.
His job as a photo-journalist for a French regional
newspaper allows him several months off a year to
concentrate on his wildlife photography.

135

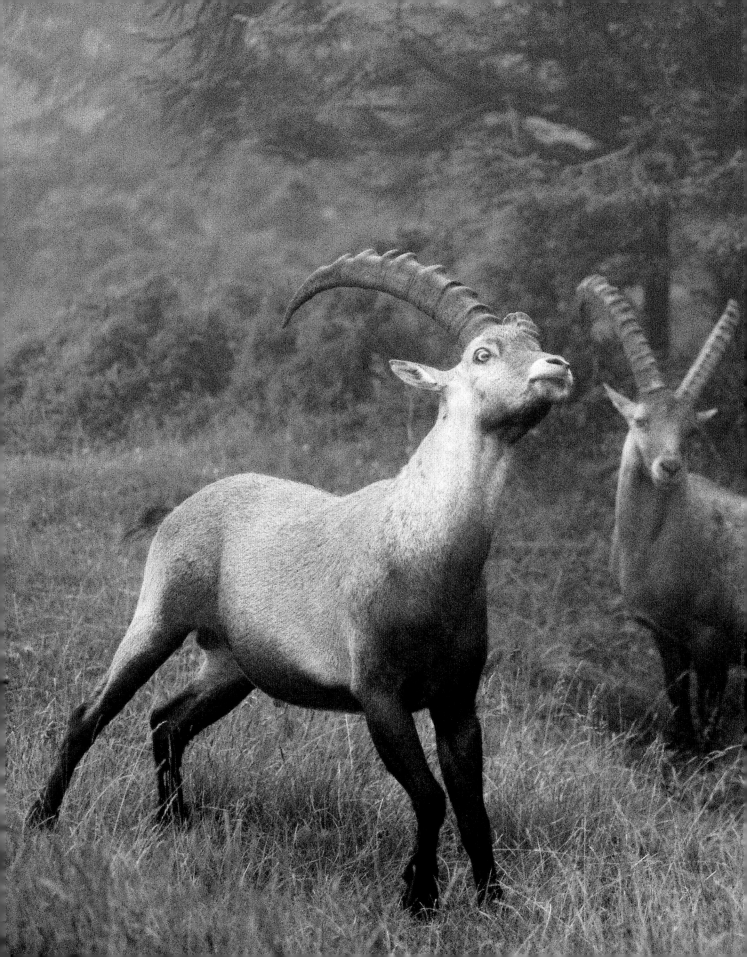

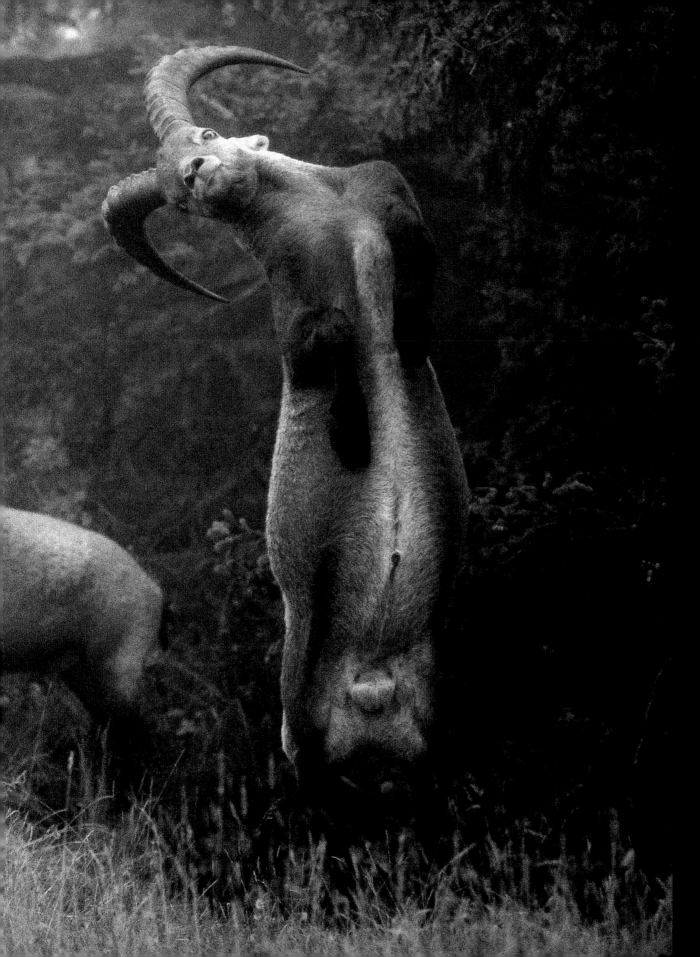

Vincent Munier
France

IBEX MALES SPARRING

Nikon F801s with 80-200mm lens; 1/125 sec at f2.8; Fujichrome Provia 400; tripod

One autumn in Creux-du-Van, Switzerland, I camped beneath some pine trees, and the next morning, a blanket of fog enveloped the countryside. Next to my hide, some male ibex began fighting for dominance. Just before I took this photograph, the one on the right was getting ready to give the one on the left a sharp blow.

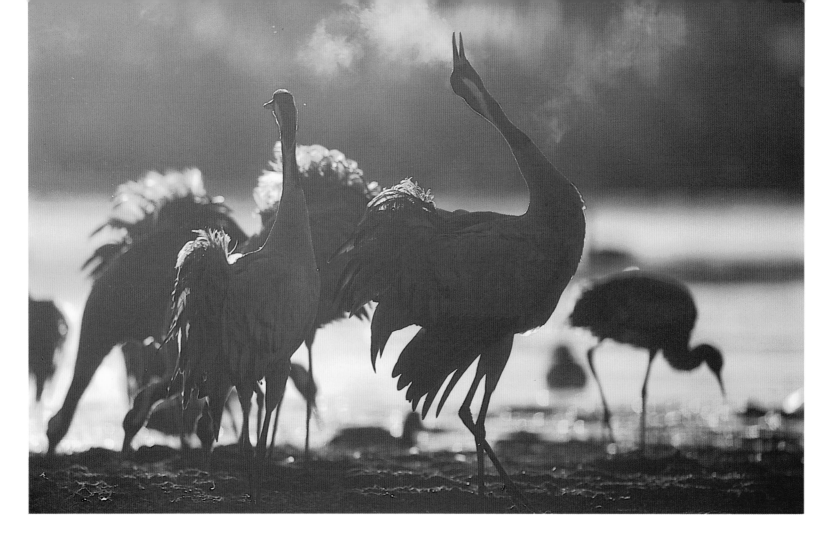

Vincent Munier
France

COMMON CRANES CALLING AT DAWN

Nikon F5 with 600mm lens; 1/250 sec at f4; Fujichrome Velvia; tripod

The return of the common cranes in April heralds the start of spring at Lake Hornborga, Sweden. They overwinter in Spain, Portugal and North Africa, passing through France on their way to breed in Scandinavia and central Europe. I spent several nights in my hide, listening for their arrival. One morning, they landed loudly, making their distinctive strident calls and stealing the show from the singing whooper swans.

Vincent Munier
France

MALE COMMON CRANE PREENING AFTER A FIGHT

Nikon F5 with 600mm lens; 1/100 sec at f11; Fujichrome Velvia; tripod

Common cranes are among my favourite birds, and I follow them on their migratory trail from Spain to Sweden over France. They are very camera-shy, and so I have to use a hide at all times. This one had reached Lake Hornborga in Sweden and was delicately preening his full breeding plumage. After each confrontation with other males at this time of year, cranes always have a good preen.

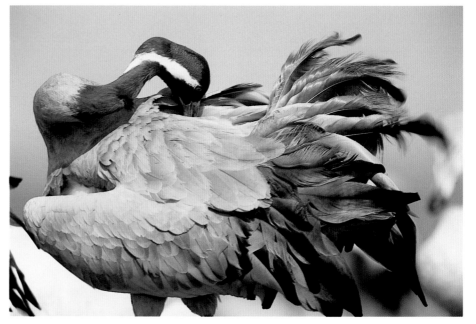

Vincent Munier
France

RED FOX CUB IN AUTUMN

Nikon F5 with 600mm lens;
1/125 sec at f5.6; Fujichrome
Sensia 100; tripod

One evening in the Vosges Mountains in eastern France, I watched a young fox, in the autumn light, taking a stroll along a small path. I decided I would photograph the scene, and so set myself up in a hide nearby. I waited patiently, and by the fourth evening, a fox came back to re-enact the scene for me.

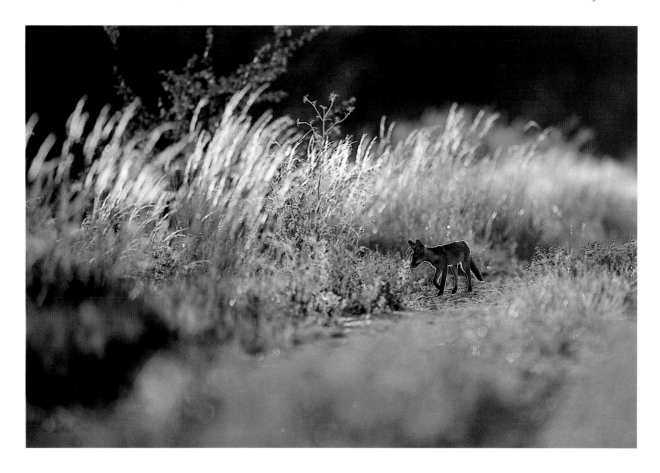

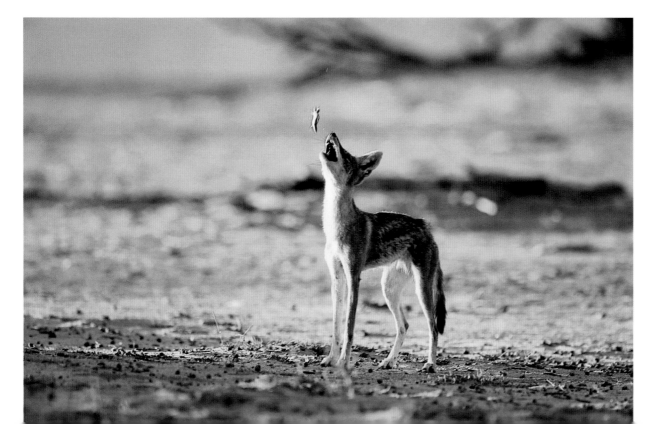

Vincent Munier
France

BLACK-HEADED JACKAL PLAYING WITH A LIZARD

Nikon F5 with 600mm lens;
1/200 sec at f5.6; Fujichrome
Velvia; tripod

In Botswana's Kalahari Desert, I saw two jackals hunting together at the side of the road. One of them caught a lizard. Turning towards my camera lens, it tossed it in the air several times before eventually swallowing it. It was the end of the dry season, and food was in short supply, but jackals adapt by considering most things to be edible.

The BG Young Wildlife Photographer of the Year

The BG Young Wildlife Photographer of the Year title is awarded for the single image judged to be the most striking and memorable of all the photographs entered for the competition.

Kobe Van Looveren

It was a stunning sunset near his home in Flanders that inspired Kobe Van Looveren to take up photography at the age of 13. Using an old SLR camera he found in a cupboard and encouraged by a nature-photographer friend of the family, Kobe started to take pictures of the wildlife near his village. As he became more skilful, he graduated to a second-hand Nikon F90 and joined a national association for nature photographers, which urged him to enter the BG Wildlife Photographer of the Year Competition. Kobe is now considering a career in either photography or landscape gardening. He's particularly drawn to animals from cold regions and hopes to be able to travel north soon, possibly to Norway, so that he can "photograph day and night."

BG
YOUNG WILDLIFE
PHOTOGRAPHER
OF THE YEAR
2000

Kobe Van Looveren
Belgium

SMALL COPPER AMONG GRASSES

Nikon F90 with Nikkor 105mm Micro lens; 1/60sec at f4; Fujichrome Sensia

One warm, windy evening, I set off to photograph the butterflies in the nearby meadow. In spite of the wind, this small copper managed to sit still on a blade of grass long enough for me to make a careful composition. Small coppers are found across most of Europe and, as butterflies go, are aggressive – they have even been known to 'attack' cameras.

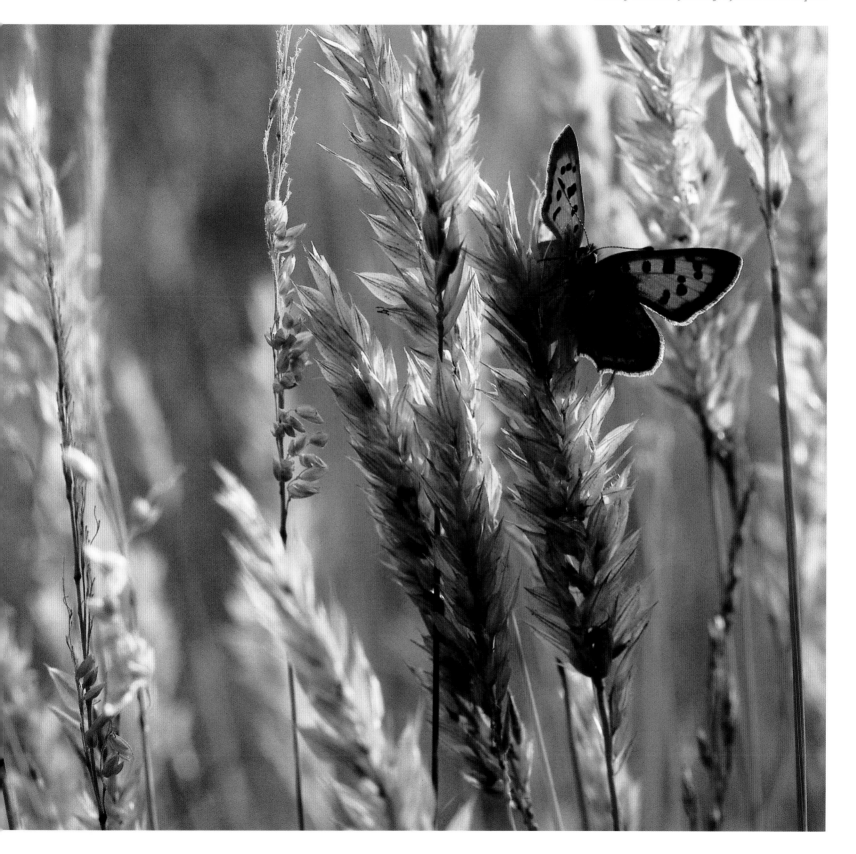

WINNER

Oliver Kois
Germany
10 YEARS AND UNDER

**GANNET SCANNING
FOR FISH**

Canon EOS 100 with 100-300mm
lens; 1/250 sec at f5.6;
Fujichrome Sensia 100

Bass Rock is a 100-metre
column of basalt a kilometre
and a half off the east coast
of Scotland. It is home to
thousands of guillemots,
razorbills, shags and puffins
and is also the largest single
colony of gannets in the UK,
with 50,000 pairs migrating
there from Africa every year
to nest. The gannet is
Britain's largest seabird – it
has a wingspan of more
than two metres.

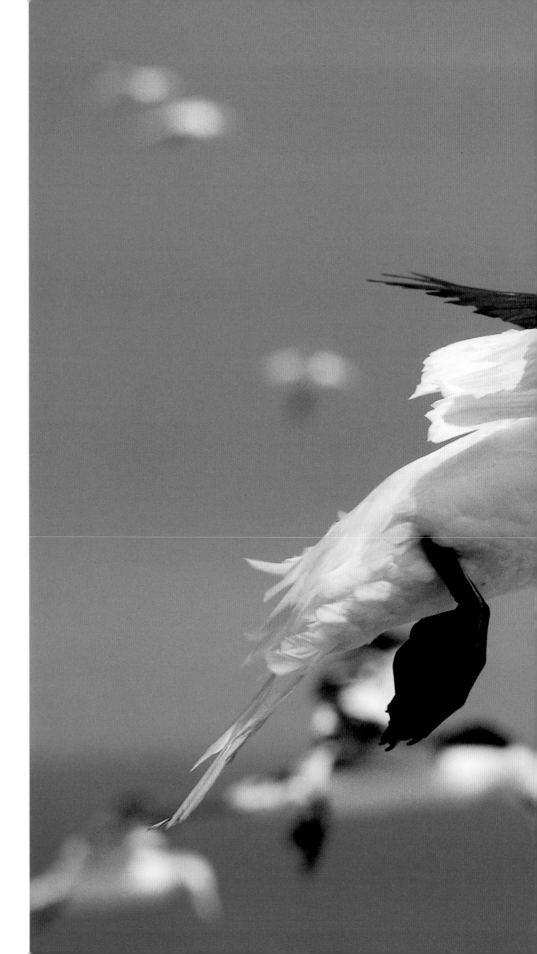

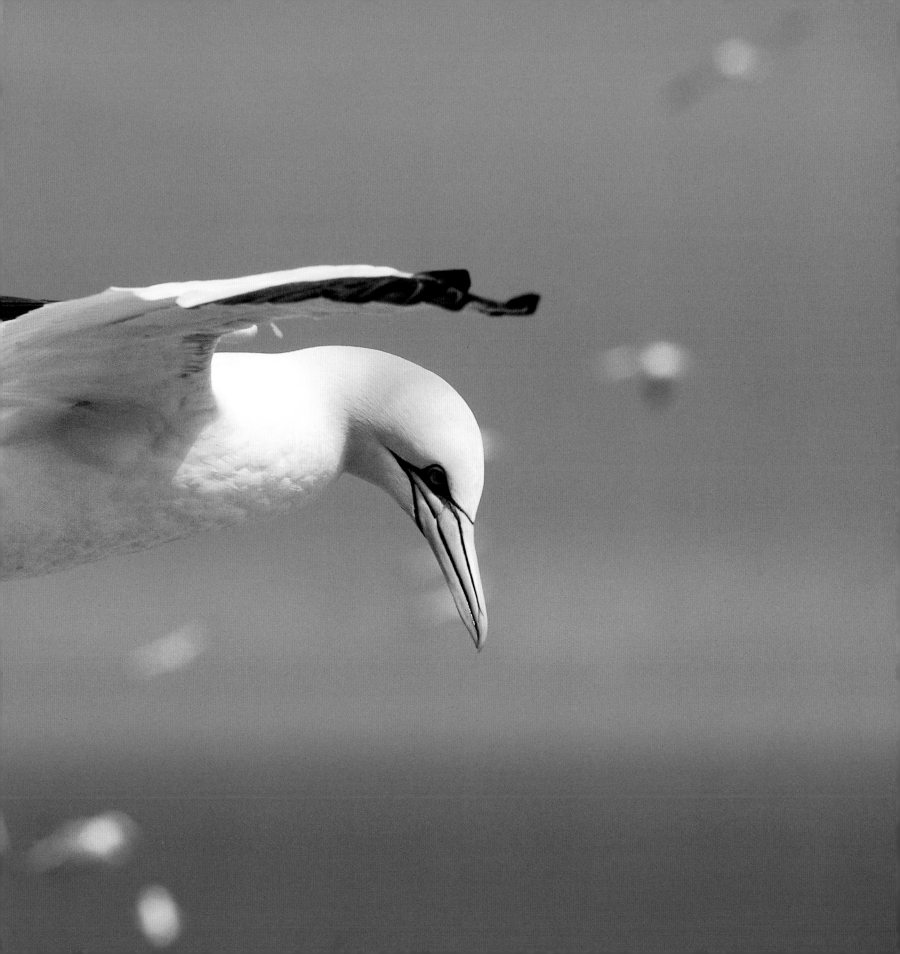

Dan Slootmaekers
Belgium
HIGHLY COMMENDED
10 YEARS AND UNDER

**THOMSON'S GAZELLE
AT DAWN**

Canon EOS 500 with 300mm
lens; f4; Fujichrome Sensia II 100;
beanbag

These animals are so
common in Tanzania's
Serengeti plains that they
are usually overlooked. This
one caught my attention
because it was so close. The
early-morning backlight was
attractive, and so I waited
for the gazelle to walk past.

WINNER

Becky Chadd
UK
11-14 YEARS OLD

CURIOUS ROE DEER

Canon EOS 50E with Sigma
400mm lens; 1/350 sec at 5.6;
Fujichrome 100 rated at 200;
tripod

Every afternoon, the does
would bring their fawns to
farmland near the English
town of Guildford to feed.
My dad and I would sit in a
hide to try to photograph
the fawns, but the grass was
so tall you could hardly see
them. This doe heard my
camera click and came
closer to investigate.

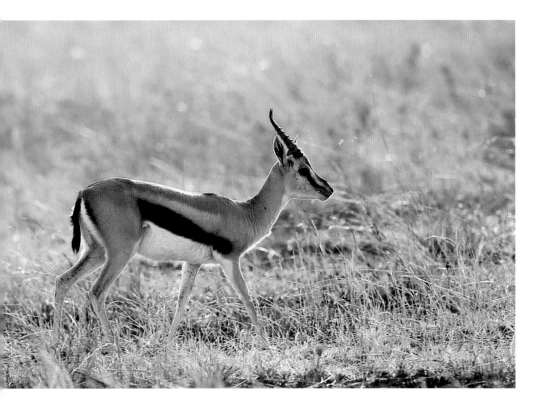

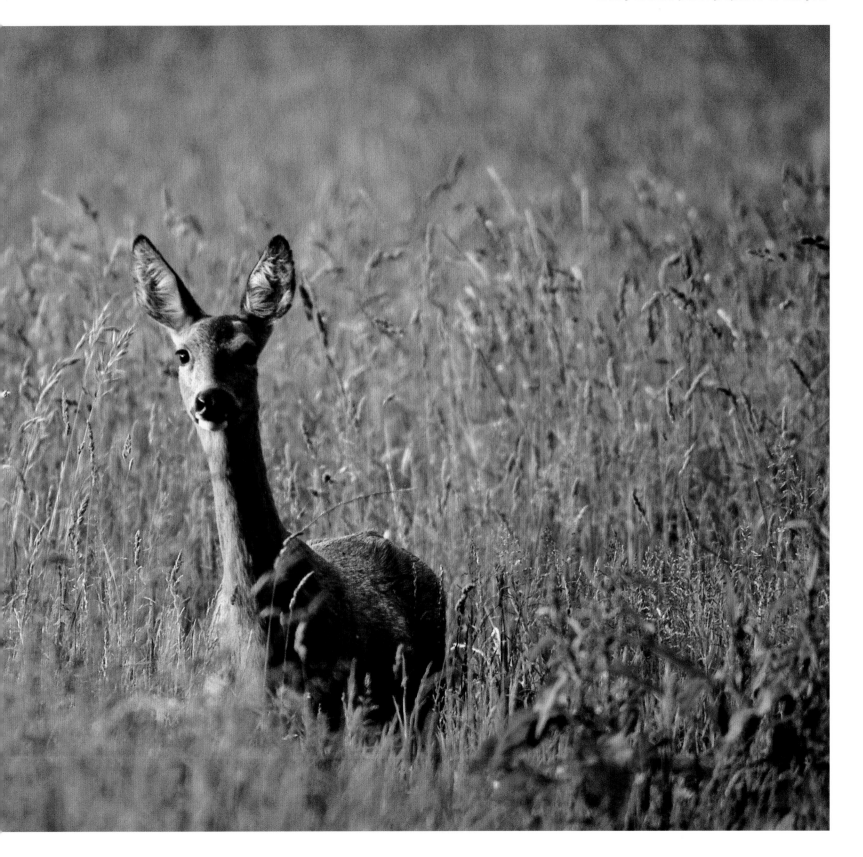

RUNNER-UP

Ashleigh Rennie
South Africa
11-14 YEARS OLD

BURCHELL'S ZEBRA
AT DAWN

Canon EOS 5 with 100-400mm
lens; Fujichrome Sensia 100;
beanbag

As usual, we got up early
in the morning to catch
the beautiful light in the
Kruger National Park, South
Africa. We stopped to watch
a herd of Burchell's zebras
grazing near the road.
That's when I noticed the
dark background and super
lighting on this zebra.

Sean McMillan
USA
HIGHLY COMMENDED
11-14 YEARS OLD

WESTERN
DIAMONDBACK
RATTLESNAKE

Canon AE1 with Vivitar
28-200 lens; 1/60 sec at f16;
Kodak Gold 100

When threatened, a
rattlesnake lifts its head well
above its coils and sounds its
warning rattle. This captive
western diamondback, at
the Oklahoma Zoological
Society herpetarium,
reacted when a child
disturbed it by tapping on
the glass of its tank. Western
diamondbacks, the largest
venomous snakes in the
world, are not endangered,
but they are the victims of
hunting, habitat loss and, in
several states, cruel
rattlesnake 'round-ups'.

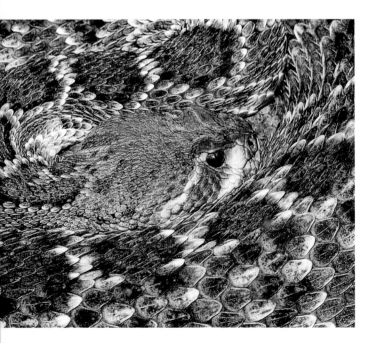

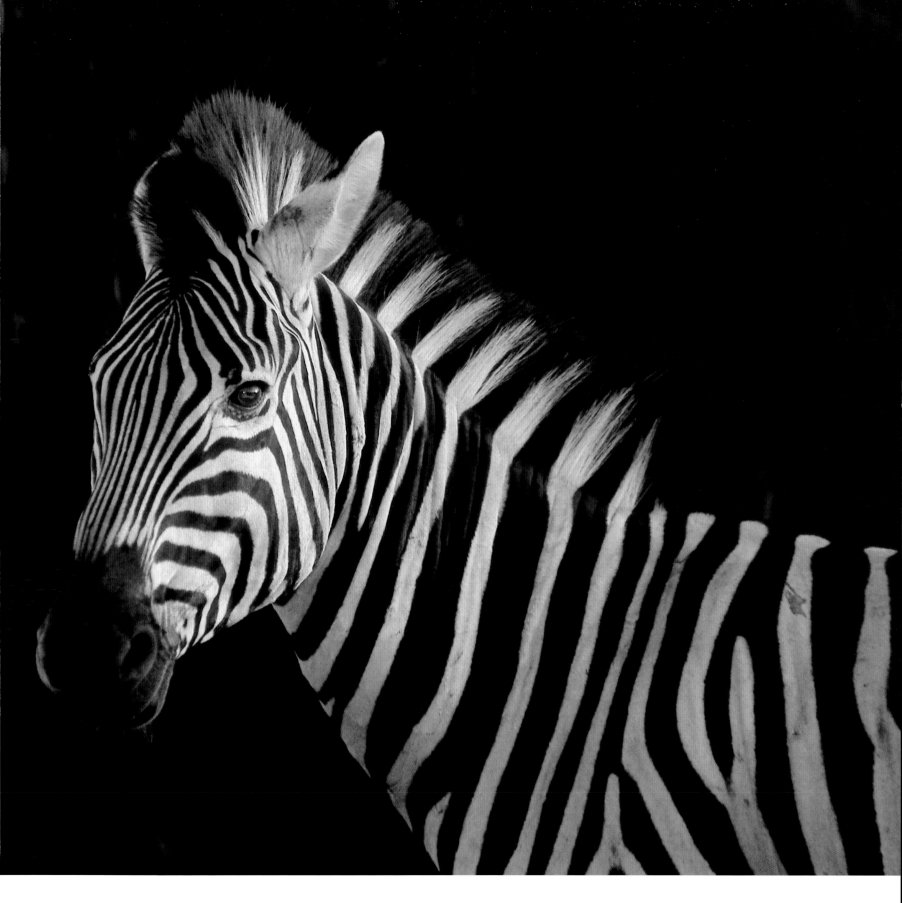

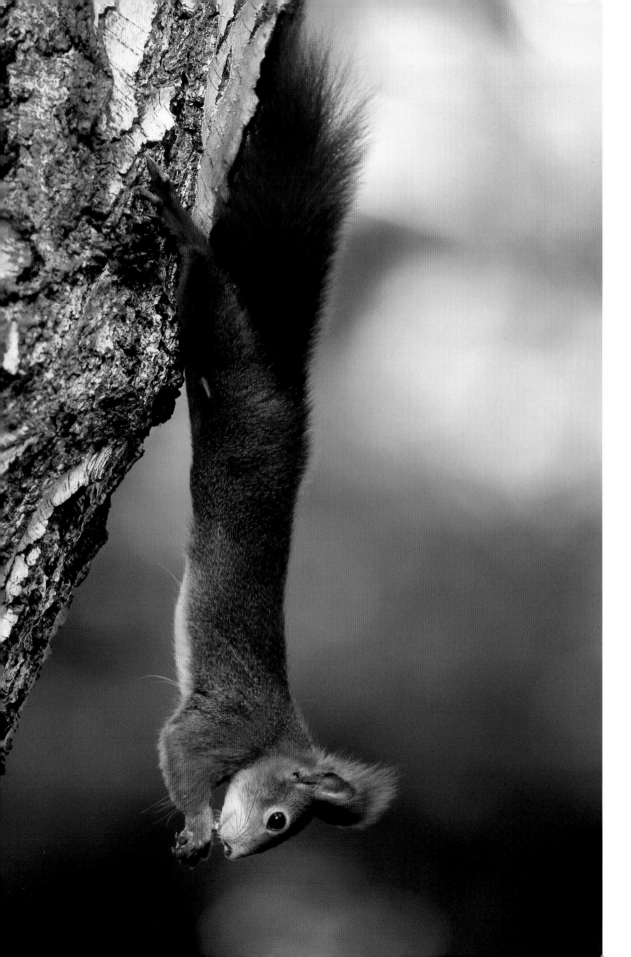

Fabian Fischer
Germany
15-17 YEARS OLD

RED SQUIRREL

Nikon F90X with 300mm lens;
1/125 sec at f4; Fujichrome
Sensia II 100

I put nuts out in an area near
my home in Bavaria, where
squirrels are often seen in
autumn. Then I hid and
waited, hoping one would
come to collect the nuts.
This squirrel, instead of
taking the nut away to store
it for the cold winter ahead,
ate it there and then,
hanging from a tree.

Fabian Fischer
Germany
15-17 YEARS OLD

IBEX SPARRING

Nikon F90X with 500mm lens and
1.4x teleconverter; 1/320 sec at
f5.6; Fujichrome Sensia II 100

In May, the male ibex in the
Austrian Alps begin to fight
for females. The first time I
saw this, I couldn't take any
photos because the terrain
was too rough to climb close
enough. The next day, I
found a more accessible
place near the 3,800-metre
Großglockner peak where I
was lucky enough to watch
ibex fighting in front of
alpine scenery.

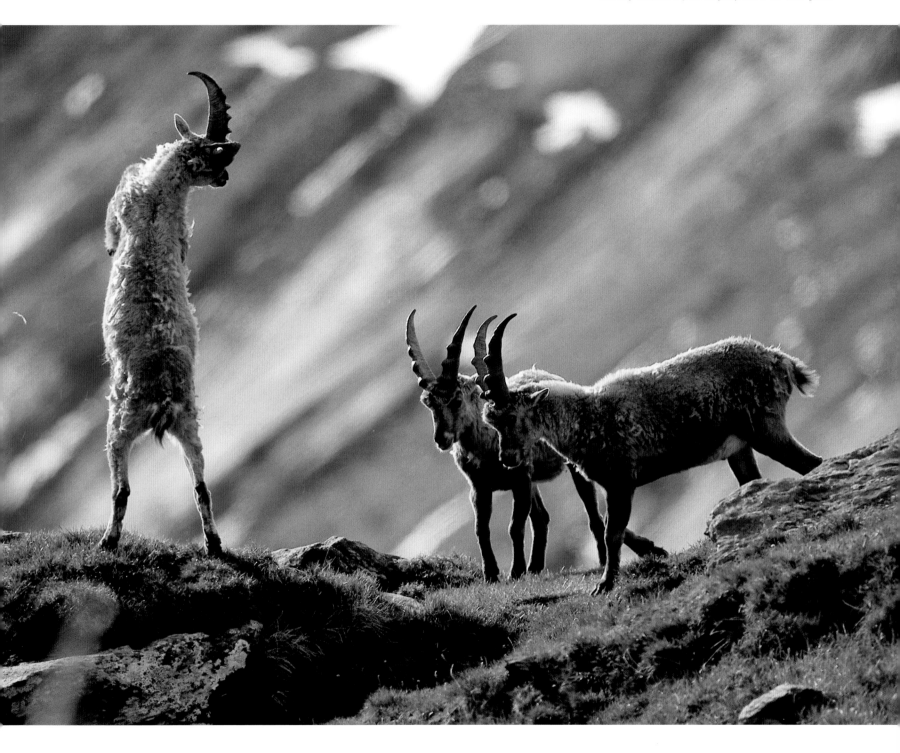

Rony Vander Elst
Belgium
HIGHLY COMMENDED
15-17 YEARS OLD

EUROPEAN ROBIN AMONG HAZEL CATKINS

Nikon F90X with Sigma 400mm lens; f5.6; Fujichrome Sensia II +0.3 stop; tripod

I thought this robin – perching on a hazel-tree branch in a small wood in Koumprehaut, Belgium – was too far away to photograph. I wanted to get closer, but there was a brook in the way. Then there was a brief sunny moment, and that's when I saw that a composition with the catkins would work.

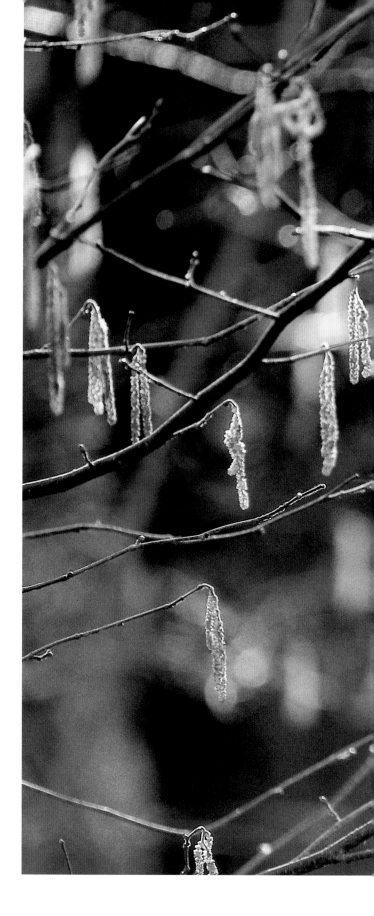

Martin Broman
Sweden
HIGHLY COMMENDED
15-17 YEARS OLD

HEDGEHOG

Canon T-90 with 400mm lens; Fujichrome Sensia II 100; tripod

One early April day, I heard rustling in the dry leaves in the forest behind our home. A hedgehog emerged, slightly lethargic, as if it had just come out of hibernation. When I returned with a camera and lay down to take photos, the hedgehog moved towards me. I couldn't believe my luck when it stopped and sniffed, looking directly at me just as the sun dappled its back.

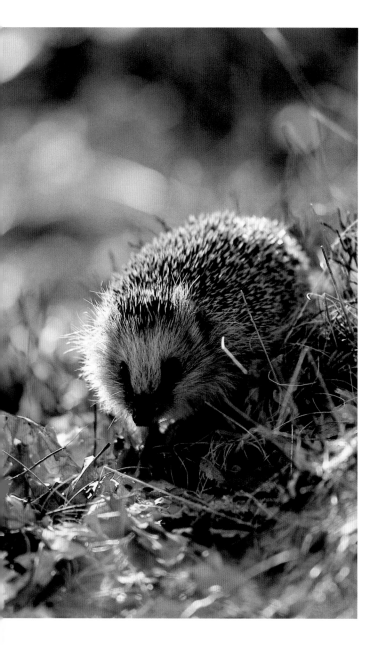

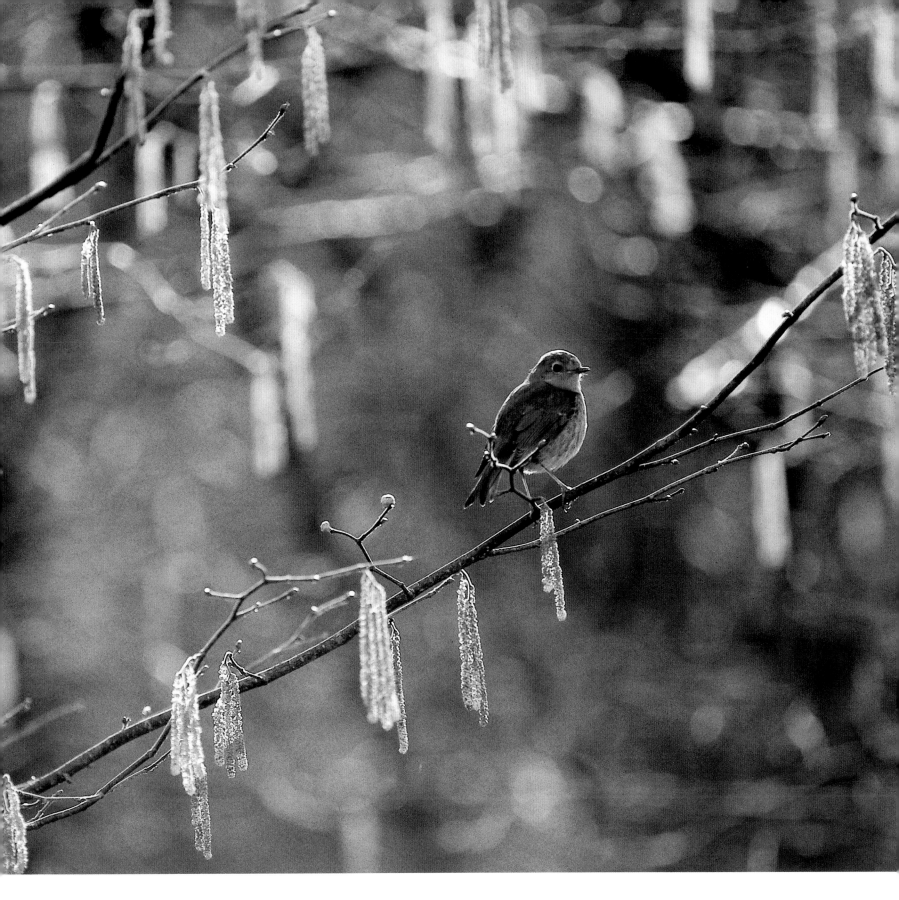

Charlotte Renaud
France
HIGHLY COMMENDED
15-17 YEARS OLD

**AFRICAN WILDLIFE
AT A WATERHOLE**

Nikon F801 with 35-70mm lens;
1/250 sec at f8; Fujichrome
Sensia 100

Early one August morning, I spent a few hours at this waterhole in Buffalo Springs National Reserve in Kenya, watching the comings and goings. The special moment came when a noisy baboon troop arrived to drink, and I managed to capture the whole scene, including the huge bull elephant.

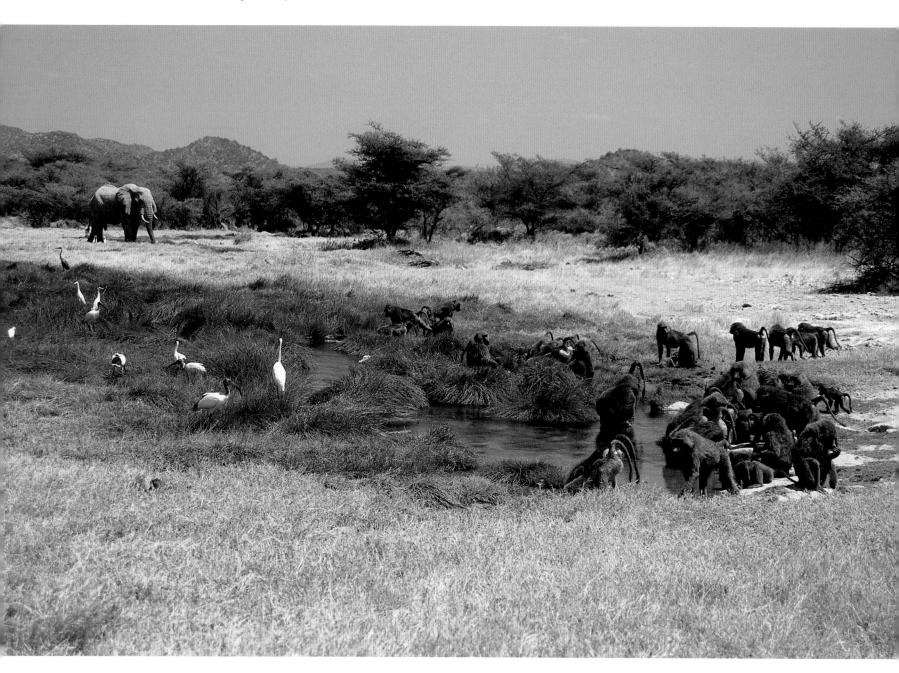

Fabian Fischer
Germany
HIGHLY COMMENDED
15-17 YEARS OLD

HUNTING LION

Nikon F90X with 300mm lens;
1/20 sec at f5.6; Fujichrome
Velvia; beanbag

We were in the Maasai
Mara Game Reserve in
Kenya trying to photograph
lions. We knew they
were often active early in
the day. One morning, we
spotted a lion near some
wildebeest. I used a low
exposure to take this picture
when the attack began.

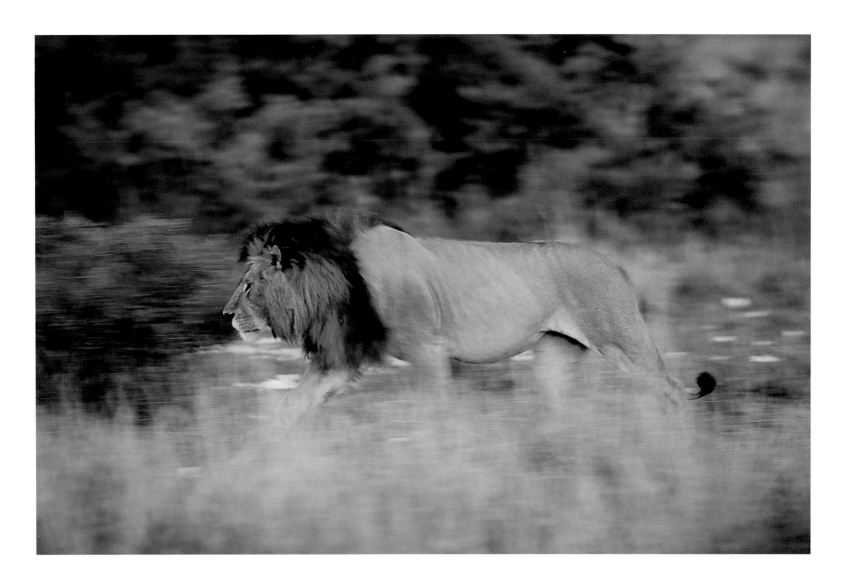

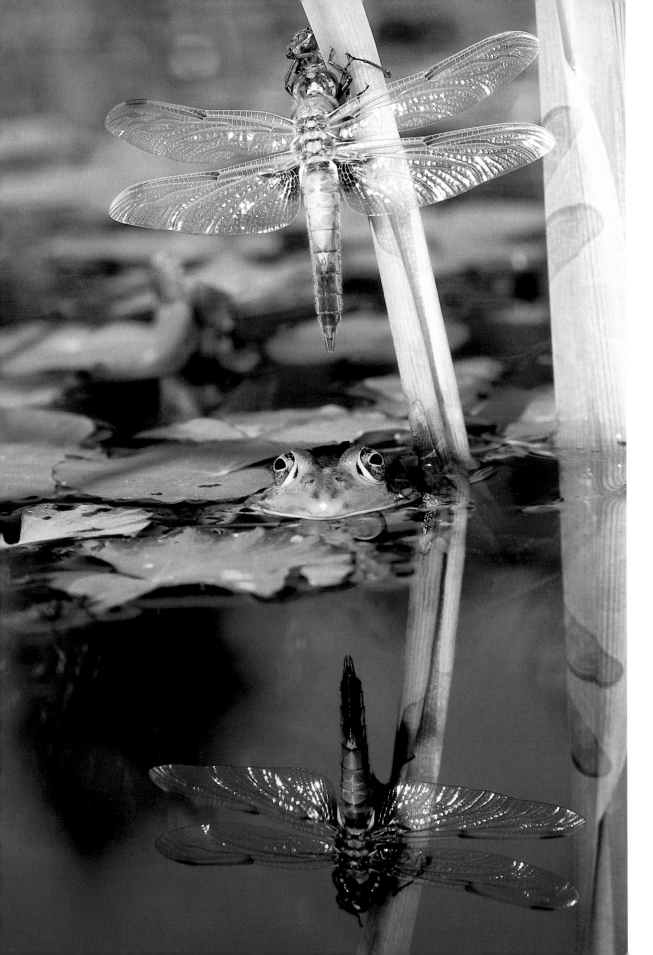

RSPB Wildlife Explorers Award

This award is for the best picture of an animal, plant or wild place taken close to home by a photographer aged 17 or under. It is offered by the RSPB Wildlife Explorers, the junior membership of the Royal Society for the Protection of Birds – an international wild bird and environmental conservation charity with more than a million members worldwide.

WINNER

Kobe Van Looveren
Belgium

EUROPEAN GREEN FROG WATCHING A FOUR-SPOTTED CHASER DRAGONFLY

Nikon F90 with Micro Nikkor 105mm lens; 1/60 sec at f8; Fujichrome Sensia; beanbag

This dragonfly was drying out after emerging from our pond to a reed to cast off its nymph skin. I decided to photograph it, but the overall composition was spoiled by a leaf. I carefully removed the leaf just as a frog leapt towards it, thinking it was a tasty meal. The frog seemed oblivious to the genuine dragonfly prey directly above. With only one exposure left, I was lucky to capture this scene.

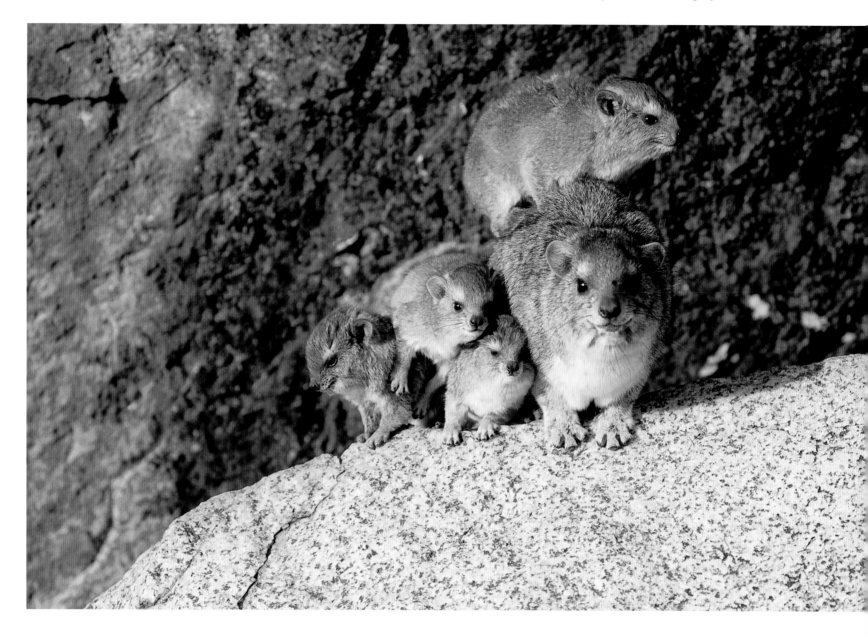

meg@ award

WINNER

Dan Slootamaekers
Belgium

HYRAX FAMILY WARMING UP

Canon EOS 500 with 300mm lens; f4; Fujichrome Sensia II 100; beanbag

The hyraxes around the lodge where I was staying in the Serengeti were used to humans. So, when I got up early one cold morning, I managed to get quite close to these ones playing and warming themselves in the first rays of the sun. I love the way their colour blends in with the rocks they use for shelter.

Index of photographers

The numbers before the photographers' names indicate the pages on which their work can be found.

All contact numbers are listed with international dialling codes from the UK – these should be replaced when dialling from other countries.

71
Kenneth Crossan
St Combs
Newton Road
Wick, Caithness
Scotland KW1 5LL
UK

Tel: 01955 605597
Email: KenCrossan@aol.com

20, 28
Manfred Danegger
Hasenbühlweg 9
88696 Quingen-Billafingen
GERMANY

Tel: (0049) 7557 8765
Fax: (0049) 7557 8970

70
Steve Day
3 Forest Houses
Farley
Salisbury
Wiltshire
SP5 1AG

Tel: 01722 712713
Email: steve@steveday.co.uk

75
Enrique del Campo
Av/Reyes Católicos 25 4°C
28803 Alcalá de Henares
Madrid
SPAIN

Tel: (0034) 91 8804473

90
Jose Delgado
C/Silvano 143 3°D
28043 Madrid
SPAIN

Tel: (0034) 91 388 9828
Fax: (0034) 91 581 5639
Email: josedel@mapfre.com

AGENT
COVER
Isaac Jimere 25
28037 Madrid
SPAIN

Tel: (0034) 91 327 2418
Email: cover@cover.es

15
**Cornelia and
Ramon Doerr**
Merowingerstrasse 63
40225 Düsseldorf
GERMANY

Tel: (0049) 211 319 0425
Fax: (0049) 211 600 7101
Email: c.doerr@mail.isis.de

47
Ulrich Döring
PO Box 9550
Moshi
TANZANIA

Tel: (00255) 27 2753599
Fax: (00255) 27 2753430
Email: gaatz@eoltz.com

58
Thomas Dressler
Edf Marbella 2000
Apt 701
Paseo Marítimo
29600 Marbella
SPAIN

Tel: (0034) 952 860 260
Fax: (0034) 952 860 260

AGENT
Planet Earth Pictures
The Innovation Centre
225 Marsh Wall
London E14 9FX
UK

Tel: 020 7293 2999
Fax: 020 7293 2998

88
Wynand du Plessis
PO Box 13
Etosha National Park
Okaukuejo, via Outjo
NAMIBIA

Tel: (00264) 67 229813
Fax: (00264) 67 229813
Email: cwdup@mweb.com.na

92
Guy Edwardes
'Byways', St Marys's Lane
Yawl, Uplyme
Lyme Regis
Dorset DT7 3XH
UK

Tel: 01297 443276
Email: guyedwardes@
eggconnect.net

AGENT
NHPA
57 High Street
Ardingly
W Sussex RH17 6TB
UK

Tel: 01444 892514
Fax: 01444 892168

46, 64
Thomas Endlein
Topplerweg 24
91541 Rothenburg
GERMANY

Tel: (0049) 9861 4501
Email: thomas.endlein@
stud-mail.uni-wuerzburg.de

40
Yossi Eshbol
27 Hagidonim Street
Zichron Ya'acov 30900
ISRAEL

Tel: (00972) 6 639 8733
Fax: (00972) 6 629 0183

AGENT
Frank Lane Picture Agency Ltd
Pages Green House
Wetheringsett
Stowmarket
Suffolk IP14 5QA
UK

Tel: 01728 860789
Fax: 01728 860222

34
Luca Fantoni
Via Monviso 11/A
20050 Camparada (MI)
ITALY

Tel: (0039) 03 96069943

81
Berndt Fischer
Reuthstrasse 3b
91099 Poxdorf
GERMANY

Tel: (0049) 9133 602 616
Fax: (0049) 9133 602 616

148, 149, 153
Fabian Fischer
Reuthstrasse 3b
91099 Poxdorf
GERMANY

Tel: (0049) 9133 4960
Fax: (0049) 9133 602 616
Email: fischer_fabian@
yahoo.de

30
Tim Fitzharris
223 North Guadalupe Street
PMB 161
Santa Fe
NM 87501
USA

Tel: (001) 505 988 5530
Fax: (001) 505 988 5530
Email: fitzharris@earthlink.net

99
Ivor Fulcher
Dockside Dive Centre
PO Box 815
San Antonio
FL 33576
USA

Tel: (001) 504 455 5505
Fax: (001) 504 455 5505
Email: docside@hondutel.hn

12, 123
Nick Garbutt
c/o 30 School Road
Wales
Sheffield
S26 5QJ

Tel: 01909 770 954
Email: ng.indri@netgates.co.uk

AGENT
Planet Earth Pictures
The Innovation Centre
225 Marsh Wall
London E14 9FX
UK

Tel: 020 7293 2999
Fax: 020 7293 2998

102
Jose Luis Gonzalez
c/Tui, 13 3°A
36209 Vigo
SPAIN

Tel: (0034) 986 201 162
Fax: (0034) 986 215 886

23
George Gornacz
c/o Southern Xray
Box 188
Gympie
Queensland 4570
AUSTRALIA

Tel: (0061) 7 5447 5743
Fax: (0061) 7 5448 0284
Email: petty@ozemail.com.au

AGENT
Woodfall Wild Images
17 Bull Lane
Denbigh
Denbighshire LL16 3SN
UK

Tel: 01745 815903
Fax: 01745 814581

54
Karen Gowlett-Holmes
PO Box 714
Sandy Bay
Tasmania 7006
AUSTRALIA

Tel: (0061) 417 730 085
Fax: (0061) 362 652 251
Email: karen.gowlett-holmes@
h130.aone.net.au

AGENT
Oxford Scientific Films Ltd
Lower Road
Long Hanborough
Witney
Oxfordshire OX8 8LL
UK

Tel: 01993 881881
Fax: 01993 882808

76
Thomas Grüner
Maillingerstrasse 3
80636 München
GERMANY

Tel: (0049) 89 184 797
Email: thomas_gruener@
web.de

112
Thomas Haider
Steinergasse 2/12
1170 Wien
AUSTRIA

Tel: (0043) 1 403 42 94
Fax: (0043) 1 403 42 94
Email: thomas.haider@
univie.ac.at

49, 121, 50
David Hall
257 Ohayo Mountain Road
Woodstock
NY 12498
USA

Tel: (001) 914 679 6138
Fax: (001) 914 679 4085
Email: david@seaphotos.com

72
Dale Hancock
4 Kingsbury Park
20 John Barker Avenue
Pelham, Pietermaritzburg
3201 Kwa Zulu-Natal
SOUTH AFRICA

Tel: (0027) 33 3460 710
Fax: (0027) 33 3877 335
Email: hancock@webmail.co.za

18
Tony Heald
23 Elvaston Mews
London SW7 5HZ
UK

Tel: 020 7584 1441
Fax: 020 7584 1441
Email: t-heald@netcomuk.co.uk

AGENT
BBC Natural History Unit
Picture Library
Broadcasting House
Whiteladies Road
Bristol BS8 2LR
UK

Tel: 0117 974 6720
Fax: 0117 923 8166
Email: nhu.picture.library@
bbc.co.uk

100
Pål Hermansen
Brubråten Siggerudveien 908
1400 Ski
NORWAY

Tel: (0047) 6486 5515
Fax: (0047) 6486 5515
Email: paal.hermansen@
c2i.net

AGENT
NHPA
57 High Street
Ardingly
W Sussex RH17 6TB
UK

Tel: 01444 892514
Fax: 01444 892168

120
Malcolm Hey
54 The Thicket
Romsey
Hampshire SO51 5SZ
UK

Tel: 01794 513 248
Fax: 01794 513 248
Email: mdh@malcolmhey.co.uk

117
Christian Hütter
Schlägelstrasse 54
59192 Bergkamen
GERMANY

Tel: (0049) 238 945 667
Fax: (0049) 238 945 667
Email: ChristianHuetter@
gmx.de

59
Bror Johansson
Älvbrovägen 84
77435 Avesta
SWEDEN

Tel: (0046) 226 57530

65
Jan Töve Johansson
Prästgården
Hàrna
52399 Hökerum
SWEDEN

Tel: (0046) 33 274 028
Fax: (0046) 33 274 028
Email: jan.tove@telia.com

AGENT
Planet Earth Pictures
The Innovation Centre
225 Marsh Wall
London E14 9FX
UK

Tel: 020 7293 2999
Fax: 020 7293 2998

96
Helen A Jones
222 Indian Meal Line
Torbay
Newfoundland AIK1B4
CANADA

Tel: (001) 709 437 6852
Fax: (001) 709 738 4832
Email: jblakele@mun.ca

101
**Burt Jones and
Maurine Shimlock**
c/o Beth Shimlock
134 Sherry Lane
New Milford
CT 06776
USA

Tel: (001) 860 355 5303
Fax: (001) 860 355 5305
Email: secretseavisions@
aol.com

131
Janos Jurka
Storängsvägen 5
77160 Ludvika
SWEDEN

Tel: (0046) 240 39087
Fax: (0046) 240 39087

AGENT
Bruce Coleman Ltd
16 Chiltern Business Village
Arundel Road
Uxbridge
Middlesex UB8 2SN
UK

Tel: 01895 257094
Fax: 01895 272357

63
**Murray S Kaufman and
Richard McEnery**
618 North Sierra Drive
Beverly Hills
CA 90210
USA

Tel: (001) 310 278 8841
Fax: (001) 310 278 8844
Email: murray300@aol.com

142
Oliver Kois
Brandheide 73
59071 Hamm
GERMANY

Tel: (0049) 238 186 433

24, 29
Willem Kolvoort
Hessenweg 100
8051 Le Hattem
NETHERLANDS

Tel: (0031) 384 441 815
Fax: (0031) 384 441 815

31
Richard Kuzminski
476 Highland Avenue
Wood-Ridge
NJ 07075
USA

Tel: (001) 201 507 0368
Fax: (001) 201 599 7399
Email: rrown@aol.com

48
Felix Labhardt
Bruderholzstrasse 26
4103 Bottmingen
SWITZERLAND

Tel: (0041) 61 421 0516
Fax: (0041) 61 421 0516

42
Ryo Maki
4-13-6 Ankoji-cho
Takatsuki-city
Osaka 569-1029
JAPAN

AGENT
Japan Professionals
PO Box 5238 - Central
Queensland Mail Centre
North Rockhampton
Qld 4701
AUSTRALIA

Tel: (0061) 7 4926 6839
Fax: (0061) 7 4926 6849
Email: japanpr@attglobal.net

75
Armando Maniciati
Via G. Boccaccio 34/P
35128 Padova
ITALY

Tel: (0039) 0 498 074 396
Fax: (0039) 0 498 783 899
Email: a.maniciati@tin.it

128
Armin Maywald
Brandtstrasse 7
28215 Bremen
GERMANY

Tel: (0049) 421 352 384
Fax: (0049) 421 353 250
Email: arminmaywald@aol.com

33
Mary Ann McDonald
73 Loht Road
McClure
PA 17841-8900
USA

Tel: (001) 717 543 6423
Fax: (001) 717 543 6423
Email: hoothollow@
acsworld.net

146

Sean McMillan
4320 Saint Gregory Drive
Oklahoma City
OK 73120
USA

Tel: (001) 405 751 6708
Fax: (001) 405 752 9566
Email: mcmillan3@msn.com

126

Mike Mockler
Gulliver's Cottage
Chapel Rise, Avon Castle
Ringwood
Hampshire BH24 2BL
UK

Tel: 01425 478 103
Fax: 01425 478 103
Email: mikemockler@
lineone.net

98

Helmut Moik
Flurweg 172
8311 Markt Hartmannsdorf
AUSTRIA

Tel: (0043) 3114 2759
Fax: (0043) 3167 090501

15

Arthur Morris
BIRDS AS ART
PO Box 7245
Indian Lake Estates
FL 33855
USA

Tel: (001) 863 692 0906
Fax: (001) 863 692 2806
Email: birdsasart@att.net

124

Peter Muehlbacher
Am Reichertsberg 15
74172 Neckarsulm
GERMANY

Tel: (0049) 713 283 687
Fax: (0049) 713 283 687

35

Rainer Müller
Unterer Pustenberg 66
45239 Essen
GERMANY

Tel: (0049) 201 493 585

134-139, 26

Vincent Munier
36 rue Etienne Simard
88130 Charmes
FRANCE

Tel: (0033) 6 07 12 00 97
Fax: (0033) 3 29 38 00 88
Email: vincent.munier@voila.fr

AGENT

BBC Natural History Unit
Picture Library
Broadcasting House
Whiteladies Road
Bristol BS8 2LR
UK

Tel: 0117 974 6720
Fax: 0117 923 8166
Email: nhu.picture.library@
bbc.co.uk

69

Andy Newman
24 Orchard Avenue
Bishopstoke
Eastleigh
Hampshire SO50 8HP
UK

Tel: 023 8060 0792
Email: andyphoto@bun.com

22, 133, 51

Paul Nicklen
PO Box 31283
211 Main Street.
White Horse
YT-Y1A5P7
CANADA

Tel: (001) 867 668 4583
Fax: (001) 250 248 2728
Email: nicklen@pioneernet.net

66

Jun Ogawa
LT 2313, Yatuka
77-1 Sezaki-cho
Soka-shi
Saitama Prefecture
JAPAN

Tel: (0081) 489 27 2213
Fax: (0081) 489 27 2213

16

Jo Overholt
PO Box 102466
Anchorage
AK 99510
USA

Tel: (001) 907 279 7626
Email: joverholt@GCI.net

AGENT

Alaska Stock
2505 Fairbanks Street
Anchorage
AK 99503
USA

Tel: (001) 907 276 1343

94

Jim Petek
PO Box 792
Red Lodge
MT 59068
USA

Tel: (001) 406 446 1598
Email: bjpetek@hotmail.com

82

Fritz Pölking
Münsterstrasse 71
48268 Greven
GERMANY

Tel: (0049) 2571 52115
(0049) 2571 2864
Fax: (0049) 2571 953269
Email: FritzPoelking@
t-online.de

105

Mike Powles
9 Marryats Loke
Langham
Norfolk NR25 7AE
UK

Tel: 01328 830 406
Fax: 01328 830 406
Email:
mike.powles@dial.pipex.com

118

Stefan Preis
Windhalmweg 31
13403 Berlin
GERMANY

Tel: (0049) 304 142 864
Fax: (0049) 304 142 864

108

Helmut Pum
Goldbacherstrasse 78
4400 Steyr
AUSTRIA

Tel: (0043) 725 242 300

152

Charlotte Renaud
48 allée Albert Camus
59500 Douai
FRANCE

Tel: (0033) 3 27 88 1599
Fax: (0033) 3 27 88 1599
Email: renaud.haution@
wanadoo.fr

147

Ashleigh Rennie
PO Box 9158
Minnebron 1549
SOUTH AFRICA

Tel: (0027) 11 454 3988
Fax: (0027) 11 453 0558
Email: hinde@netactive.co.za

21

Kari Reponen
Säklänmäentie 141
52100 Anttola
FINLAND

Tel: (00358) 500 154 298
Fax: (00358) 157 600 471

14

Tom Schandy
Elgfaret 35
3320 Vestfossen
NORWAY

Tel: (0047) 32 700 581
Fax: (0047) 32 700 585
Email: tschandy@online.no

AGENT

Bruce Coleman Ltd
16 Chiltern Business Village
Arundel Road
Uxbridge
Middlesex UB8 2SN
UK

Tel: 01895 257094
Fax: 01895 272357

108

Daniel Schär
Eigenstrasse 15
3367 Thörigen
SWITZERLAND

Tel: (0041) 629 610 453
Fax: (0041) 629 611 034

11

Manoj Shah
PO Box 44219
Nairobi
KENYA

Tel: (00254) 2 743 962
Fax: (00254) 2 751 692
Email: manojshah@
iconnect.co.ke

109

Jorge Sierra
P°Juan XXIII N°24, 2°-1
28040 Madrid
SPAIN

Tel: (0034) 915 346 850

116

Raoul Slater
PO Box 1157
Gympie
Queensland 4570
AUSTRALIA

Tel: (0061) 7 5485 0918
Fax: (0061) 7 3202 7009
Email: slaterjackson@
bigpond.com.au

AGENT

Woodfall Wild Images
17 Bull Lane
Denbigh
Denbighshire LL16 3SN
UK

Tel: 01745 815903
Fax: 01745 814581